MY SWEET KITCHEN

linda lomelino

ROOST BOOKS
BOULDER
2016

238. NEDBØJET RANUNKEL, RANUNCULUS F

CONTENTS

RECImpES

IT WAS ONLY about five years ago that I started baking seriously. Of course, there had been the occasional Swedish-style sticky cake to satisfy a craving, but now I was driven by something other than a desire for sweetness. I wanted to create something that was both delicious and beautiful.

After a few days of baking I also wanted to blog about baking, and because a baking blog is nothing without good photos, I dusted off my camera and began experimenting. I still remember exactly what my first "real" picture looked like. I had photographed mini cupcakes in colorful, polka-dotted paper muffin cups on a shiny, bright-white coffee table (which is still in my living room).

I still work in just about the same style today. I don't have a professional studio and I don't think I need one.

Baking in my untidy little kitchen and taking photos in my living room or out on the balcony works quite well for me. I have a corner with a small table in it, where I know exactly how the light comes in and moves during the day. Sometimes my partner laughs at me when he sees me balancing on various chairs and, with the help of our thin curtains, screening off the light while at the same time handling the camera to take a great photo. I learned the hard way: there are good reasons why the curtain rods must be screwed into the wall securely.

It is not the path to a successful picture that is important but the end result. It doesn't matter if you have taken a picture on your old windowsill or in a flashy studio, just as it doesn't matter if your cake is not quite perfect (most problems can be fixed with a little frosting).

It is better that you work in a place where you feel at home and know where everything is as well as understand what you have for available light. The important thing is that you are satisfied with your creations.

I also don't think that you need the most expensive gadget or the latest technique to take a good photo. Learn to work with what you have. For example, a regular smartphone works as reliably as a camera, so any extra equipment you buy is a bonus later on. The most important skill is to learn how to *see* a picture. What makes a good picture? What are you trying to show? Play with and learn to feel the light; experiment with color and style. You cannot find your style in a day or even in a week, but the more photos you take, the better they will be. I promise!

I believe I will never be an expert when it comes to baking, or styling and photography—which is also what makes them so exciting! The feelings that a pretty cake or a fine photo of a pretty cake awaken in me are fantastic. And, certainly, isn't it a bit more fun when you can document something beautiful that you've created? That combination of good baking with lovely styling and photography is what I am so happy to be sharing through this book.

Here I've collected my best recipes along with tips on how to make sweet food look so tempting that sharing these treats with your family and friends will leave them over the moon. If you also want to photograph your creations, try some of my tips on styling and photography. I hope you find this book both inspiring and enriching!

—Linda Lomelino

GARDEN DREAMS

COCONUT CAKE

This cake with pretty lilacs garnishing the top is a true garden dream. Even if you aren't going to eat the flowers, you must use fresh-picked garden flowers. Unfortunately, blooms from the flower shop are often sprayed and not suitable for coming into contact with food.

COCONUT MILK REDUCTION
One 13.5-ounce can coconut milk

CAKE LAYERS
1⅔ cups all-purpose flour
1¼ teaspoons baking powder
Pinch of salt
9 tablespoons salted butter, at room temperature
¾ cup + 1 tablespoon granulated sugar
3 eggs
¾ cup coconut milk reduction (see instructions below)
1 tablespoon coconut liqueur, such as Malibu, or coconut liqueur extract

COCONUT FROSTING
1 cup whipping cream
⅓ cup confectioners' sugar
⅔ cup coconut cream
1 teaspoon coconut liqueur, such as Malibu, or coconut liqueur extract

Lilac flowers, for garnish

MAKING THE COCONUT MILK REDUCTION

1. Pour the coconut milk into a saucepan and bring to boil. Reduce the heat and let simmer until the milk is reduced by about half, about 20 minutes. Stir occasionally.
2. Let cool to room temperature and then refrigerate. The coconut milk reduction can be made up to 2 days ahead of time.

MAKING THE CAKE LAYERS

1. Preheat the oven to 350°F. Butter and flour three 6-inch cake pans or two 8-inch pans.
2. Mix the flour, baking powder, and salt in a medium bowl.
3. In a separate medium bowl, beat the butter and sugar until light and creamy. Add the eggs one at a time, beating thoroughly after each addition.
4. Sift half of the dry ingredients into a large bowl and add half of the reduced coconut milk. Stir in the butter mixture. Sift the rest of the dry ingredients over the batter, then add the rest of the reduced coconut milk and the coconut liqueur. Beat until smooth.
5. Divide the batter evenly among the prepared cake pans and bake for 20 to 30 minutes, until a toothpick inserted into the center comes out with moist crumbs. Let the layers cool in the pans for 10 to 15 minutes, then turn out onto wire cooling racks to cool completely.

MAKING THE COCONUT FROSTING

1. Whip the cream and confectioners' sugar together in a medium bowl until thick.
2. Add the coconut cream and coconut liqueur and beat a little longer until it just comes together—but not too long or the frosting will separate.

ASSEMBLING THE CAKE

Place one of the cake layers on a plate and cover with a thick layer of frosting. Stack and frost each of the other layers, ending with a thick layer of frosting over the top of the cake. I decided to leave the sides free of frosting for a "naked cake," but that is a matter of taste; do what you like best. Garnish the cake with lilac flowers.

[STABILIZING A CREAMY LAYERED CAKE]

Cakes layered with a lot of creamy frosting can be difficult to keep stable. To keep the layers from sliding and shifting, cut a few bamboo skewers to the same length as the height of the cake and insert them down through the top. Refrigerating the cake for a while before slicing it will further stabilize it.

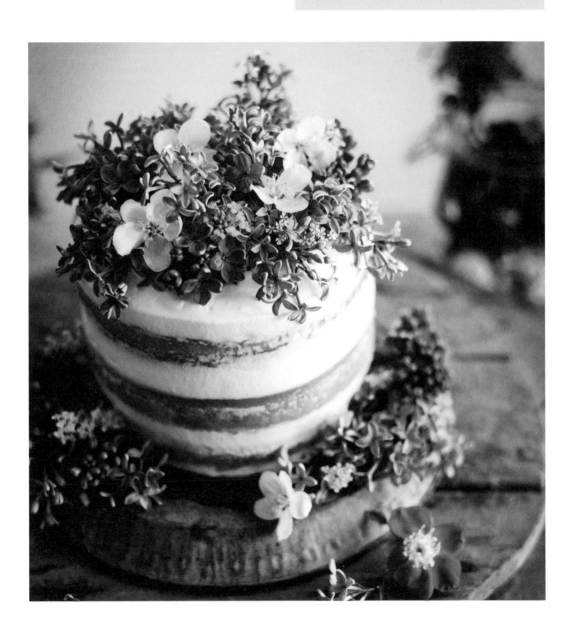

BUNDT CAKE WITH ELDERFLOWER GLAZE

An absolutely perfect Bundt cake made even better with an elderflower glaze. Homemade elderflower syrup beats any commercially made version, but you must plan ahead and be ready to make it during the very short period in the spring when the trees or shrubs bloom. You can of course also use store-bought elderflower cordial to make the glaze all year round.

BUNDT CAKE

2 eggs
¾ cup granulated sugar
1¼ cups all-purpose flour
2 teaspoons baking powder
Pinch of salt
5½ tablespoons salted butter
¼ cup + 2 tablespoons milk
Finely grated zest of 1 lemon

ELDERFLOWER GLAZE

¾ cup confectioners' sugar
2 tablespoons concentrated elderflower syrup
Elderberry flowers, for garnish (optional)

MAKING THE BUNDT CAKE

1. Place an oven rack in the lowest position in the oven and preheat the oven to 350°F. Butter and flour a Bundt pan that holds about 1½ quarts.
2. Beat the eggs and sugar together in a large bowl until light and fluffy, about 5 minutes. In a medium bowl, mix the flour, baking powder, and salt. Sift the dry ingredients over the egg mixture and beat until incorporated.
3. Melt the butter and add to the batter along with the milk and lemon zest. Beat until smooth and then pour the batter into the prepared pan.
4. Place the Bundt pan in the oven on the low rack and bake for 45 to 50 minutes, until a toothpick inserted into the center comes out with moist crumbs. Let the cake cool in the pan for a little while and then turn out onto a wire cooling rack to cool completely.

MAKING THE ELDERFLOWER GLAZE AND TOPPING THE CAKE

Mix the confectioners' sugar and elderberry syrup in a small bowl until smooth. Place the cooled cake on a plate and spoon the glaze over the cake. Garnish with elderberry flowers, if available.

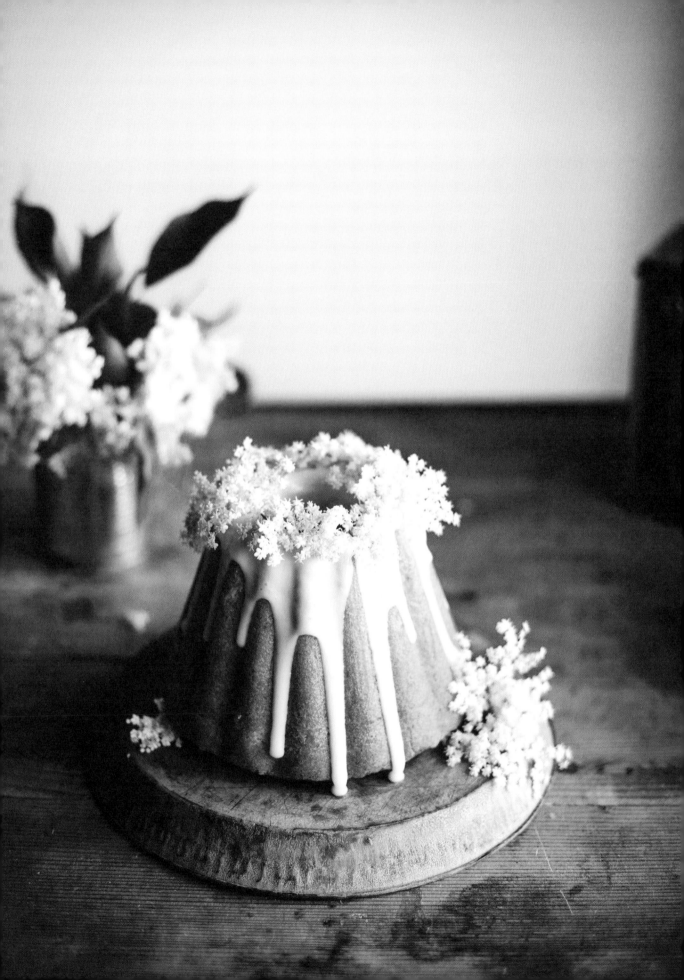

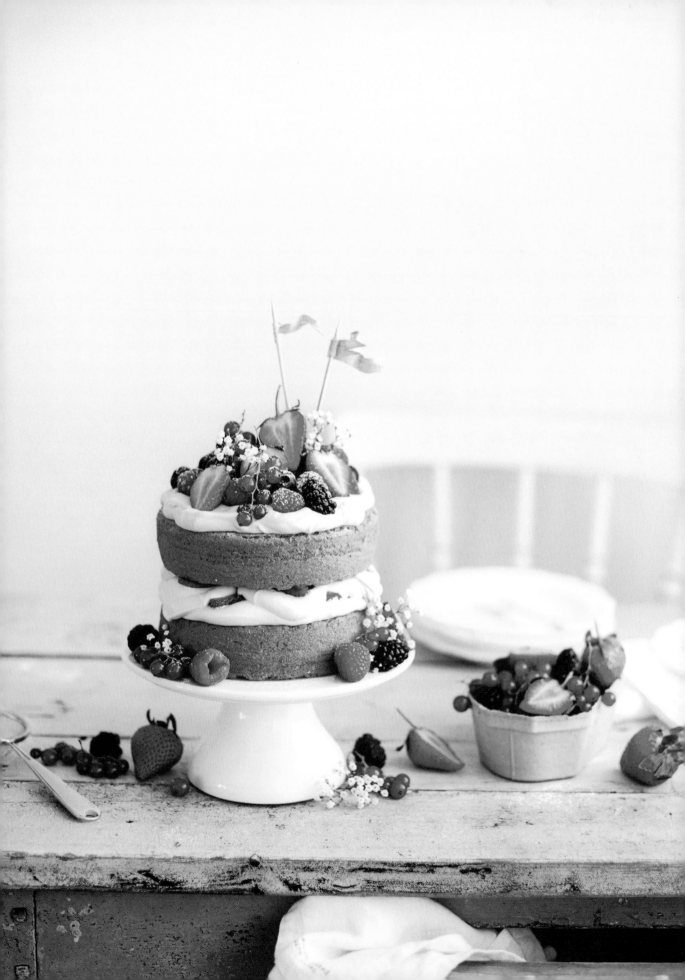

SPONGE CAKE WITH FRESH BERRIES AND MASCARPONE

The mascarpone in the filling lends a fresh taste and a smooth, firm consistency that makes it easy to stack this cake sky-high. Leave the sides of the layer cake unfrosted as shown, or slather the entire cake with frosting; it's equally delicious both ways.

SPONGE CAKE

1¼ cups all-purpose flour

2 teaspoons baking powder

Pinch of salt

14 tablespoons salted butter, at room temperature

¾ cup granulated sugar

1 teaspoon vanilla extract, or ¼ teaspoon vanilla powder

3 eggs, at room temperature

1 tablespoon + 2 teaspoons milk, at room temperature

MASCARPONE FROSTING

9 ounces mascarpone

2 tablespoons confectioners' sugar

¾ cup whipping cream

9 ounces mixed fresh berries, for garnish

Confectioners' sugar, for garnish

MAKING THE SPONGE CAKE

1. Preheat the oven to 350°F. Butter two 6-inch cake pans. Cut out two circles of parchment paper to fit into the bottom of the pans and lay in each pan. Dust flour around the sides of the pan.
2. Mix the flour, baking powder, and salt in a medium bowl.
3. In a large bowl, beat the butter, sugar, and vanilla until light and creamy, about 5 minutes.
4. Add the eggs one at a time, beating thoroughly after each addition.
5. Sift the dry ingredients over the butter mixture and fold in with a spatula. Add the milk and stir until the batter is smooth and even.
6. Divide the batter evenly between the prepared pans and bake in the center of the oven for 25 to 30 minutes, until a toothpick inserted into the center comes out with moist crumbs. Let the layers cool in the pans for a little while and then turn out onto wire cooling racks to cool completely. Remove the parchment paper from the layers.

MAKING THE MASCARPONE FROSTING

Beat the mascarpone and confectioners' sugar in a medium bowl until creamy. Slowly add the cream and beat until the frosting is a spreadable consistency.

ASSEMBLING THE CAKE

Place one of the cake layers on a cake plate. Spread with a thick layer of frosting, then add some fresh berries. Add the other cake layer and spread frosting on top. Decorate with more berries and dust with confectioners' sugar.

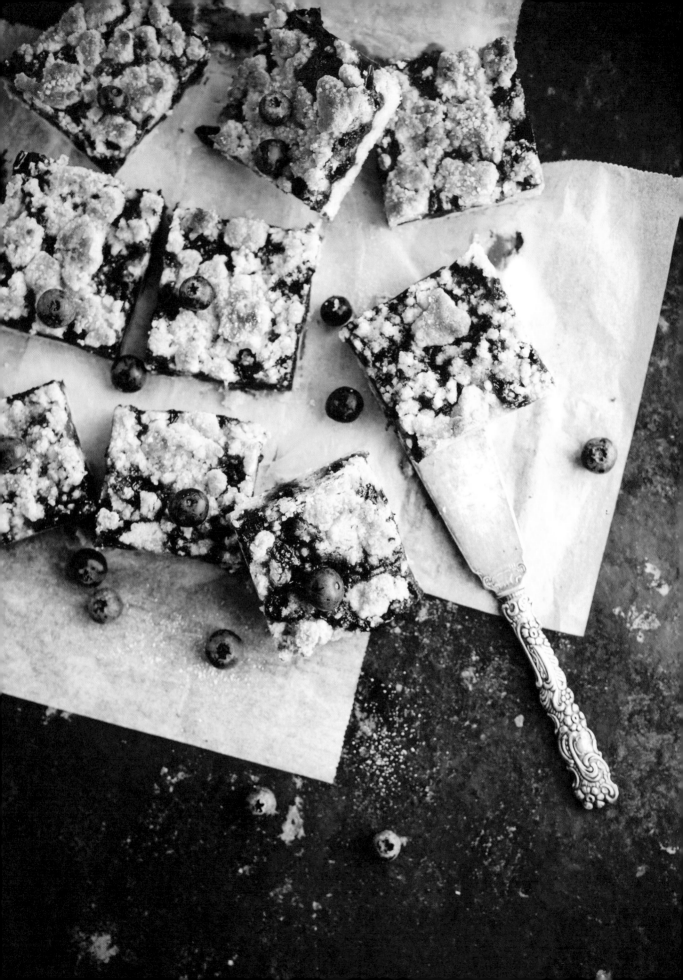

BLUEBERRY BARS

These bars have a wonderful consistency and are devoured quickly whenever I share them with my friends! They are also simple to make and delightful for any occasion. If you don't want to make bars, you can press the dough into a round pie pan and serve in slices.

CRUST

1¼ cups all-purpose flour

½ cup granulated sugar

½ teaspoon baking powder

Pinch of salt

9 tablespoons cold salted butter, diced

1 large egg yolk

1 teaspoon freshly squeezed lemon juice

FILLING

1 cup fresh or frozen blueberries

¼ cup granulated sugar

2 teaspoons cornstarch

1 teaspoon finely grated lemon zest

1 tablespoon freshly squeezed lemon juice

2 teaspoons unrefined sugar or granulated sugar, for garnish

MAKING THE CRUST

1. Preheat the oven to 400°F. Butter an 8 x 8-inch baking pan and line the bottom and sides with parchment paper. (The easiest method is to cut two 8 x 16-inch strips and lay them in a cross on the bottom of the pan.)

2. Mix the flour, sugar, baking powder, and salt in a large bowl. Add the butter, egg yolk, and lemon juice and combine with your fingers until the dough is crumbly but holds together well. Press two-thirds of the dough into the bottom of the prepared pan.

MAKING THE FILLING AND BAKING

1. Stir together the blueberries, sugar, cornstarch, lemon zest, and lemon juice in a medium bowl. Spread over the dough in the pan.

2. Sprinkle the remaining third of the crust dough over the blueberry mixture. Sprinkle with sugar.

3. Bake for 30 to 35 minutes, only until the crust is golden brown. Let cool completely in the pan, then refrigerate. Cut into squares for serving. Serve the bars cold, or warm them slightly in the microwave to soften.

RASPBERRY AND WHITE CHOCOLATE CUPCAKES

A cupcake is the perfect baked good for practicing piping and decorating techniques. Try out various piping-bag tips and make daring swirls. For details on making meringue buttercream, see pages 43–44. For tips about piping, see page 81.

CUPCAKES

1⅓ cups all-purpose flour

¾ cup granulated sugar

1½ teaspoons baking powder

Pinch of salt

7 tablespoons salted butter, at room temperature

2 eggs, at room temperature

¼ cup yogurt or sour cream, at room temperature

1 teaspoon vanilla extract, or ¼ teaspoon vanilla powder

1¾ ounces white chocolate

1¾ ounces fresh raspberries

RASPBERRY MERINGUE CREAM

4 egg whites

¾ cup + 1 tablespoon granulated sugar

18 tablespoons unsalted butter (2 sticks + 2 tablespoons), at room temperature

4½ ounces fresh or thawed frozen raspberries

Dab of pink gel food coloring (optional)

MAKING THE CUPCAKES

1. Preheat the oven to 350°F. Line a muffin tin with 12 paper cupcake liners.
2. Mix the flour, sugar, baking powder, and salt in a large bowl. Add the butter, eggs, yogurt, and vanilla and beat until it makes a smooth batter.
3. Chop the chocolate and stir it into the batter.
4. Divide the batter among the muffin cups and press a few berries into the batter in each. Bake for 20 to 23 minutes, until a toothpick inserted into the center comes out with moist crumbs. Let cool completely.

MAKING THE RASPBERRY MERINGUE CREAM

1. Add water to a saucepan or the bottom of a double boiler and simmer over low heat. Put the egg whites and sugar into a heatproof bowl or saucepan and place over the simmering water in the bottom pan. Using a hand whisk, beat the egg whites and sugar until the mixture reaches 150°F, or until all the sugar crystals have dissolved. Pour the mixture into a large bowl and continue beating with an electric mixer until the meringue is white and fluffy. The mixture will cool during this step, about 10 minutes.
2. Add the butter a little at a time as you beat the meringue. Once the butter is incorporated, beat for another 3 to 5 minutes, until the frosting holds together.
3. Purée the raspberries in a blender. Press the purée through a fine-mesh sieve over a small bowl and discard the seeds. Add the strained purée to the frosting and beat until evenly incorporated. Add a little pink gel food coloring if you'd like a deeper color.

DECORATING THE CUPCAKES

Fit a piping bag with your choice of tip and fill with the meringue cream. Remove the cupcakes from the pan and decorate.

19

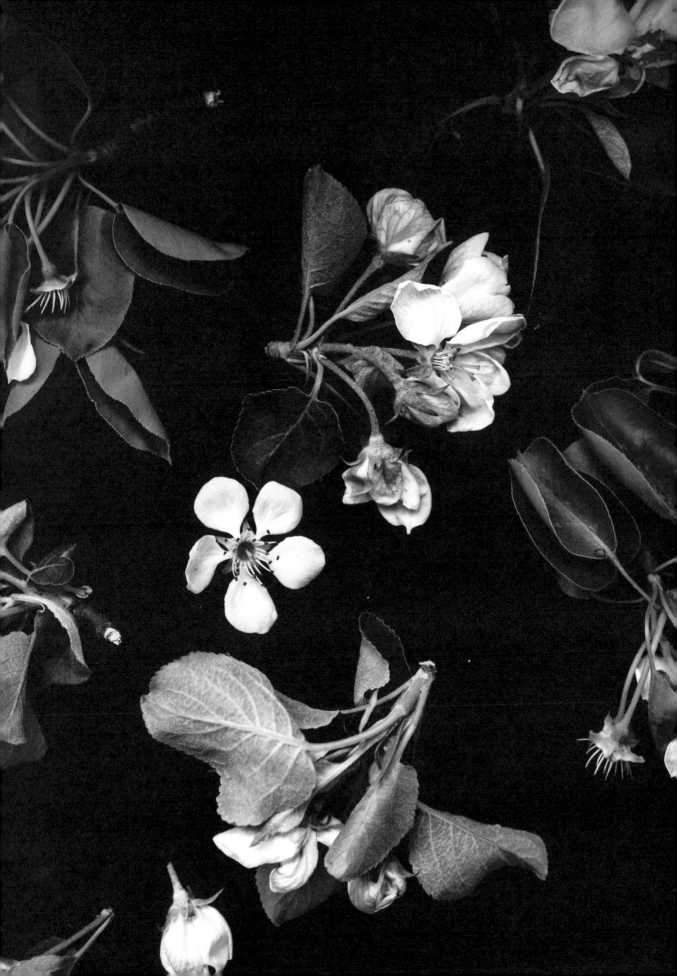

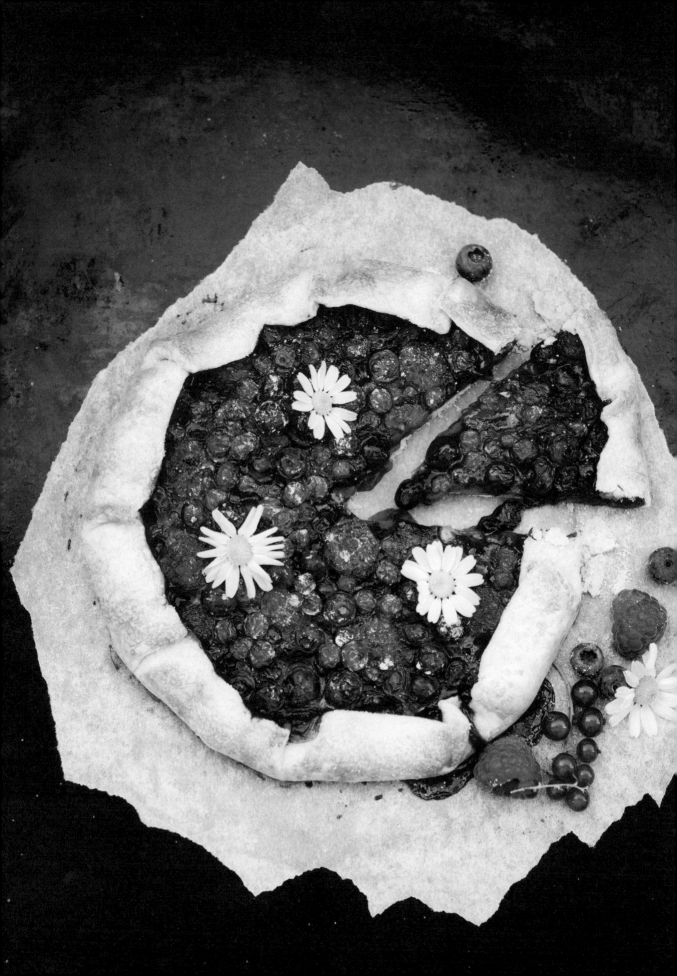

BERRY GALETTES

Neatly fitting a pie crust just so in a pie pan can be maddening; when your patience is short, a galette is the perfect alternative. You don't need a pie pan, and you don't even need to be very precise to get delicious results. You might say this is a relaxed pie! It is also not overly sweet, which is by design: all the better to sneak a scoop of vanilla ice cream beside it.

PIE CRUST

1⅓ cups all-purpose flour

1 tablespoon confectioners' sugar

Pinch of salt

7 tablespoons cold salted butter, diced

¼–⅓ cup ice water

FILLING

2 cups fresh berries, such as raspberries, blueberries, and currants

¼ cup granulated sugar

2 teaspoons vanilla extract, or ½ teaspoon vanilla powder

1 tablespoon + 1 teaspoon cornstarch

1 egg

1 tablespoon milk

1 tablespoon granulated sugar, for garnish

MAKING THE PIE CRUST

1. Mix the flour, confectioners' sugar, and salt in a medium bowl. Add the butter and work in with your fingers until the dough is crumbly. Add the cold water in small increments and incorporate with your fingers, adding more gradually if the dough feels dry. Shape the mixture into a ball and knead only until it comes together.
2. Divide the dough in half. Form the halves into balls and carefully press each into a flattened round. Place the dough rounds in a plastic bag or wrap with plastic. Refrigerate for at least 2 hours.

MAKING THE FILLING

Stir together the berries, sugar, vanilla, and cornstarch in a bowl.

ASSEMBLING AND BAKING THE GALETTES

1. Preheat the oven to 350°F.
2. On a lightly floured work surface, roll out each piece of dough into a circle about ⅛ inch thick. Lay the dough circles next to each other on a piece of parchment paper.
3. Divide the filling between the two circles and spread it out to about 2 inches from the edge. Working all the way around each circle, fold the edge of the dough up over some of the filling and press down so it holds its shape.
4. Transfer the galettes still on parchment onto a platter or cutting board and place in the freezer for about 10 minutes (this will help the dough hold its shape during baking).
5. Place the frozen galettes onto a baking sheet. Beat the egg and milk lightly in a small bowl and drizzle around the edge of each galette. Sprinkle ½ tablespoon of the sugar over each pie.
6. Bake the galettes in the center of the oven for 35 to 45 minutes, until the crust is golden brown and the berries are bubbling and soft.

RASPBERRY AND OREO CHEESECAKE

This recipe has simple components and a dramatic presentation. If the ingredients for the filling are allowed to come to room temperature beforehand, you'll get a fine cheesecake that doesn't split or sink while baking. A note on equipment: You will need a long pan, big enough to fit the cake pan inside, for the bain-marie baking.

COOKIE BASE

4 tablespoons salted butter

7 ounces Oreo cookies (or Ballerina cookies, available at IKEA or Swedish import shops)

CHEESECAKE FILLING

21 ounces cream cheese, at room temperature

¾ cup granulated sugar

Finely grated zest of 1 lemon

1 tablespoon freshly squeezed lemon juice

2 eggs, at room temperature

⅔ cup sour cream, at room temperature

1 tablespoon all-purpose flour

RASPBERRY SAUCE

5¼ ounces fresh raspberries (or thawed frozen)

¼ cup + 2 tablespoons water

¼ cup granulated sugar

1 teaspoon vanilla extract, or ¼ teaspoon vanilla powder

2 teaspoons cornstarch

4½ ounces fresh raspberries, for garnish

Making the Cookie Base

1. Preheat the oven to 325°F.
2. Melt the butter. Pulse the cookies into fine crumbs in a blender or food processor. Add the butter and pulse. Press the cookie mixture into the bottom and partway up the sides of a 7-inch springform pan. (You can use up to a 9½-inch pan, but the cake will be much shallower.) Prebake the crust for 10 minutes. Remove from the oven and let cool.
3. Wrap the bottom of the cooled springform pan with two thick layers of aluminum foil to prevent water from seeping into the pan when the cheesecake bakes in the bain-marie.

Making the Cheesecake Filling

In a large bowl, beat the cream cheese, sugar, lemon zest, and lemon juice into a creamy batter. Add the eggs and beat for another minute. Beat in the sour cream and then sift the flour over the batter. Continue beating until the batter is smooth and then pour it over the cookie base in the springform pan.

Baking the Cheesecake

1. Bring a kettle of water to a boil. Set the springform pan in a long baking pan and place in the oven at 325°F. Pour the hot water into the long pan so that it reaches halfway up the springform pan.
2. Bake for 50 to 80 minutes (the smaller the pan diameter, the less baking time is needed), until the cheesecake is firm around the edges but still slightly wobbly in the middle. Turn off the heat and leave the cheesecake in the oven for 1 more hour.
3. Remove the springform pan from the oven and the water bath and let the cheesecake cool completely in the pan. Refrigerate the cheesecake (still in the springform pan) for 6 to 8 hours.

Making the Raspberry Sauce

1. Stir together the raspberries, water, sugar, and vanilla in a saucepan. Mash the raspberries with a fork and bring the mixture to a boil over medium heat.
2. Stir the cornstarch with a little water in a small bowl until dissolved. Add to the raspberry mixture and stir well. Let the mixture simmer until it thickens, stirring constantly to avoid sticking to the bottom.
3. Press the sauce through a sieve over a small bowl and discard the seeds. Let the strained sauce cool to room temperature, then refrigerate.

Decorating the Cheesecake

Remove the cheesecake from the refrigerator about 15 minutes before serving. Carefully loosen the sides of the springform pan and remove. Transfer the cake to a platter and garnish with the raspberry sauce and fresh raspberries.

RHUBARB SUMMER CAKE

This is one of my most versatile recipes. It comes together easily and has so many tasty variations for every part of the growing season. In this version I've used rhubarb, but you can also try it with your favorite berries or stone fruit. Allow the butter, milk, and egg to sit at room temperature for at least 30 minutes before baking.

CAKE

1¼ cups all-purpose flour

1½ teaspoons baking powder

1 teaspoon cardamom seeds, ground

Pinch of salt

7 tablespoons salted butter, at room temperature

¾ cup + 1 tablespoon granulated sugar

1 egg

1 teaspoon vanilla extract, or ¼ teaspoon vanilla powder

½ cup milk

RHUBARB TOPPING

5¼ ounces rhubarb

2 teaspoons granulated sugar

MAKING THE CAKE BATTER

1. Preheat the oven to 350°F. Butter a pie pan or a 9- to 9¾-inch springform pan and line with parchment paper (see page 37).
2. Mix the flour, baking powder, cardamom, and salt in a medium bowl.
3. In a large bowl, beat the butter and sugar until light and creamy, about 4 minutes. Add the egg and vanilla and beat until smooth.
4. Alternate adding some of the milk and some of the dry ingredients, beating after each addition, until all the ingredients have been incorporated. Beat until smooth. Pour the batter into the prepared pan.

MAKING THE RHUBARB TOPPING

1. Peel the rhubarb (if the outer layer is thick and fibrous) and cut into 2- to 3-inch-long pieces. If the pieces are wide, cut in half lengthwise to prevent the rhubarb from sinking to the bottom during baking.
2. Arrange the rhubarb pieces in a pretty pattern on top of the batter in the pan. Sprinkle with the sugar.

BAKING THE CAKE

Bake the cake for 10 minutes, then lower the heat to 300°F and bake for another 40 to 50 minutes, until the cake is golden brown and a toothpick inserted into the center comes out with moist crumbs. Leave in the pan to cool.

[APPLE AND CINNAMON VARIATION]

APPLE TOPPING

2–3 apples

1 tablespoon + 2 teaspoons granulated sugar

1 teaspoon ground cinnamon

1. Peel, core, and slice the apples. Arrange the apple slices on top of the batter instead of the rhubarb.
2. Mix the sugar and cinnamon in a small bowl and sprinkle on top of the cake.

PAVLOVA ROULADE with MASCARPONE and RASPBERRIES

This cake is truly something special: a crispy but still soft meringue cake with a creamy filling and fresh berries. It's uniquely perfect for a summer gathering.

MASCARPONE FILLING
1 cup mascarpone

⅔ cup whipping cream

2 tablespoons confectioners' sugar

1 teaspoon finely grated lemon zest

MERINGUE CAKE
4 large egg whites

¾ cup granulated sugar

1 teaspoon cornstarch

1 teaspoon white wine vinegar

Confectioners' sugar

1¼ ounces fresh raspberries

2¼ ounces mixed fresh berries, for garnish

MAKING THE MASCARPONE FILLING

Beat the mascarpone, whipping cream, confectioners' sugar, and lemon zest in a medium bowl until it forms a thick cream. Refrigerate while you make the cake.

MAKING THE CAKE LAYERS

1. Preheat the oven to 325°F.
2. Beat the egg whites in a large bowl until frothy and then add the sugar a little at a time with the mixer running. Continue to beat until the egg whites thicken into a rich, lofty consistency. You should be able to tip the bowl without the meringue falling out. Fold in the cornstarch and vinegar.
3. Line a 9½ x 13-inch baking pan with parchment paper and use a spoon or offset spatula to spread the meringue evenly to about ¾ inch thick. Bake in the center of the oven for 15 to 20 minutes, until the meringue begins to brown slightly. Watch the browning process closely, as meringue can burn quickly.
4. Lay a clean baking towel on a work surface. Cover it with parchment paper and dust the entire piece of paper generously with confectioners' sugar.
5. Remove the pan from oven and let cool for about 3 minutes, then turn the meringue cake out onto the sugared parchment paper. Peel off and discard the parchment paper used during baking. Let the meringue cool for about 10 minutes.

ASSEMBLING THE ROULADE

1. Spread the filling in an even layer on the meringue cake, leaving 1¼ inches free of filling along one of the long sides. Sprinkle the raspberries over the filling.
2. With the other long side closest to you, carefully roll up the cake, working away from you and toward the edge that is free of filling. Use the parchment paper and towel to help with the rolling. Making sure that the overlapping edge ends up at the bottom, wrap the roulade well in the parchment and towel. Refrigerate for about 4 hours.
3. To serve, carefully transfer the roulade to a serving platter and decorate with mixed berries. Dust with confectioners' sugar.

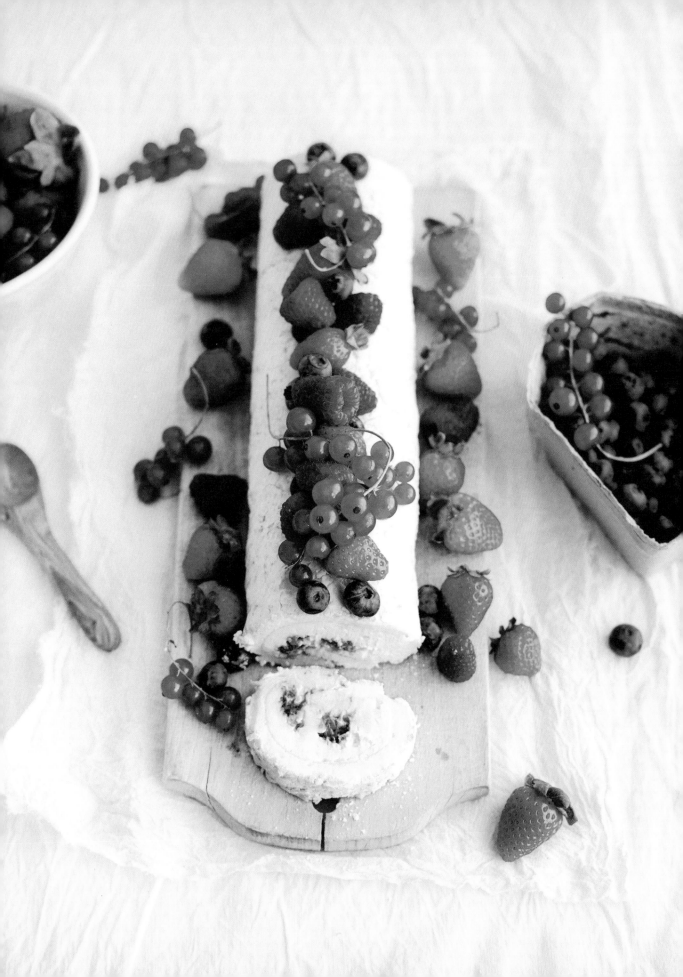

[BAKING ESSENTIALS]

[INGREDIENTS]

Quality ingredients are the foundation of successful baking. I use organic and locally grown ingredients as much as possible for the simple reason that they taste better and yield excellent results. For the best results, work with ingredients that are all at room temperature, unless otherwise stated. Gather the items you will need about an hour beforehand.

EGGS

Choose large organic eggs and remove them from the refrigerator 30 to 60 minutes before you start baking. If you will be separating the whites from the yolks, however, always do so when the eggs are still cold; otherwise, the yolks can easily disintegrate.

Because egg yolks contain fat, it is important not to let any of the yolk mix with the white, as fat prevents egg whites from making stiff peaks when beaten. Therefore, the bowl you whisk the whites in also must be clean and free from any fats or oils. It is best to beat egg whites in a stainless steel or glass bowl, both of which are easier to clean than plastic bowls. To be completely sure the bowl is clean, wipe it out with a paper towel dabbed with a few drops of vinegar or lemon juice.

You can freeze extra unwhipped egg whites for future use.

BUTTER AND OIL

Most of my recipes call for regular salted butter. "At room temperature" means that the butter has been out of the refrigerator for at least 1 hour and up to overnight. You can also slowly heat the butter in the microwave, a few seconds at a time. If you use cold butter in a recipe calling for butter at room temperature, the ingredients may separate.

Always use real butter, not margarine, when you bake, because butter adds a better flavor and is less processed. Butter is commonly packaged in 1-pound boxes of 4 sticks. In this book, we've used the tablespoon as our basic unit of measure for butter: 8 tablespoons equals 1 stick.

If the recipe calls for oil, use neutral oils such as sunflower or canola oil, which won't affect the taste.

MILK AND CREAM

For baking, use milk that is at least 1.5 percent fat.

Cream, unlike many other ingredients, should be chilled (that is, at refrigerator temperature) when used for baking. There are several types of cream, but I use cream with a fat content of 40 percent, because it does not have any additives.

SOFT CHEESES

Several types of soft cheese are ideal for sweets; most often, I use cream cheese or mascarpone.

Cream cheese should be plain (unflavored) with a fat content of about 23 percent. Low-fat versions do not work as well for baking.

Mascarpone is an Italian soft cheese similar to cream cheese, but it has a somewhat stronger flavor and thicker consistency.

SUGAR

Sugar is primarily for sweetening baked goods but is also important for texture and preserving freshness. Most often I use granulated sugar, which is regular white sugar, but other types are also called for in these recipes:

Confectioners' sugar is fine-ground white sugar that has been blended with cornstarch to prevent clumping. It is useful when you don't want the appearance or texture of the large sugar crystals of regular sugar, such as when dusting sugar over a finished cake or when making buttercream.

Brown sugar is white sugar that has been mixed with molasses for a golden brown,

moist, and very flavorful sugar. If you use brown sugar instead of white sugar in a recipe, the cake will have a more concentrated flavor and deeper color.

Muscovado sugar is a type of raw sugar produced in Mauritania and available in both light and dark varieties with a characteristic moistness. Light Muscovado tastes like caramel and dark Muscovado has a licorice flavor. If you can't find Muscovado sugar, substitute brown sugar. When measuring Muscovado sugar, pack it rather firmly into the measuring cup to get the correct amount.

FLOUR

I use regular white all-purpose flour when I bake, so just choose a brand you like. When measuring flour, do not pack it too tightly into the measuring cup. Stir the flour in the bag or bin with a spoon or whisk to make it lighter before measuring. All the measurements for flour in this book are level: fill the cup with flour and then swipe your index finger or a butter knife straight across the top of the cup to remove any excess.

For larger amounts of flour (more than 2 cups), it is usually easier to weigh rather than measure (see the weight equivalency table on page 35).

Some recipes ask you to sift your flour, which means that you should pour the measured flour into a fine-mesh sieve and then let it pass through the sieve into the bowl. Sifting removes any lumps that might be difficult to blend in, and the flour will be airy and distribute evenly.

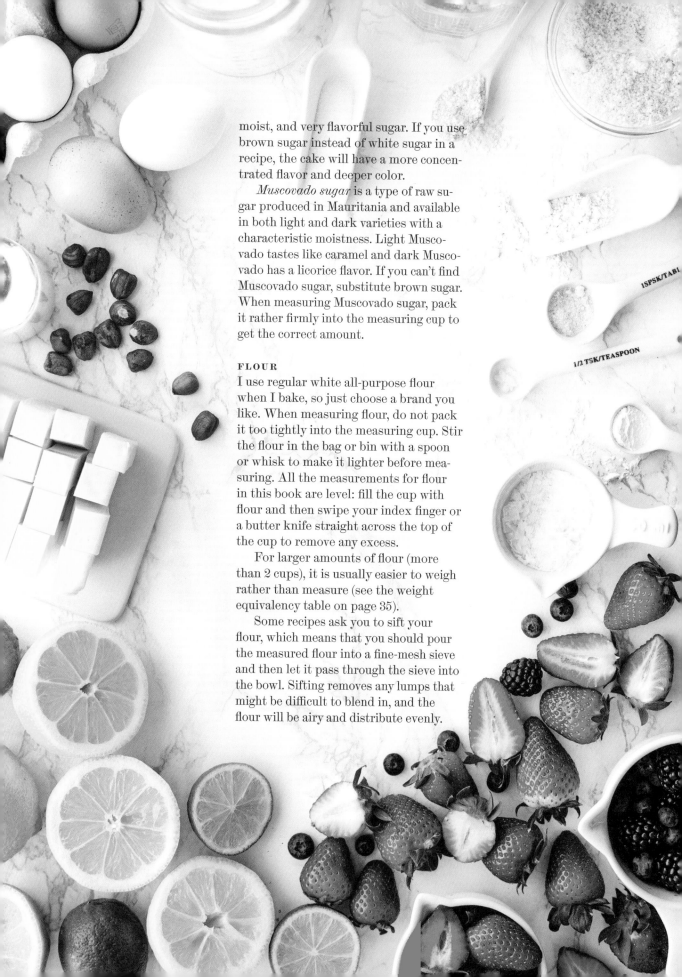

CHOCOLATE AND COCOA

Cocoa is available in many qualities containing varying amounts of cocoa. When chocolate is the main ingredient of your baking, it is important that it be the best quality you can afford. Most often, I use dark chocolate with 70 percent cocoa.

If you don't like the bitterness of dark chocolate, keep in mind it will be blended with other ingredients in baking. Substituting milk chocolate for dark chocolate will lead to a less distinct chocolate taste, and the overall quality of your baked goods can be affected.

Chocolate burns easily, so it must be melted very gradually. It is best to melt it over a double boiler. You don't have to own a special piece of equipment for this: Heat some water in a large saucepan but do not let it boil. Place a smaller saucepan or heatproof bowl over the large pan. Keep the bottom pan over low heat, still on the burner. Chop the chocolate and put it in the small pan. Stir the chocolate until all the pieces have melted. It is very important that no water splash into the pan with the chocolate; even the tiniest amount of water can make the chocolate seize and become grainy.

You can also melt chocolate in the microwave. Place it in a microwave-safe bowl, and heat it only a few seconds at a time for the best results. Take the bowl out occasionally and stir the chocolate until all the pieces have melted. Chocolate can burn and turn grainy in just a few seconds in the microwave, and

there is no trick for rescuing it! White chocolate burns even more quickly than dark, so you will need to be extra cautious.

NUTS

There are so many different types of nuts to choose from. Almonds, hazelnuts, pecans, peanuts, and walnuts are some of the kinds I like and often include in my baking. Toasting nuts intensifies their flavor: Preheat the oven to 350°F. Spread the nuts on a baking sheet in a single layer and toast in the oven for about 10 minutes. Keep an eye on the nuts because they can burn quickly!

Always store nuts in a cool place, preferably in the refrigerator, because they have a high fat content and can go rancid quickly.

VANILLA

Pure vanilla can be bought as whole vanilla beans, vanilla extract, or vanilla powder.

A vanilla bean should be soft and easy to slice down its length so you can scrape out the seeds, which contain most of the flavor.

Vanilla extract is made from vanilla beans that have been soaked in alcohol for a long time. It is sometimes difficult to find pure vanilla extract, but it is easy to make your own (see recipe on page 40). If replacing vanilla powder with extract, use about twice the amount.

Vanilla powder (vanilla bean in powdered form) can usually substitute for vanilla extract in most recipes. The powder has a more concentrated flavor than vanilla extract, so use about half as much.

BERRIES AND FRUIT

Use fresh berries that are in season. There is an enormous difference in flavor between strawberries picked locally at their peak season and those sold in stores in the winter.

Where indicated in the recipe, you can use frozen rather than fresh berries. Frozen berries that have been thawed can be a bit watery and lose their shape, but that rarely makes any difference in the flavor and presentation.

For citrus, most recipes call for just the peel or zest, so always use organic fruit. If you can't find organic citrus, wash it very thoroughly before you grate the peel.

[WEIGHING INGREDIENTS]

When using a large amount of an ingredient, it is usually easier to weigh rather than measure the amount. If you have a good kitchen scale with a tare function, you'll find it more accurate to weigh all the ingredients called for in a recipe.

1 cup all-purpose flour = 160 g / 5.6 oz.
1 cup granulated sugar = 240–253 g / 8.5–9.0 oz.
1 cup confectioners' sugar = 160 g / 5.6 oz.
1 cup brown sugar = 200 g / 6.9 oz.
1 cup Muscovado sugar = 200 g / 6.9 oz.
1 cup cocoa = 107 g / 3.7 oz.
1 cup milk/whipping cream = 267 g / 9.3 oz.
1 large egg = 63–73 g / 2.2–2.6 oz.
1 large egg white = approx. 30 g / 1.1 oz.

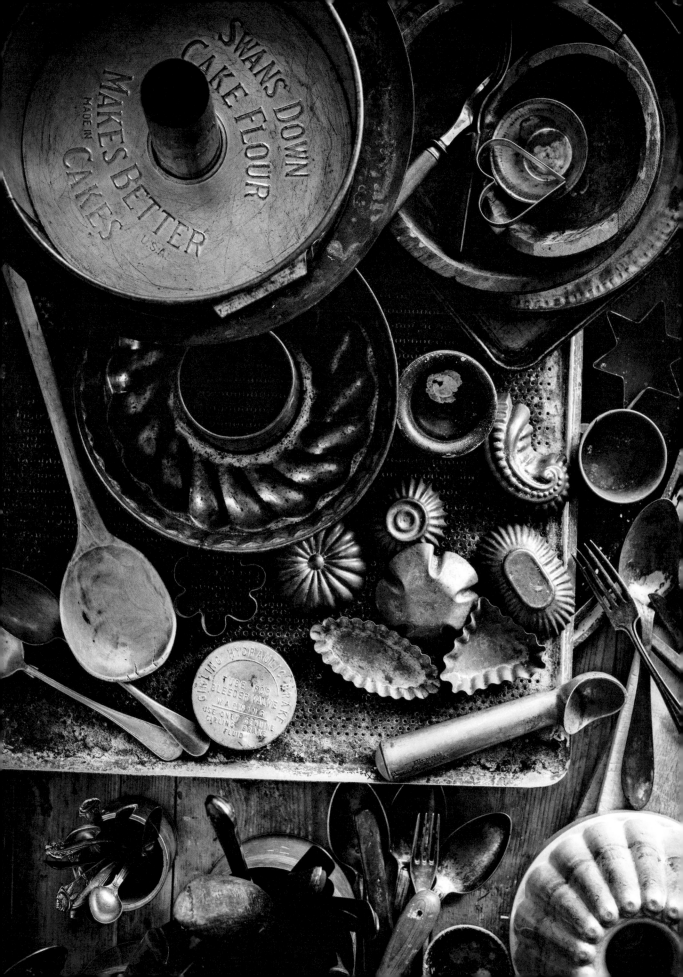

[PREPARING PANS WITH PARCHMENT PAPER]

Preparing a pan with parchment paper has its advantages. The cake will be easier to remove from the pan after baking, and if you need to bake a lot of batter in a pan that isn't high enough, you can make a parchment paper collar for it, taller than the sides of the pan. I usually bake cakes in 6-inch round pans, but this technique can be used for a pan of any size.

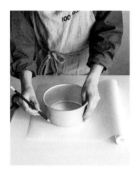

LINING A ROUND PAN
1. Place the pan on a piece of parchment paper.

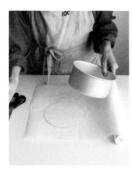

2. Trace around the bottom of the pan with a pencil.

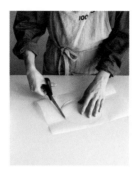

3. Cut out a circle just inside the traced line.

4. Measure how much paper you'll need to wrap all the way around the pan for the collar.

5. Cut a piece of paper that length and about twice as high as the height of the pan.

6. Cut small (about 1 inch deep) notches along one of the long sides of the paper strip.

7. Coat the entire inside of the pan with butter. With the notched edge down, wrap the strip around the inside of the pan.

8. Bend the notches inward to lie against the bottom of the pan. Coat the tops of the flaps with a little butter to seal.

9. Lay the circle of parchment paper in the bottom of the pan so it fits snugly and press to seal.

LINING A SQUARE PAN
1. Cut two long strips of parchment paper, each as wide as the pan and long enough to overhang each edge by 4 to 6 inches. Coat the inside of the pan with butter and lay in the first strip.

2. Coat the section of the first strip that is in the bottom of the pan with more butter and lay in the second strip crossways. Press the bottom and sides to seal.

Many baking books present pies as complicated, with a great deal of advice about how to produce the perfect crust. That is totally unnecessary! I love to bake pies and think they should be as easy as possible. My pie dough is very easy to make, but there are a few things to think about:

- Keep all the ingredients and mixing tools as cold as possible. Cold dough transforms into a fine, crispy pie crust.
- Do not overwork the dough. The butter should not be completely and perfectly incorporated. Small flakes of butter make the dough crispier.

- Sometimes a food processor is recommended for pie dough, but I prefer mixing it with my hands.

If you want to make a really simple pie, I suggest baking a galette (see page 23). For a galette, you don't need to line a pie pan with dough. You just roll out the dough, transfer it to a baking sheet, fill it, and fold in the edges. It couldn't be any easier!

Pie dough can be made 2 to 3 days ahead. Just be sure to wrap it well in plastic wrap and store it in the refrigerator.

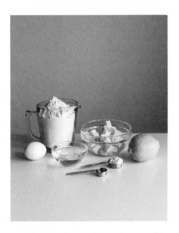

1. For best results, have all ingredients at refrigerator temperature.

2. Mix the dry ingredients. Add the butter and pinch into the dry ingredients with your fingers until the dough is crumbly.

3. The butter does not need to be completely mixed in. Do not overwork the dough.

4. Add the lemon juice, egg, and cold water; carefully press together into the dough.

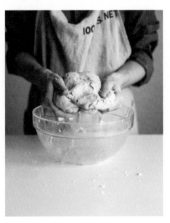

5. Carefully knead the dough just until it holds together. Flatten into a thick disc.

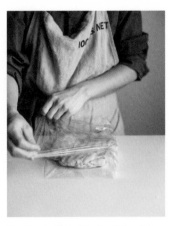

6. Cover the dough with plastic wrap and refrigerate for at least 30 minutes.

[LEMON CURD AND DULCE DE LECHE]

After I first made lemon curd from scratch, I never wanted to buy it again. It is so easy! Select good-quality lemons and salted butter to bring out the flavors. You can buy prepared *dulce de leche* these days, and that will save you a few hours. If you can't find ready-made *dulce de leche*, you can make your own with a can of sweetened condensed milk.

LEMON CURD
1. Put the egg yolks and sugar into a heavy-bottomed saucepan.

2. Finely grate the lemon peel into the pan.

3. Add the freshly squeezed lemon juice. Set the pan on medium heat and whisk the mixture as it thickens.

4. Remove the pan from the heat and whisk in the butter.

5. Press the curd through a sieve.

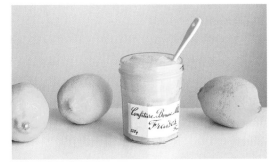

6. Store the curd in the refrigerator. It will stay fresh for a couple of weeks.

DULCE DE LECHE
1. Remove the paper from a can of sweetened condensed milk. (Make sure the can is covered by water the whole time it cooks, to avoid its possibly exploding!)

2. Place the can in a saucepan and completely cover with water. Bring the water to a boil and then turn down the heat. Simmer for about 2 hours, turning the can frequently to ensure even cooking.

3. Do not open the can until it is completely cool. Store *dulce de leche* in a sterilized glass jar in the refrigerator.

[VANILLA AND NUTS]

Making your own vanilla extract is actually very easy. The only things you need are vanilla beans and some type of liquor. For the most neutral flavor, use vodka. Rum and whiskey are excellent choices for a richer flavor.

I also have some suggestions for removing the skin from hazelnuts and almonds.

VANILLA EXTRACT
1. Gather 3 to 5 vanilla beans, ¾ to 1¼ cups liquor, and a sterilized bottle.

2. Slice the vanilla beans lengthwise and open them up.

3. Put the vanilla beans in the bottle and fill with the liquor. Seal the bottle.

4. Shake the bottle well and leave it in a dark and cool spot for at least 2 months. Shake the bottle occasionally.

PEELING HAZELNUTS
1. Preheat the oven to 350°F. Spread your whole hazelnuts on a baking sheet in a single layer and toast in the oven for about 10 minutes.

2. Let the hazelnuts cool slightly, then transfer them onto a clean kitchen towel.

3. Rub the skins from the hazelnuts using the kitchen towel.

4. Sometimes it is hard to get all the skin off, but do the best you can.

PEELING ALMONDS
1. Bring a pot of water to boil and add your whole almonds. Remove the pot from the heat and let stand for about 30 seconds.

2. Drain the water through a sieve and transfer the almonds to a parchment-lined table.

3. Remove the skins by pinching each nut between your fingers so the almond pops out.

MY SWEET KITCHEN

Sometimes one is lucky when making macarons, and sometimes it's a total disaster, and you don't always know why. That's just how it is. The most important thing is not to give up and to try again. After a while, you'll learn exactly what consistency the meringue should be, how to pipe it, and precisely how long to bake the macarons. Practice makes perfect! Results can vary enormously depending on your oven, so make sure you learn how your oven performs and how accurate the temperature is.

When preparing macarons, the proportions of the ingredients are important, so weigh each of them. If you don't have a kitchen scale, I recommend you buy one now. It will be very useful in general, and weighing the ingredients will make your baking more successful.

I prefer grinding my own almond flour, but store-bought works just as well.

To make almond flour: Boil and peel the almonds (see page 40). Let them dry for a couple of hours in an oven set on low heat (125°F–170°F). Process the almonds to a fine meal in the blender, or grind them in a food processor.

If using store-bought almond flour, I recommend you pulse it with the confectioners' sugar in the food processor to break up any large chunks.

For colored macarons, remember that paste and gel food coloring are very concentrated: a little goes a very long way. If you are using liquid food coloring, use no more than a couple of drops because the added liquid will affect the macarons' consistency.

All kinds of fillings can be used for macarons—buttercream, ganache, caramel cream, *dulce de leche*, lemon curd, cream cheese frosting, Nutella, peanut butter, and more. Experiment and find your dream combinations!

After you've filled the macarons, store them in an airtight container in the refrigerator. Let them "mature" for 1 to 2 days before eating them; they will be so much better. The unfilled macaron shells can be frozen in an airtight container or freezer bag. Layer the macarons with waxed paper or parchment paper so they don't stick to each other.

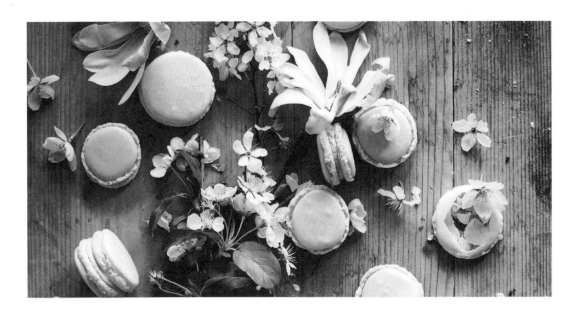

1. Blend the almond flour with the confectioners' sugar.

2. Sift the almond mixture through a sieve to remove any remaining large pieces of almond.

3. If there are many large pieces, process the mixture once more.

4. Beat the egg whites in a dry, clean bowl.

5. When the egg whites begin to foam, gradually add the granulated sugar. Beat until a firm meringue forms.

6. Fold in the almond mixture with a spatula.

 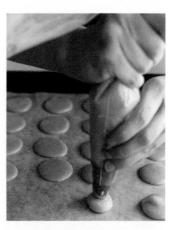

7. If you like, add some food coloring. The batter should be neither firm nor loose. To see if the batter has the correct consistency, spoon out a little bit on a piece

of parchment paper. The test sample should spread out and acquire a smooth surface after a while. If not, stir the batter a bit more and do the same test again.

8. Spoon the batter into a pastry bag fitted with a round tip. Pipe rounds of meringue onto a baking sheet lined with parchment paper. Leave out for at least 1 hour to allow a "skin" to develop on top before baking. See baking instructions in Macaron recipes (page 115).

[SWISS MERINGUE BUTTERCREAM]

Most bakers know that there absolutely must not be any fat from the egg yolks in the whites when beating meringue. For that reason, it is perhaps not so remarkable that this buttercream, which combines warm beaten meringue with butter, easily separates. Meringue and butter do not normally combine well in the same bowl—that's just their nature. But we can force them, or at least encourage them! No matter how badly your meringue buttercream separates, it is possible, in principle, to rescue it.

Here are a few things to keep in mind:

- The butter should not be cold. It should be room temperature or close to it.
- If your meringue buttercream is really runny, it is most likely too warm. Place the bowl in the refrigerator for 10 minutes and then try to beat the mixture again.
- If your buttercream separates badly, it could be too cold. Set the bowl over a double boiler with simmering water in the bottom pan for a few minutes and then beat again.
- Meringue buttercream freezes well. Thaw it in the refrigerator overnight and then set it out to come to room temperature. Beat until creamy.

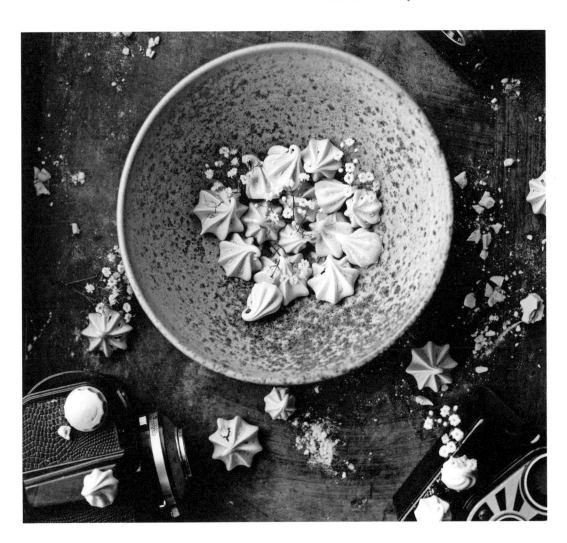

1. Pour the egg whites into a heatproof bowl.

2. Add the sugar.

3. Use a hand whisk to beat the mixture.

4. Place the bowl over a double boiler with simmering water in the bottom pan. Whisk, until the mixture reaches 150°F, or all the sugar crystals have dissolved.

5. Pour the mixture into a large bowl or the bowl of a stand mixer.

6. Beat the mixture until it forms a white and fluffy meringue. Continue beating until mixture cools, about 10 minutes.

7. Add the butter, a little at a time, as you continue beating.

8. When all the butter has been incorporated, beat for another 3 to 5 minutes, until the cream holds together.

9. Add flavoring or coloring, or both, if desired.

10. Beat until the cream is evenly colored and smooth.

[FRYING]

For frying, it is very important to use a neutral vegetable oil that tolerates high heat, such as corn or peanut oil. Package labeling often indicates whether an oil is suitable for frying.

You must use a thermometer when frying, because it is otherwise difficult to tell if the oil is hot enough (or too hot).

The first time I tried to fry, the oil was very hot and I ran a high risk of getting burned. Hot oil must be respected, but do not be *too* afraid of it because being tense while cooking could increase the risk of an accident. Select a heavy-bottomed pot, and make sure it can't be tipped over. Make absolutely sure that the handle isn't sticking out over the edge of the stove where you could accidentally catch it. Always have a lid on hand, ready to cover the pan in case the oil catches fire.

Fried sweets are best the same day they are made, and even better within a couple of hours of cooking; otherwise they become stale and disappointing.

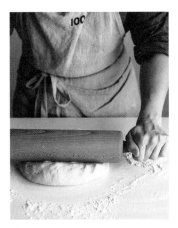

DOUGHNUTS
1. Roll out the dough on a floured work surface until it is about ⅜ to ⅝ inch thick.

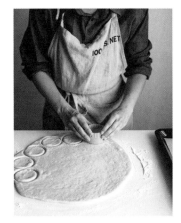

2. Cut out as many small circles as possible from the rolled dough.

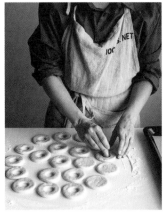

3. Cut out the center of each circle with a small cutter. Let the doughnuts rise for about 1 hour, until doubled in size.

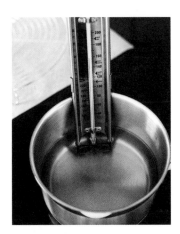

4. Pour the oil into a heavy-bottomed pan and heat to 360°F.

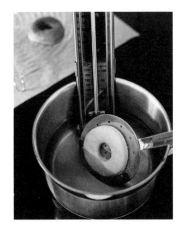

5. Fry the doughnuts, one at a time, for about 1 minute on each side, until golden brown.

6. Use a slotted ladle to lift the doughnuts out of the oil and place them on paper towels or on a cooling rack to drain.

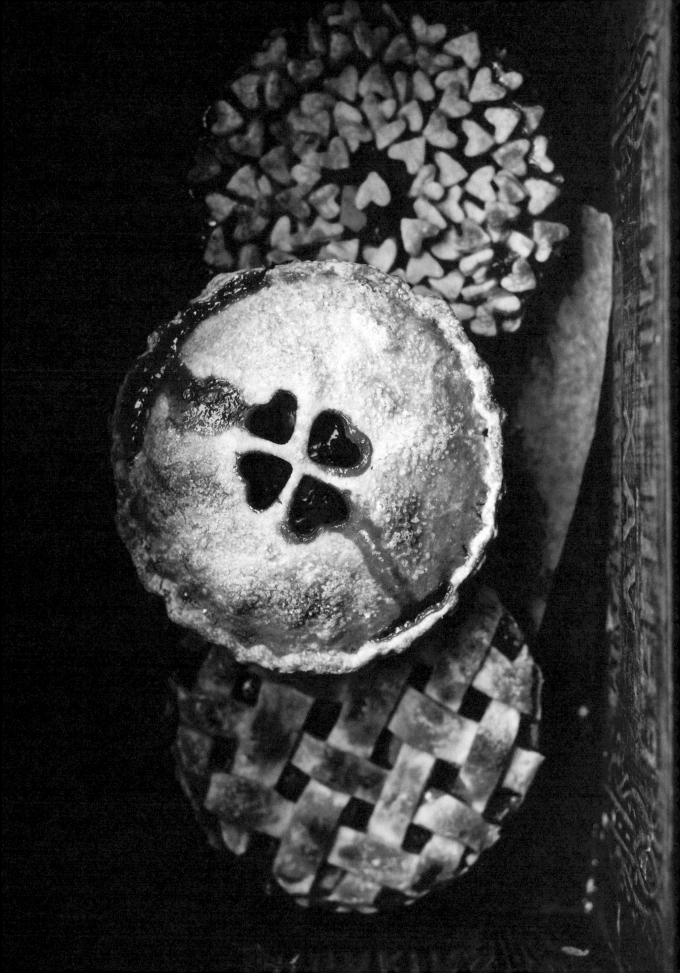

AUTUMN INSPIRED

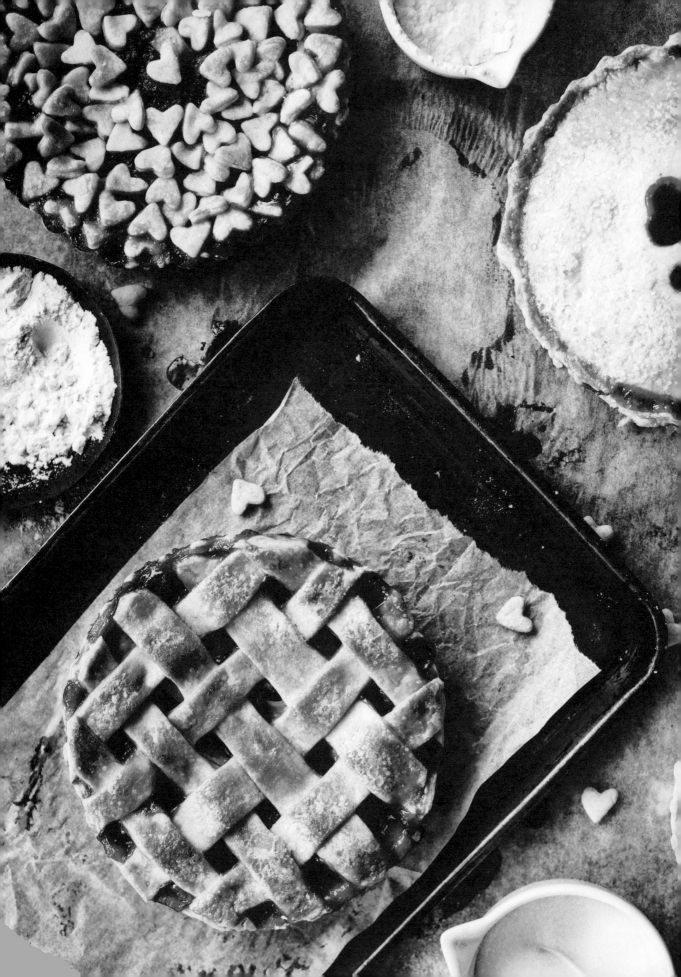

APPLE AND STRAWBERRY PIE WITH CARDAMOM

I can't say enough good things about this pie-crust dough. It is a dream to work with. Filling it with fresh strawberries and apple only adds to its appeal. Instead of making four small pies, you can, of course, make one large one.

PIE CRUST

2¼ cups + 1 tablespoon all-purpose flour
1 tablespoon confectioners' sugar
¼ teaspoon salt
10 tablespoons cold salted butter, diced
2 teaspoons freshly squeezed lemon juice
1 egg
5–6 tablespoons ice water

APPLE AND STRAWBERRY FILLING

1 pound + 10 ounces strawberries
2 large apples (about 14 ounces)
⅔ cup granulated sugar
3 tablespoons cornstarch
Finely grated zest from ½ lemon
1 teaspoon ground cardamom

1 egg white
2 teaspoons water
2 tablespoons granulated sugar, for garnish

MAKING THE PIE CRUST

1. Mix the flour, confectioners' sugar, and salt in a medium bowl. Add the butter and pinch the ingredients together with your fingers until the dough is crumbly.
2. Add the lemon juice, egg, and water and carefully press the dough together (begin with the smaller amount of water and add more if the dough seems dry). Knead the dough only until it holds together.
3. Wrap the dough in plastic wrap and refrigerate for 30 minutes.
4. Divide the dough into four equal-sized pieces. Use three-quarters of each ball of dough for the bottom crusts and save the other quarter for the top crusts.
5. Roll out each ball of dough. Lay each circle of dough into a 5½-inch pie pan. Press the dough into the pie pan and trim the dough around the top with scissors—but don't trim all the way to the edge. Save any dough scraps to add to the top crust. Refrigerate the pie crusts and the dough for the top crusts while you make the filling.

MAKING THE APPLE AND STRAWBERRY FILLING

1. Sort the strawberries and cut them into halves or quarters so they are about 1 inch wide.
2. Peel and core the apples and cut them into small pieces, the same approximate size as the strawberries.
3. Stir the strawberries and apples in a large bowl and then toss in the sugar, cornstarch, lemon zest, and cardamom.
4. Divide the filling evenly among the four chilled pie crusts. Return the pies to the refrigerator while you roll out the top crusts.

ASSEMBLING AND BAKING THE PIE

1. Preheat the oven to 400°F.
2. Roll out each top crust large enough to cover the top of a pie. Remove the pies from the refrigerator.

3. Beat the egg white with the water and brush the mixture around the edges of each bottom crust to help seal the crusts together. Place a top crust over each pie and press down around the edges. Brush the top of each pie with the egg-white mixture and then sprinkle with $\frac{1}{2}$ tablespoon of the sugar.

4. Cover a baking sheet with parchment paper and put the pies on the baking sheet (the filling can spill over). Bake for 35 to 40 minutes, until the crust is golden brown and the filling is bubbly.

ALMOND AND CHERRY MINI PIES

These small pies are rather fussy to make but are well worth the effort. They are the perfect companion for afternoon coffee! The almond flour in the filling thickens it so it won't spill out too much. If you can't find almond flour, you can make your own by grinding blanched and peeled almonds (see page 40).

PIE CRUST

1⅓ cups all-purpose flour

1 tablespoon confectioners' sugar

Pinch of salt

7 tablespoons cold salted butter, diced

¼ cup ice water

CHERRY FILLING

9 ounces cherries

1 tablespoon freshly squeezed lemon juice

1 tablespoon kirsch (cherry brandy)

⅓ cup granulated sugar

1 teaspoon vanilla extract, or ¼ teaspoon
 vanilla powder

2 tablespoons cornstarch

1 tablespoon water

1 egg

1 tablespoon milk

2 tablespoons almond flour

¼ cup slivered almonds

1 tablespoon granulated sugar, for garnish

MAKING THE PIE CRUST

1. Mix the flour, confectioners' sugar, and salt in a medium bowl. Add the butter and pinch the ingredients together with your fingers until the dough is crumbly.
2. Add the cold water and carefully press dough together. Knead the dough only until it holds together. Wrap in plastic wrap and refrigerate for at least 2 hours.

MAKING THE CHERRY FILLING

1. Pit the cherries and cut each in half. Put into a saucepan with the lemon juice, kirsch, sugar, and vanilla and stir. Bring the mixture to a boil and then lower the heat and simmer for about 5 minutes, until the cherries have softened somewhat.
2. Stir the cornstarch and water in a small bowl until the cornstarch is dissolved, then stir into the mixture in the saucepan. Simmer on low heat and stir until the mixture thickens. Take the pan off the heat and let the filling cool completely. Refrigerate.

ASSEMBLING AND BAKING THE MINI PIES

1. Preheat the oven to 350°F.
2. Roll out the dough on a lightly floured work surface until it is about ⅛ inch thick. Cut out as many small circles as possible from the rolled dough using a small cutter (or inverted glass). Gather up any leftover dough into a ball and wrap in plastic wrap; refrigerate for 20 minutes before rolling out again. Cut out more circles.
3. Whisk the egg and milk in a small bowl, then brush around the edge of half of the circles. Put about ½ teaspoon of the almond flour in the center of each circle. Add a bit of cherry filling and some almond slivers. Cover with another circle and, using a fork, press around the edges to seal each pie.

4. Line a baking sheet with parchment paper. Put the mini pies on the sheet and freeze for 10 to 15 minutes.
5. Cut small slits into the top of each pie.

Brush the tops with the egg mixture and sprinkle with a bit of the sugar. Bake in the center of the oven for about 30 minutes, until the crust is golden.

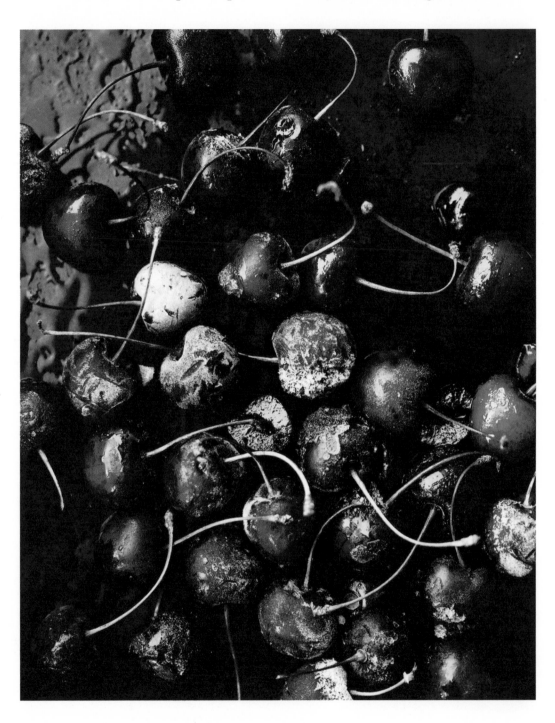

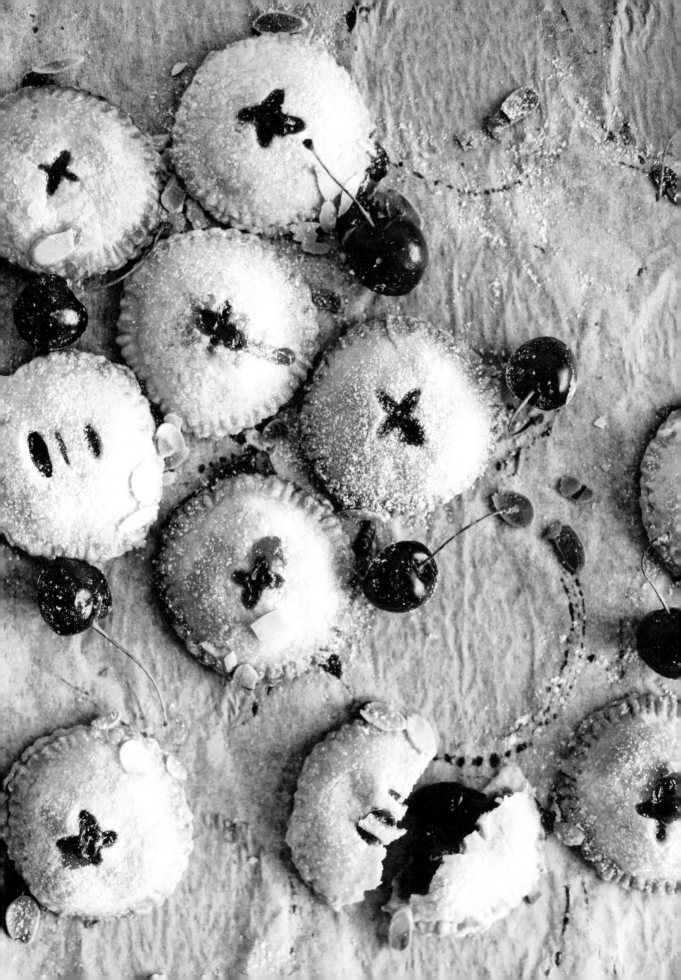

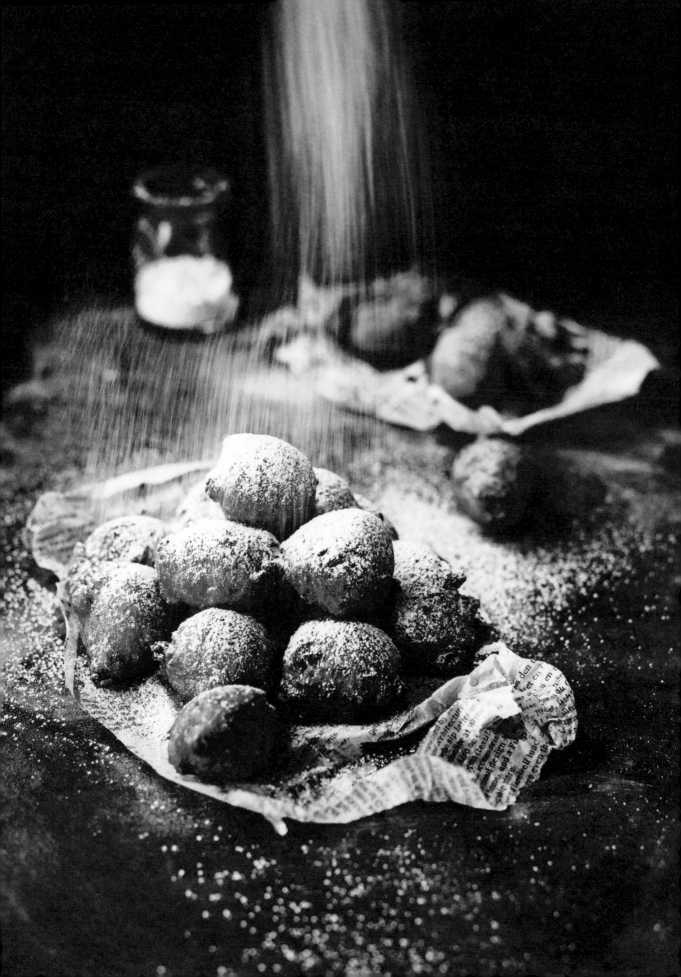

APPLE FRITTERS

Fried bites of anything are difficult to resist, let alone fried sweet apple. Be careful when you handle the hot oil, and choose a neutral-flavor oil that is safe at the high heat necessary for frying.

APPLE FRITTER BATTER

1 apple (about 3½ ounces)

1 cup all-purpose flour

1¼ teaspoons baking powder

½ teaspoon ground cinnamon

1 teaspoon salt

¼ cup granulated sugar

⅓ cup milk

1 egg

2¼ cups vegetable oil such as canola, sunflower, or peanut oil

Confectioners' sugar, for garnish

MAKING THE APPLE FRITTER BATTER

1. Core the apple and chop it into fine pieces (it doesn't need to be peeled).

2. Sift the flour, baking powder, cinnamon, salt, and sugar into a medium bowl. Add the milk and egg and beat until smooth. Fold in the chopped apple.

FRYING THE FRITTERS

1. Pour the oil into a heavy-bottomed saucepan and heat to 355°F.

2. Drop heaping teaspoons of batter into the hot oil, frying 2 or 3 at a time for 2 to 3 minutes. Turn them as they fry so they brown evenly.

3. Use a slotted ladle to lift the fritters out of the oil and place them on paper towels to drain. Dust with confectioners' sugar and serve immediately.

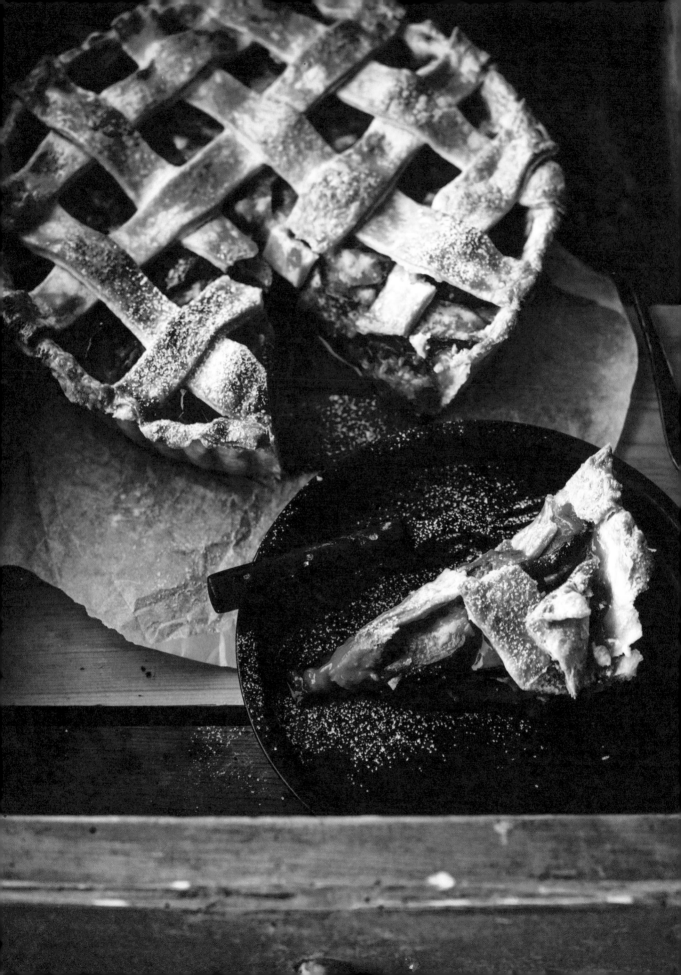

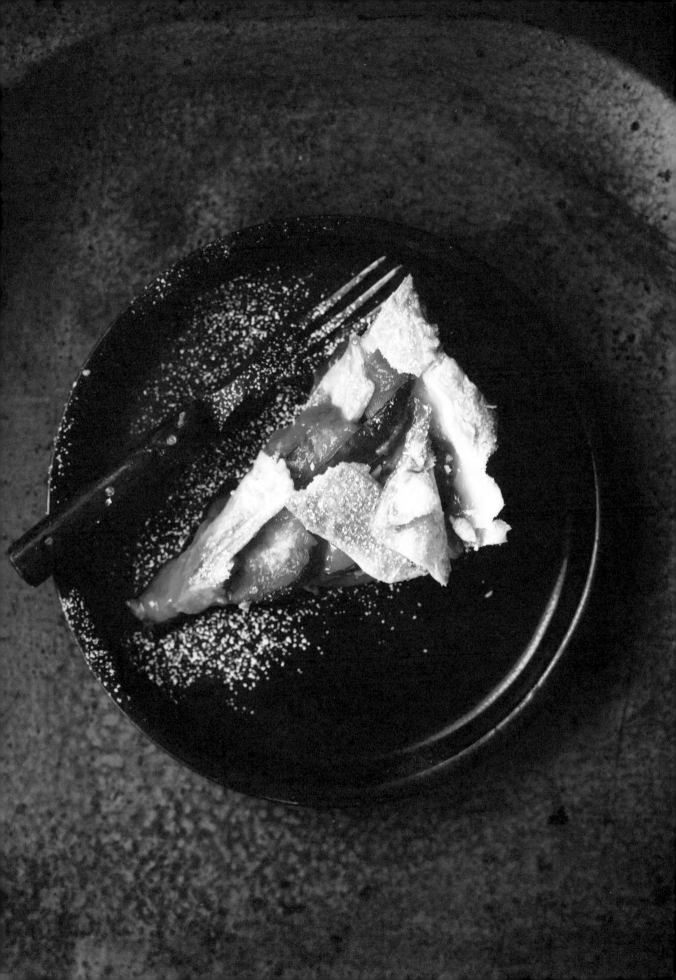

PEACH AND PLUM PIE

This pie combines two of summer's finest stone fruits. Don't remove this pie from the oven too early—bake it fully or the filling will be runny.

PIE CRUST

2¼ cups + 2 tablespoons all-purpose flour

1 tablespoon confectioners' sugar

¼ teaspoon salt

10 tablespoons cold salted butter, diced

2 teaspoons freshly squeezed lemon juice

1 egg

5–6 tablespoons ice water

PEACH AND PLUM FILLING

17¼ ounces peaches

17¼ ounces plums

⅓ cup all-purpose flour

1 tablespoon cornstarch

1 cup granulated sugar

4 tablespoons cold salted butter, diced

1 teaspoon vanilla extract, or ¼ teaspoon vanilla powder

1 egg

1 tablespoon water

Pinch of salt

1 teaspoon granulated sugar, for garnish

MAKING THE PIE CRUST

1. Mix the flour, confectioners' sugar, and salt in a medium bowl. Add the butter and pinch the ingredients together with your fingers until the dough is crumbly. Add the lemon juice, egg, and water and carefully press the dough together (begin with the smaller amount of water and add more if the dough seems dry). Knead the dough only until it holds together.

2. Wrap the dough in plastic wrap and refrigerate for 30 minutes.

3. Divide the dough into thirds. Combine two of the pieces and roll out into a circle large enough to line a 9½-inch pie pan and come up above the sides.

4. Roll out the remaining one-third of the dough and cut into long strips to crisscross over the filling. Lay the strips on a piece of parchment paper and refrigerate them as well as the crust in the pan while you prepare the filling.

MAKING THE PEACH AND PLUM FILLING

1. Cut each piece of fruit in half and remove the pits. Slice the fruit.

2. Mix the flour, cornstarch, and sugar in a medium bowl. Add the butter and vanilla and pinch together with your fingers until the dough is crumbly.

ASSEMBLING AND BAKING THE PIE

1. Preheat the oven to 400°F.

2. Layer the fruit with the crumbly mix in the pie pan. Weave the crust strips into a crisscross pattern on top.

3. Beat the egg lightly with the water and salt in a small bowl and brush over the pie crust. Sprinkle the crust with the sugar.

4. Place the pie pan on a baking sheet (to prevent spills during baking). Bake for 10 minutes and then lower the temperature to 350°F. Bake the pie for another 45 minutes. Turn off the oven and leave the pie in the oven for another 30 minutes.

5. Remove the pie from oven and allow to cool completely at room temperature.

CITRUS FLAVORS

LEMON MERINGUE CAKE

A delicious, magnificent cake with two of my favorite flavors: tangy lemon curd and sweet meringue. Adding a final (optional) brûlée flourish with a kitchen blowtorch will impress everyone!

CAKE LAYERS

3 cups all-purpose flour

¼ cup + 2 tablespoons cornstarch

1 tablespoon + ½ teaspoon baking powder

¼ teaspoon salt

14 tablespoons salted butter, at room temperature

2¼ cups granulated sugar

Finely grated zest of 2 lemons

4 eggs

½ cup freshly squeezed lemon juice (from 2–3 lemons)

½ cup milk

LEMON CURD

¾ cup granulated sugar

6 egg yolks (save the whites for the meringue frosting)

Finely grated zest of 2 lemons

¼ cup + 2 tablespoons freshly squeezed lemon juice (about 2 lemons)

8 tablespoons cold salted butter, diced

MERINGUE FROSTING

6 egg whites

1¼ cups granulated sugar

1 teaspoon vanilla extract or vanilla sugar

Making the Cake Layers

1. Preheat the oven to 350°F. Butter two 8-inch cake pans. Line the bottom of each pan with a circle of parchment paper.
2. Sift the flour, cornstarch, baking powder, and salt together into a medium bowl.
3. In a large bowl, beat the butter until light and creamy. Add the sugar and lemon zest and beat for 2 minutes. Add the eggs one at a time, beating thoroughly after each addition. In a small bowl, whisk together the lemon juice and milk. Alternate adding the lemon juice and milk mixture with the dry ingredients, beating after each addition, until all the ingredients have been incorporated. Beat the batter until smooth.
4. Divide the batter evenly between the two baking pans and bake in the lower part of the oven for 45 to 50 minutes, until a toothpick inserted into the center comes out with moist crumbs. Let the layers cool in the pans for a while and then turn out onto wire cooling racks to cool completely.

Making the Lemon Curd

1. Stir together the sugar, egg yolks, lemon zest, and lemon juice in a saucepan and heat over medium heat. Stir constantly until the mixture just starts to bubble. Do not let the mixture boil; that could cause the egg to cook.
2. Remove the pan from heat and stir in the butter. Press the curd through a fine-mesh sieve over a bowl, then pour into a bottle and let cool to room temperature. Refrigerate until the lemon curd is completely cold.

Building the Cake

Cut each cake layer in half horizontally so you have four layers. Place one of the cake layers on a cake plate and cover with one-third of the chilled lemon curd. Stack and cover the next two more layers the same way. Place the last layer, cut side down, on

top. Refrigerate the cake so it sets while you prepare the meringue.

MAKING THE MERINGUE FROSTING AND FINISHING THE CAKE

1. Pour boiling water into a saucepan or the bottom of a double boiler and simmer over low heat. Put the egg whites, sugar, and vanilla into a heatproof bowl or saucepan and place over the simmering water in the bottom pan. Using a hand whisk, beat the mixture until it reaches 150°F, or until all the sugar crystals have dissolved.

2. Pour the mixture into a large bowl and beat with an electric mixer until it is a white and fluffy meringue, about 10 minutes (the meringue will cool during beating).

3. Cover the chilled cake with a thin layer of meringue and then refrigerate the cake for about 10 minutes to allow the meringue to firm up. Remove the cake from the refrigerator and cover with a thick layer of meringue. Toast the meringue with a kitchen blowtorch, if you'd like a "brûléed" effect.

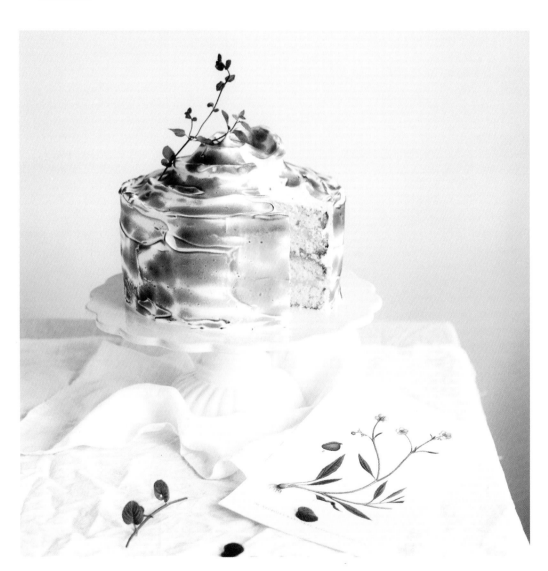

LIME PIE WITH MARINATED STRAWBERRIES

I love the unexpected and bright flavor combination of lime and strawberries. The lime filling in this pie really melts in your mouth and, combined with the strawberries and crispy crust, is a sensory delight. If you'd like, serve with a spoonful of fresh whipped cream.

PIE CRUST

9 tablespoons unsalted butter

9 ounces graham crackers or digestive biscuits

¼ cup + 2 tablespoons unsweetened coconut flakes

Pinch of salt

FILLING

4 eggs

One 14-ounce can sweetened condensed milk

1 tablespoon finely grated lime zest

¼ cup + 2 tablespoons freshly squeezed lime juice

LIME SYRUP

Finely grated zest and juice of 1 lime

¼ cup + 2 tablespoons water

⅔ cup granulated sugar

10½ ounces fresh strawberries

MAKING THE PIE CRUST

1. Melt the butter.
2. Pulse the graham crackers and coconut to fine crumbs in a blender or food processor and then transfer to a medium bowl and stir in the melted butter to combine.
3. Press the pie dough into a deep 9½-inch pie pan or springform pan. Refrigerate for 20 minutes.

MAKING THE FILLING AND BAKING THE PIE

1. Preheat the oven to 350°F.
2. Separate the whites and yolks of the eggs into two small bowls. Beat the egg yolks, condensed milk, lime zest, and lime juice in a large bowl.
3. In a medium bowl, beat the egg whites until firm. Fold half of the beaten egg whites into the lime filling with a spatula and then fold in the remaining egg whites (adding the egg whites gradually makes a light batter). Do not mix in the egg whites too thoroughly— only until you can't see any long strips of egg white.
4. Pour the filling into the crust and bake for 15 to 20 minutes, until the filling is firm.
5. Let the pie cool to room temperature, then refrigerate for at least 3 hours.

MAKING THE LIME SYRUP

Pour the lime zest and juice, the water, and sugar into a small saucepan. Bring to a boil and then lower the heat and simmer until the mixture has thickened slightly, about 10 minutes. Let cool.

DECORATING THE PIE

1. Wash the strawberries, remove the stems, and slice into halves or quarters. Add the strawberries to the cooled lime syrup and let marinate for 30 minutes at room temperature.
2. Carefully remove the chilled pie from the pan. Spoon the strawberries and a couple of tablespoons of lime syrup onto the pie immediately before serving. You can add more syrup to each slice, if desired.

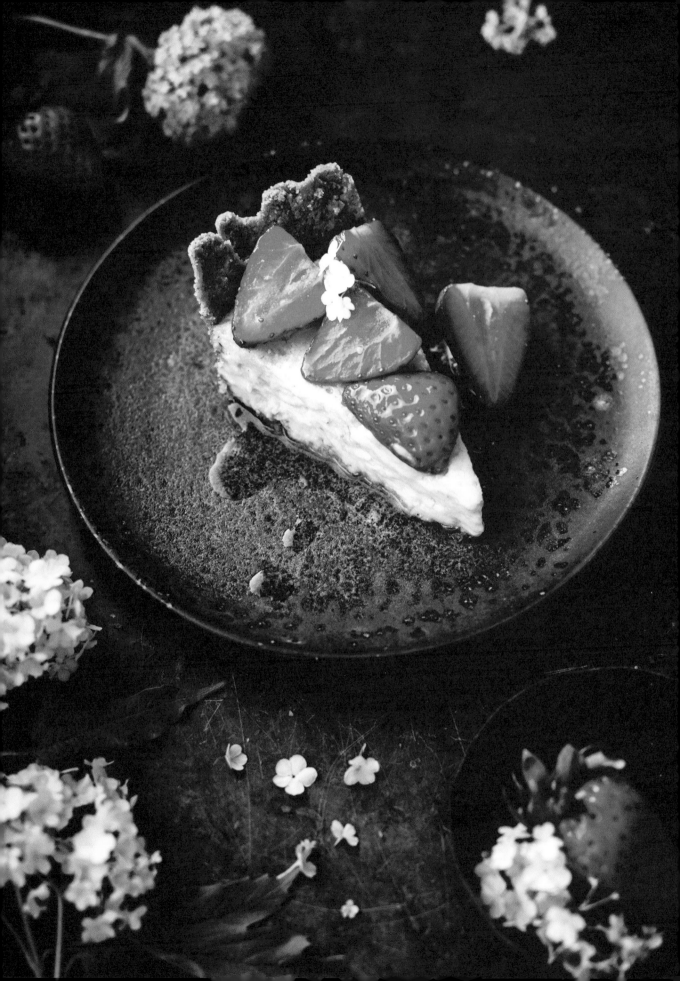

CRÊPE CAKE WITH ORANGE, CHOCOLATE, AND COINTREAU

This is a truly luxurious crêpe cake with a decadent chocolate ganache filling. The crêpes can be prepared a day ahead, wrapped in plastic, and stored in the refrigerator, so all you have to do the day of the party is assemble the cake.

CRÊPES

4 eggs

1½ cups milk

1 cup water

2¼ cups all-purpose flour

¼ teaspoon salt

2 tablespoons granulated sugar

Finely grated zest of 1 orange

5½ tablespoons salted butter

CHOCOLATE GANACHE

7 ounces dark chocolate (70% cocoa)

3½ ounces milk chocolate

1¼ cups whipping cream

2 tablespoons Cointreau or other orange
 liqueur, or 2 tablespoons whipping cream
 mixed with the finely grated peel of 1 orange
 (both optional)

¼ cup whipping cream

Chopped chocolate (70% cocoa)

1¼ ounces fresh raspberries (optional)

MAKING THE CRÊPES

1. Beat together the eggs, milk, water, flour, salt, sugar, and orange zest in a large bowl until all the clumps have dissolved. Let the mixture set at room temperature for about 30 minutes.
2. Melt the butter and let cool slightly.
3. Beat the butter into the batter. Heat a crêpe pan or small frying pan (6 to 8 inches in diameter) over high heat. Add a little butter to the pan. When the butter stops sizzling, the pan is hot enough.

4. Lower the heat to medium and spoon about 2 tablespoons of the batter onto the hot pan. Quickly lift and tilt the pan in a circle to spread the batter evenly over the entire bottom of the pan to make thin crêpes. Stack them on a plate, layering waxed paper between each crêpe so it will be easier to separate them later. Let the crêpes cool completely.

MAKING THE CHOCOLATE GANACHE

1. Chop the dark chocolate and milk chocolate into fine pieces and put in a medium heatproof bowl.
2. In a saucepan, carefully heat the whipping cream and Cointreau. Remove the pan from the heat just before the liquid reaches its boiling point. Pour the cream over the chocolate pieces and let stand for a few seconds. Stir until the chocolate melts completely and the mixture becomes a shiny cream.
3. Pour ¼ cup plus 2 tablespoons of the chocolate and cream mixture into a separate small bowl and set aside (this ganache will be used for decorating the cake). Let both bowls of ganache cool at room temperature until it is a spreadable consistency.

ASSEMBLING THE CAKE

1. Lay a crêpe on a cake platter and spread with a thin layer of chocolate ganache (the ganache not reserved for decorating). Repeat layering crêpes and ganache until you have used up all the crêpes and the

bowl of chocolate ganache. Refrigerate for about 1 hour to allow the cake to firm up.

2. Whip the cream and spoon or pipe it on top of the cake.

3. Heat the remaining ganache carefully in the microwave until it has melted slightly and is runny. (Alternatively, warm it in a heatproof bowl or saucepan on top of a double boiler with water simmering in the bottom pot.) Make sure the sauce does not get too warm, or it will be too thin to coat the cake. Pour the sauce over the cake and then decorate the cake with chopped chocolate and raspberries.

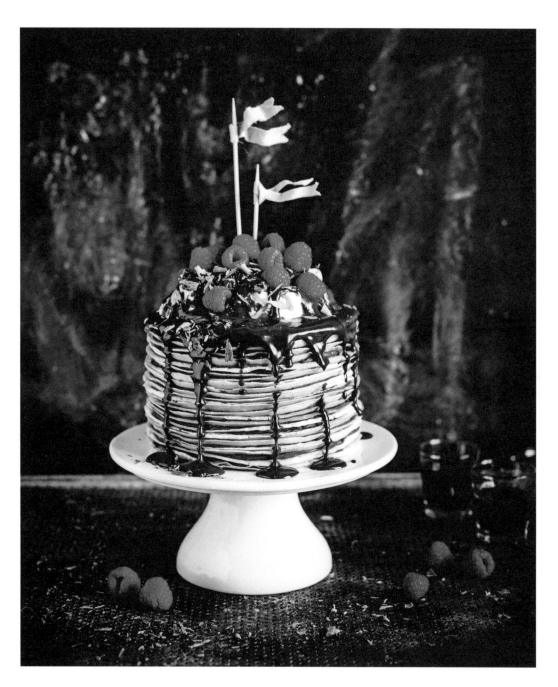

BLUEBERRY-LEMON CHEESECAKE LAYER CAKE

This cake has three pretty sugar cake layers and two layers of creamy blueberry cheesecake filling. Making it requires several steps and takes some planning, but it isn't particularly complex—like all special cakes, this is perfect for a party. A note on equipment: You will need a long pan, big enough to fit two springform pans inside, for the bain-marie baking.

1 tablespoon freshly squeezed lemon juice
2 eggs, at room temperature
¼ cup + 2 tablespoons sour cream, at room temperature
2⅔ ounces blueberries
1 tablespoon all-purpose flour

CAKE LAYERS
3 eggs
⅔ cup granulated sugar
1 teaspoon vanilla extract, or ¼ teaspoon vanilla powder
⅓ cup milk
3 tablespoons salted butter
¾ cup all-purpose flour
1 teaspoon baking powder
Pinch of salt

MASCARPONE FROSTING
4½ ounces mascarpone
⅓ cup confectioners' sugar
⅔ cup whipping cream
Purple gel food coloring
Finely grated zest of ¼ lemon

1¾ ounces fresh blueberries, for garnish
1¾ ounces fresh blackberries, for garnish
Flowers, for garnish (see suggested edible flowers on page 84)

CHEESECAKE LAYERS
21 ounces cream cheese, at room temperature
¾ cup granulated sugar
Finely grated zest of 1 lemon

Making the Cheesecake Layers

1. Preheat the oven to 325°F. Wrap the bottom of two springform pans with two thick layers of aluminum foil (to prevent water from seeping into the pans when the cheesecake bakes in the bain-marie).
2. In a large bowl, beat the cream cheese, sugar, lemon zest, and lemon juice into a creamy batter. Add the eggs and beat for another minute.
3. Add in the sour cream. Mash the blueberries in a small bowl and add them to the mixture. Sift the flour over the mixture and beat to incorporate.
4. Divide the batter between the prepared springform pans.
5. Bring a kettle of water to a boil. Place the filled springform pans onto a long baking pan and place in the oven. Pour the boiling water into the long pan until it is halfway up the sides of the springform pans.
6. Bake for 50 to 60 minutes, until the cheesecake layers are firm around the edges but still a little quivery at the center. Turn off the heat and leave the cheesecakes in the oven for 1 more hour.
7. Remove the springform pans from the oven and the water bath and let the cheesecake layers cool completely in the pans.
8. Place the springform pans in the freezer and freeze until the cheesecake layers are completely firm, about 4 hours (this will make the cakes easier to handle when you remove them from the pans). You can store the cheesecake layers in the freezer for up to 2 days.

Making the Cake Layers

1. Preheat the oven to 350°F. Butter and flour three 6-inch cake pans.
2. In a large bowl, beat the eggs, sugar, and vanilla together until light and creamy.
3. Heat the milk and butter in a saucepan until the butter has melted. Slowly beat the milk mixture into the egg mixture.
4. Mix the flour, baking powder, and salt in a medium bowl and then sift over the egg mixture. Beat until the batter is smooth. Divide the batter evenly among the three prepared cake pans.
5. Bake the cake layers in the lower part of the oven for 20 to 25 minutes, until a toothpick inserted into the center comes out with moist crumbs. Let the layers cool in the pans for a while and then turn out onto wire cooling racks to cool completely.

Making the Mascarpone Frosting

1. Beat the mascarpone and confectioners' sugar in a medium bowl until creamy.
2. Add the whipping cream, purple gel food coloring (making it exactly the shade you prefer), and lemon zest and beat until the mixture thickens. Make sure not to overmix, which will stiffen the frosting. If the frosting is overbeaten, fold in a little whipping cream (but do not beat it in).

Assembling the Cake

1. Place one of the cake layers on a cake plate. Take the cheesecakes out of the freezer and remove them from their pans.
2. Place a layer of blueberry cheesecake over the cake layer. Add another cake layer and then a blueberry cheesecake layer. Finish with the last cake layer.
3. Refrigerate the cake for 1 hour to let the cheesecake filling thaw slightly. The filling might melt a bit around the edges as it thaws, but the edges of the cake can be smoothed with a spatula or palette knife.
4. Spread a layer of mascarpone frosting over the whole cake and decorate it with berries and flowers.

LEMON AND POPPY SEED CUPCAKES WITH BLUEBERRY FROSTING

Blueberry powder provides a very pretty and intense purple color for the frosting. You can find it in health food stores or kitchen supply stores. For a lighter texture, replace the all-purpose flour with cake flour.

CUPCAKES

1⅓ cups all-purpose flour

¾ cup granulated sugar

1½ teaspoons baking powder

Pinch of salt

7 tablespoons salted butter, at room temperature

2 eggs, at room temperature

½ cup yogurt or sour cream, at room temperature

1 teaspoon vanilla extract, or ¼ teaspoon vanilla powder

Finely grated zest of 1 lemon

1 tablespoon poppy seeds

BLUEBERRY FROSTING

12 tablespoons unsalted butter, at room temperature

7 ounces chilled cream cheese

1¼–1½ cups confectioners' sugar

3 tablespoons pureed blueberries (optional)

1¾ ounces fresh blueberries, for garnish

MAKING THE CUPCAKES

1. Preheat the oven to 350°F. Line a muffin tin with 12 paper cupcake liners.
2. Mix the flour, sugar, baking powder, and salt in a large bowl. Add the butter, eggs, yogurt, vanilla, and lemon zest and beat by hand or with an electric mixer until smooth. Stir in the poppy seeds.
3. Divide the batter evenly among the prepared muffin cups and bake for 20 to 25 minutes, until a toothpick inserted into the center comes out with moist crumbs. Let the cupcakes cool in the pan for a few minutes and then turn out onto a wire cooling rack to cool completely.

MAKING THE BLUEBERRY FROSTING

In a medium bowl, beat the butter and cream cheese together until creamy. Add the confectioners' sugar and blueberry powder and continue beating until the mixture is creamy and smooth, adding more confectioners' sugar to achieve the right consistency if needed.

DECORATING THE CUPCAKES

Fit a star tip onto a pastry bag and fill the bag with frosting. Hold the tip at a 90-degree angle over the cupcake. Beginning piping at the center, draw one or two swirls, finishing once again at the center. Garnish with blueberries.

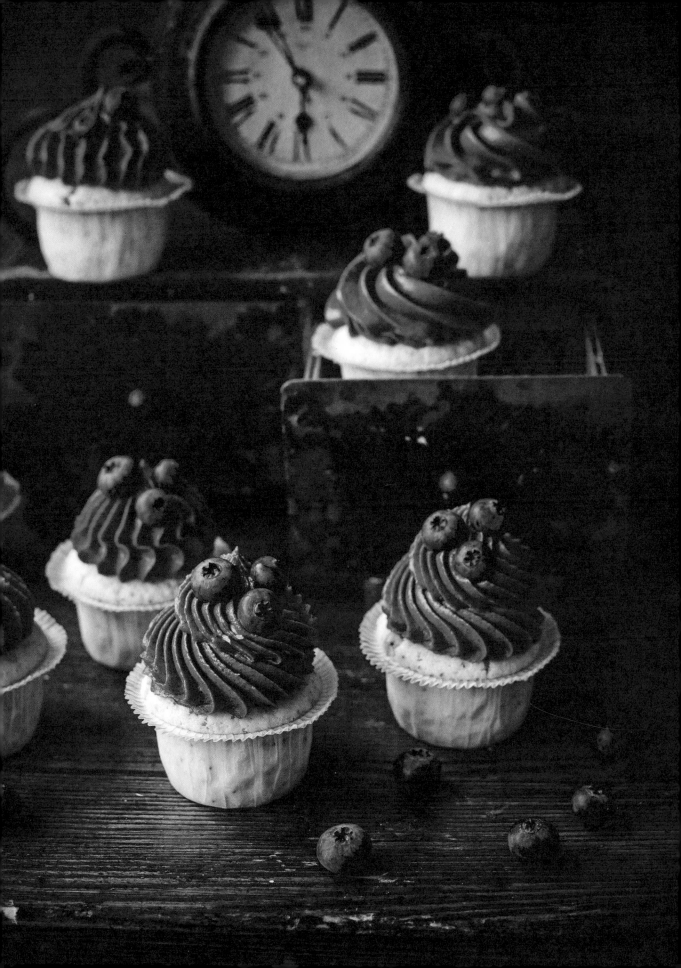

PORTUGUESE PASTÉIS DE NATA

These little cakes are not very well known around the world, but they should be! A pastel de nata (pastel *is the singular form of* pastéis) *is a typical Portuguese cake, and each local bakery keeps its recipe very secret. This is my version.*

VANILLA CREAM

2 tablespoons all-purpose flour

⅔ cup milk

⅔ cup granulated sugar

1 cinnamon stick

⅓ cup water

1 teaspoon vanilla extract, or ¼ teaspoon vanilla powder

3 egg yolks

Pinch of salt

5 sheets of puff pastry, approximately 3½ x 7 inches

Ground cinnamon, for garnish

Confectioners' sugar, for garnish

MAKING THE VANILLA CREAM

1. Beat the flour and 2 tablespoons of the milk in a small bowl and set aside.
2. Combine the sugar, cinnamon stick, water, and vanilla in a saucepan. Bring to a boil and boil for 1 minute. Set aside.
3. In a separate saucepan, bring the rest of the milk to a boil. Add the flour and milk mixture, stirring constantly with a wire whisk.
4. Remove the cinnamon stick from the sugar mixture and discard. Drizzle the sugar mixture into the milk mixture, stirring constantly.
5. Lightly beat the egg yolks by hand in a small bowl and stir in a few tablespoons of the milk mixture. Pour the egg yolks into the warm milk batter in the saucepan and stir in the salt. Carefully heat the mixture over medium heat, stirring constantly, until the mixture thickens only slightly,

about 2 minutes. Do not let the mixture boil, which could cause the egg to cook into clumps.

6. Press the vanilla cream through a sieve into a medium bowl and cover the bowl with plastic wrap. Allow to cool to room temperature.

ASSEMBLING AND BAKING THE CAKES

1. Preheat the oven to 475°F. Place 15 small aluminum cake forms on a baking sheet, or line 15 muffin-tin cups with paper liners.
2. Roll up the sheets of puff pastry from the short side and slice the roll into 15 pieces, approximately 1¼ inches wide (about the same size as for cinnamon buns).
3. Fill a small bowl with water. Place one piece of the puff pastry into the baking form with a cut side up. Dip your thumb in the water and press down in the center of the dough so that it makes a little divot. Spread the dough with your thumbs so that the pastry fills the tin out to the edge, with a small depression in the middle. Repeat with each piece of the dough.
4. Fill each piece of dough with about 1½ teaspoons of the vanilla cream. Place the pan in the middle of the oven and bake for 11 to 13 minutes, until the filling is bubbly and the edges are golden.
5. Remove the pan from the oven. Toast each cake with a kitchen blowtorch for a little extra color. Let the cakes cool completely in the pan, then dust with ground cinnamon and confectioners' sugar.

CLASSIC DOUGHNUTS

Classic, pretty sweet treat, tastefully dressed up! Each of the different topping recipes will cover one batch of doughnuts, so make a little less if you want to use a variety of toppings for the batch. Doughnuts are best eaten fresh.

DOUGHNUTS

2 tablespoons warm water (104°F–113°F)

2¼ teaspoons active dry yeast

¼ cup milk

1 egg, at room temperature

3 tablespoons unsalted butter, at room temperature

¼ cup granulated sugar

½ teaspoon salt

2½–2¾ cups all-purpose flour

2¼ cups vegetable oil, such as canola, sunflower, or peanut oil

CINNAMON SUGAR TOPPING

¼ cup + 2 tablespoons granulated sugar

2 teaspoons ground cinnamon

LEMON GLAZE

1¼ cups confectioners' sugar

3–4 tablespoons freshly squeezed lemon juice

Finely grated zest of ½ lemon

CHOCOLATE GLAZE

1 cup confectioners' sugar

¼ cup cocoa powder

2–4 tablespoons milk or water

Confectioners' sugar, for garnish (optional)

MAKING THE DOUGHNUTS

1. Whisk the warm water and dry yeast in a large bowl. Let stand for 5 minutes.
2. Heat the milk in a saucepan over low heat until lukewarm. Stir the yeast and water mixture and then add the warm milk, egg, butter, and sugar to the yeast mixture. Stir until the butter has melted and all the ingredients are incorporated.
3. Incorporate the salt and flour in the bowl with your hands. Turn the dough out onto a floured work surface and knead until smooth. Oil a bowl. Place the dough in the bowl and cover with a clean kitchen towel. Let rise until doubled in size, 1 to 1½ hours.
4. Turn the dough out onto a floured work surface and roll out to ⅜ to ⅝ inch thick.
5. Using a doughnut cutter or an upturned glass 2½ to 2¾ inches in diameter, cut out as many little circles from the dough as you can.
6. Using a smaller cutter, 1 to 1¼ inches wide, cut out the center of each circle of dough. (If you don't have a special doughnut cutter, use what you can find in your kitchen drawers; I use a piping tip.)
7. Gather up the doughnut holes and dough scraps into a ball, roll it out again, and cut out more doughnuts the same way.
8. Line a baking sheet with parchment paper and place the doughnuts on it; cover with a clean kitchen towel. Let the doughnuts rise until doubled in size, 45 to 60 minutes.

FRYING THE DOUGHNUTS

1. Pour the 2¼ cups of oil into a small heavy-bottomed saucepan and heat to 355°F.
2. Lower 1 or 2 doughnuts into the hot oil with a slotted spoon and fry until golden, about 1 minute on each side.
3. Lift the fried doughnuts out of the oil

with a slotted spoon and drain on paper towels or a wire cooling rack over parchment paper. Continue frying until all the doughnuts have been cooked. **Note:** If you will be topping the doughnuts with cinnamon sugar, dip each doughnut in the topping as soon as it comes out of the oil.

MAKING THE CINNAMON SUGAR

Mix the sugar and cinnamon in a small bowl. Dip each doughnut into the mixture as soon as it finishes frying and turn over several times to coat.

MAKING THE LEMON OR CHOCOLATE GLAZE

Stir the confectioners' sugar and the cocoa and milk or the lemon juice and zest in a small bowl until a thick cream forms. Glaze doughnuts after they have cooled a little by laying them out on parchment and spooning the glaze over them, or dipping one side of each doughnut into the bowl of glaze.

Once completely cool, dust those doughnuts without glaze or cinnamon sugar with confectioners' sugar, if desired.

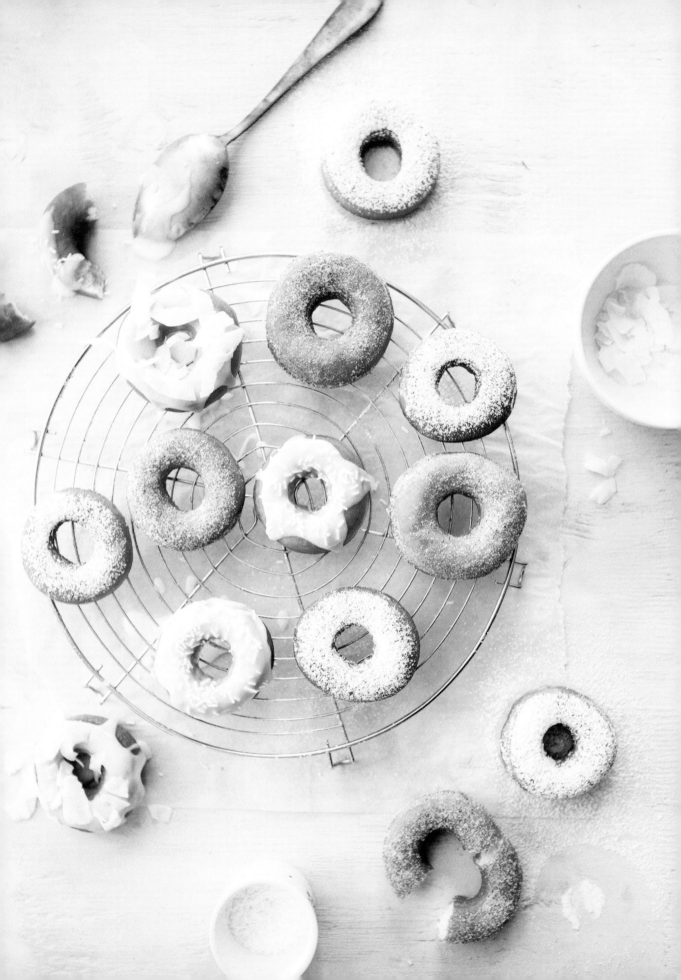

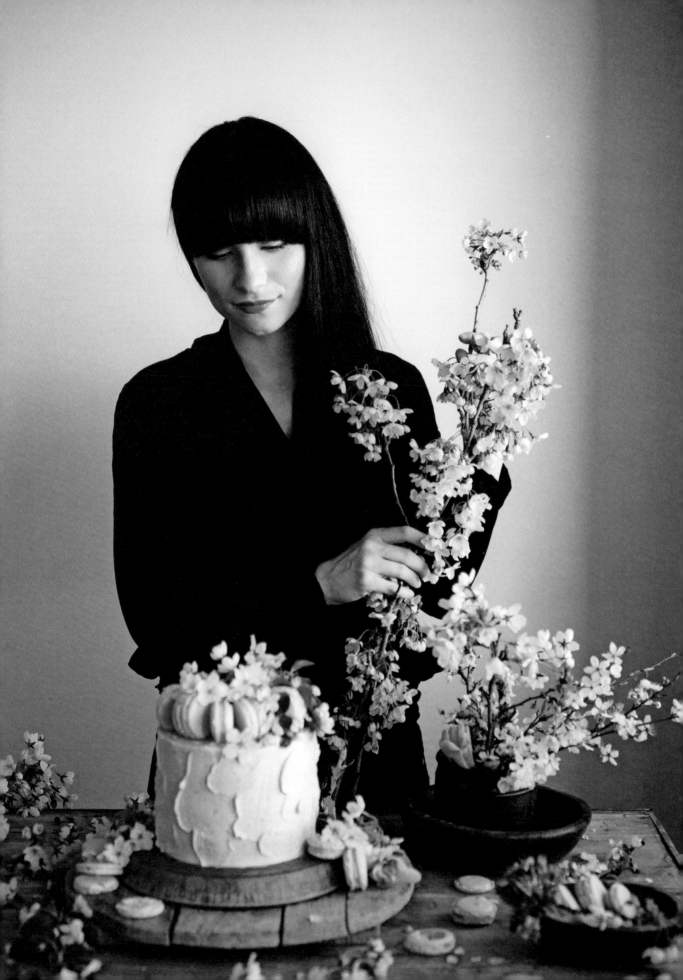

[CAKE DECORATING]

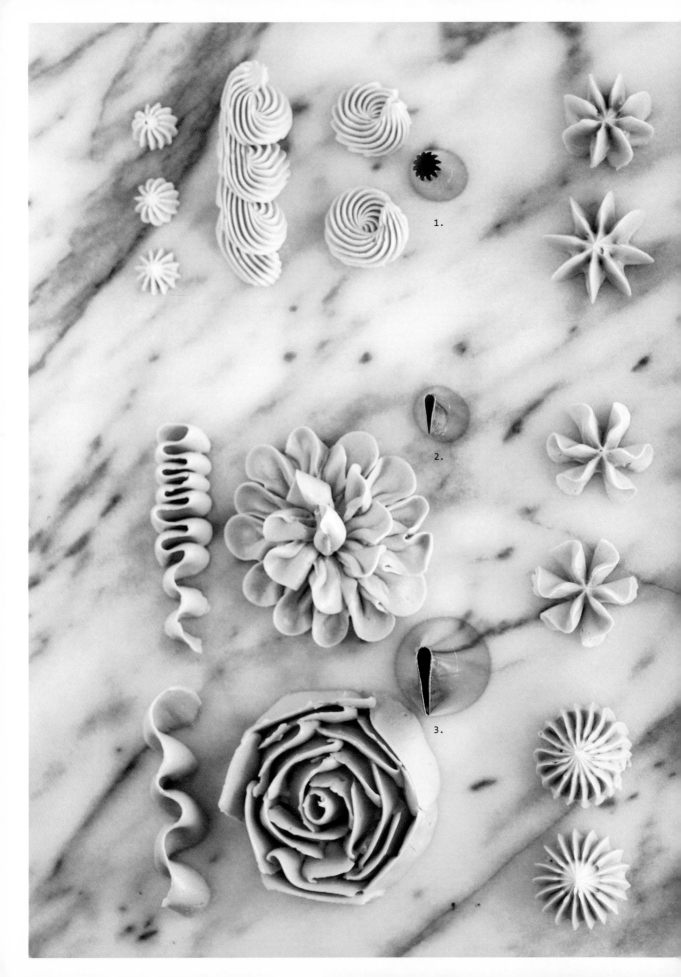

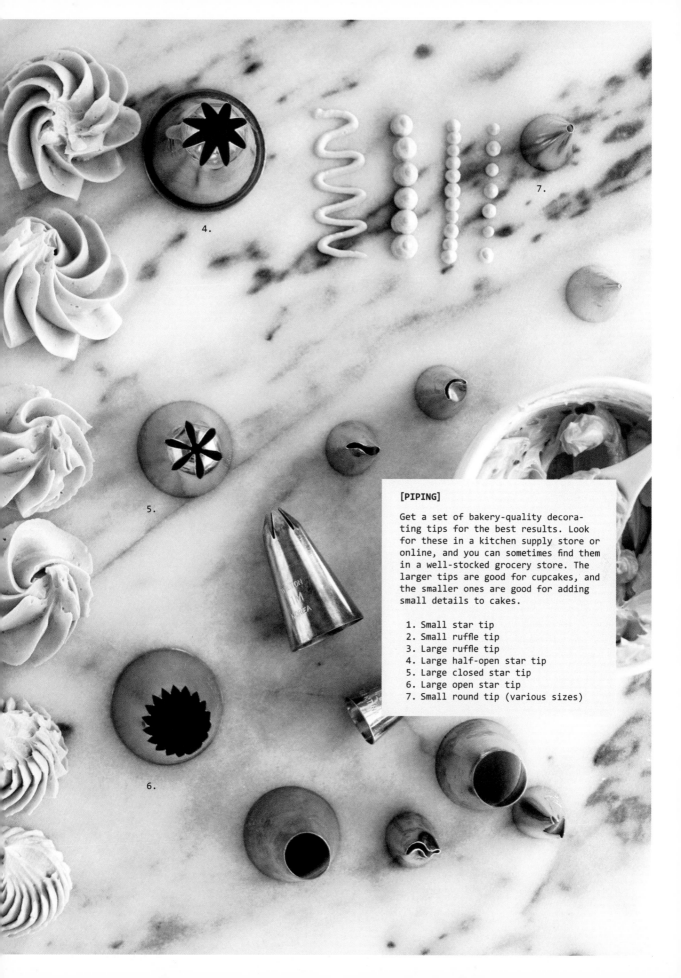

4.

7.

5.

6.

[PIPING]

Get a set of bakery-quality decorating tips for the best results. Look for these in a kitchen supply store or online, and you can sometimes find them in a well-stocked grocery store. The larger tips are good for cupcakes, and the smaller ones are good for adding small details to cakes.

1. Small star tip
2. Small ruffle tip
3. Large ruffle tip
4. Large half-open star tip
5. Large closed star tip
6. Large open star tip
7. Small round tip (various sizes)

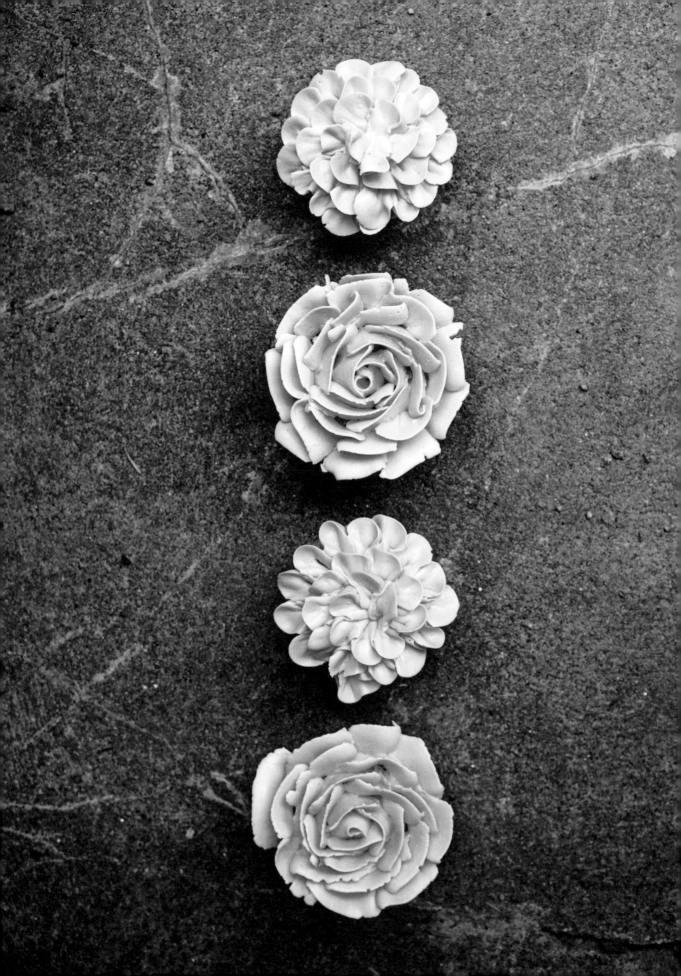

[PIPING CUPCAKES]

The easiest way to pipe frosting onto cupcakes is to hold the pastry bag in one hand and turn the cupcake with the other.

Do not put too much frosting into the bag. You must be able to fold down the end of the bag well to encourage smooth piping.

With a firm grip around the end of the bag (the folded part of the bag), apply light pressure. It is better to squeeze the bag with the palm of your hand than with your fingers. Practice holding the bag with a firm grip.

Before you try decorating any sweets, try piping onto a piece of parchment paper. The more you practice, the easier it will be! The best type of frosting to use for practice is a buttercream, particularly meringue buttercream, as it holds its shape well.

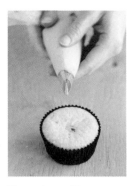 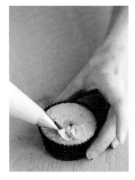 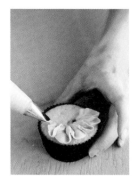 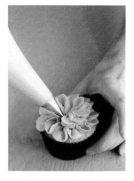

PIPING A FLOWER
(SMALL RUFFLE TIP)
1. Hold the pastry bag with a firm grip and squeeze the frosting toward the tip.

2. Hold the bag at a 75-degree angle and place the wider end of the tip at the center of the cupcake and the narrow end at the edge. Begin piping about ⅛ to ¼ inch from the edge, depending on how large you want the petals to be.

3. With light pressure, move the pastry bag forward and then back. Imagine that you are painting flower petals around a flower.

4. When the first layer is finished, continue using the same technique somewhat closer to the center. Hold the tip a little more vertical to form distinct layers.

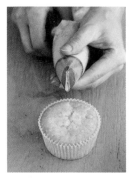 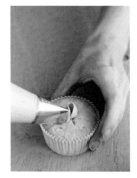 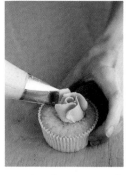 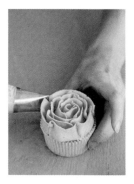

PIPING A ROSE
(LARGE RUFFLE TIP)
1. Hold the pastry bag at a 45-degree angle; the edge of the tip will be at a 90-degree angle. The wider end of the tip should be touching the cupcake and the narrower end should be pointing up.

2. Hold the tip so that the frosting "catches" on the cupcake. Begin by piping the central petal, lightly pressing on the pastry bag at the same time as you turn the cupcake.

3. Make the next petal and then continue around using the same technique.

4. Make the petals as tall as you like, but usually 1 to 1¼ inches is plenty.

[FILLING AND FROSTING A CAKE]

One of the advantages of baking small cakes is that they are much easier to split to create layers! It is best to divide them with a bread knife or a serrated knife, preferably on a cake turntable. My turntable is marble, and I lucked out by finding it at a secondhand shop.

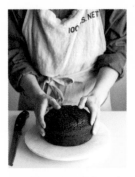

1. Place the whole cake on a cutting board or cake turntable.

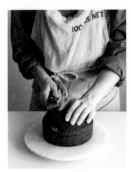

2. If the top of the cake is rounded, level it with a knife.

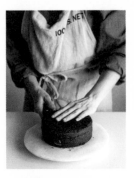

3. Split the cake horizontally at the center by carefully cutting through with a knife.

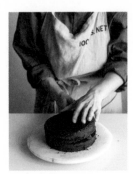

4. Try to make the cake layers as even as possible.

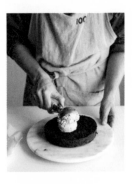

5. Measure the filling with an ice cream scoop or something similar, using about the same amount for each layer.

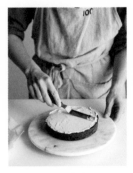

6. Spread the filling on the first layer with an offset spatula.

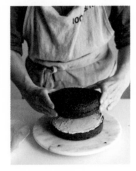

7. Place the next layer on top . . .

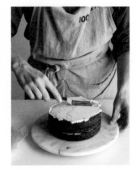

8. . . . and repeat the sequence until all the layers have been stacked.

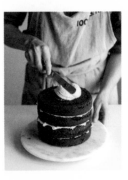

9. Spoon a rather large amount of frosting on top of the cake . . .

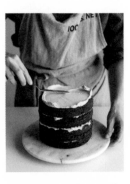

10. . . . and spread it evenly over the top and down the sides of the cake.

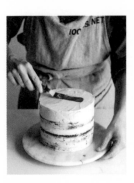

11. Refrigerate the cake for about 15 minutes before you apply the final layer of frosting.

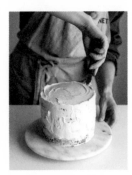

12. Spread the frosting evenly around the sides and then across the top. Wipe the spatula well after each pass.

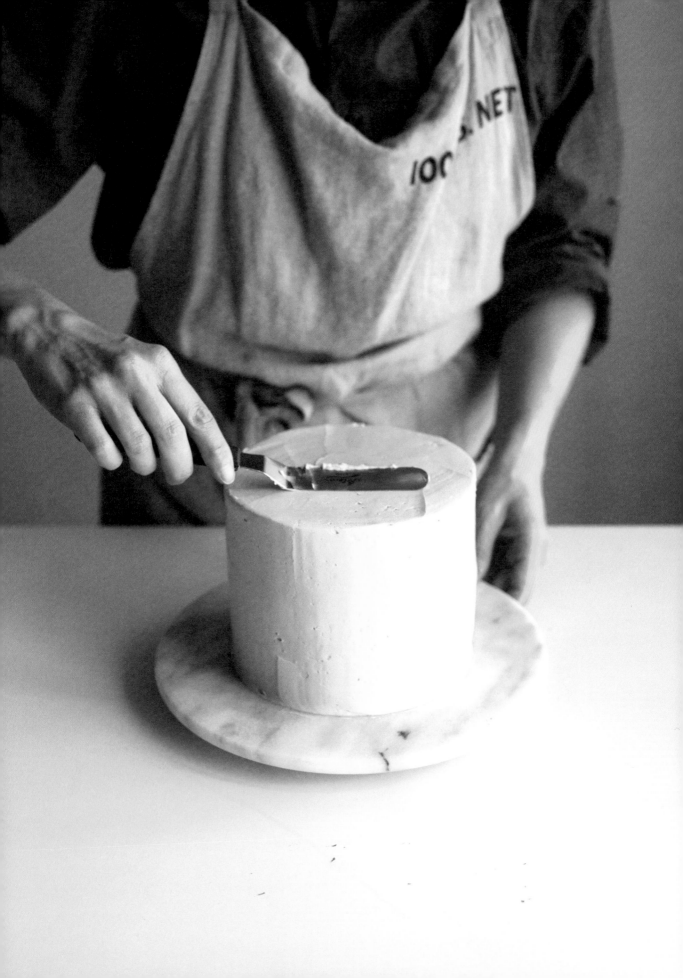

Picking your own flowers and plants for decorating is the best way to make use of nature's pantry. That way there is little risk of using plants that have been sprayed. Also avoid picking flowers too close to heavily trafficked roads. Instead, go to the edge of the woods or a more remote place or, of course, your own garden. Keep in mind that sometimes only particular parts of flowers are edible. Do your research.

Most often, my flower decorations are simply for embellishment and not to be eaten. I usually remove the flowers when the cake is cut. If you don't want flowers directly on the cake, you can adorn the serving platter with them.

Edible flowers are also wonderful for mixing with sugar in a jar. The sugar takes on the flavor of the flowers and can then be used for baking or in tea.

Experiment with freezing edible flowers or herbs in ice cube trays to add unique flavors to drinks. Make absolutely sure that flowers are edible before you do this!

If you want to decorate with flowers purchased at a florist's, ascertain that the flowers have not been sprayed. If you have even the smallest doubt, ask.

Lavender is one of the most popular flowers for baking. With its sweet, flowery taste, it pairs well with citrus and honey in muffins, cookies, ice cream, and cakes. Elderberry flowers, lilacs, daisies, roses, violets, and damask roses are other flowers you can decorate with.

[LILAC FLOWER SUGAR]

You can substitute lavender for the lilac if you like.

¼ cup lilac flowers
2¼ cups granulated sugar

1. Spread the lilac flowers out on paper towels and remove any dirt or insects. If you want to rinse the flowers, do so well ahead of time, because the flowers must be completely dry before they are mixed with the sugar.
2. Stir the flowers and sugar in a jar. Place a lid on the jar and store for 2 to 3 days; shake the jar occasionally. When you are ready to use the sugar, separate out the flowers, which will have become brown after a while. Use the sugar for baking or to sweeten tea.

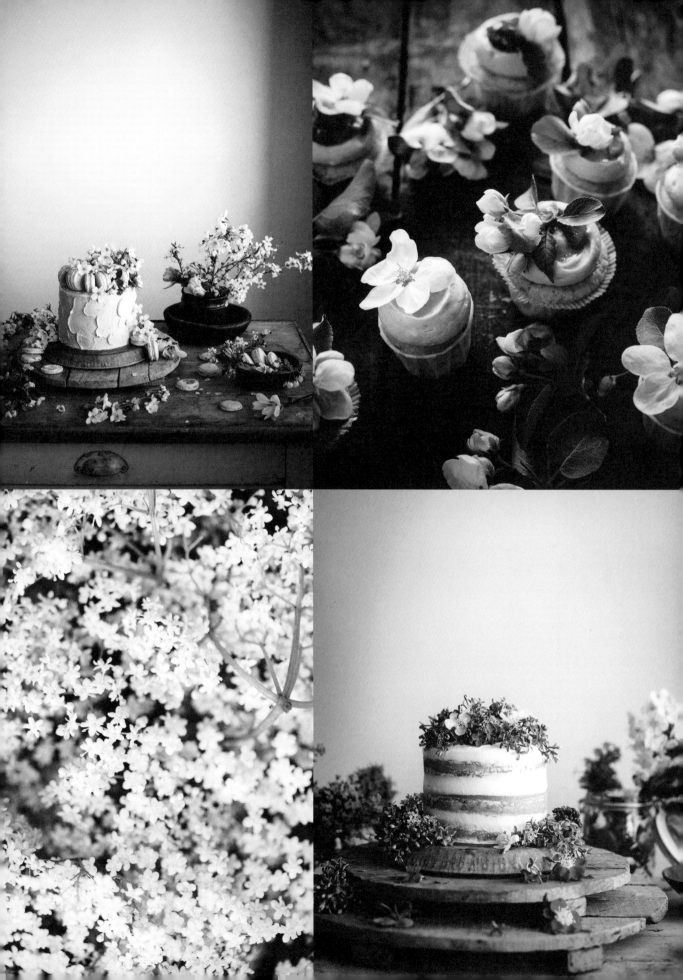

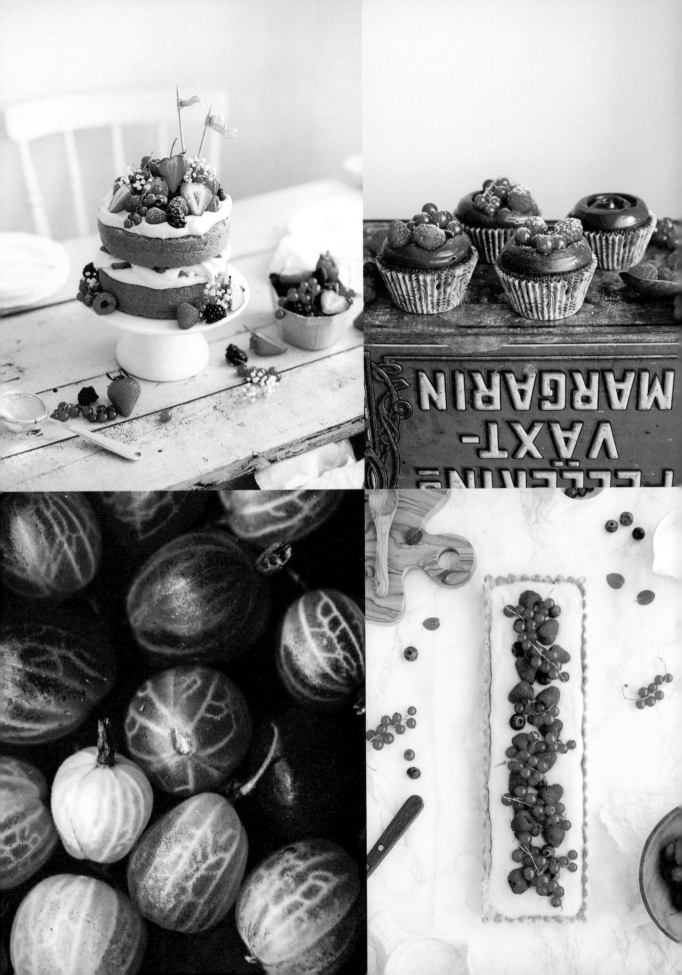

[BERRIES]

Decorating with berries is perhaps the easiest way to embellish a cake and still makes it look especially pretty!

Arrange your favorite berries on the cake and then dust with confectioners' sugar. I like to mix different kinds of berries and spoon them on randomly, but it can also be nice to arrange them in a pattern.

Fresh berries are best, because frozen berries become soft and lose their shape as they thaw. Chocolate-dipped strawberries are also lovely arranged atop a cake.

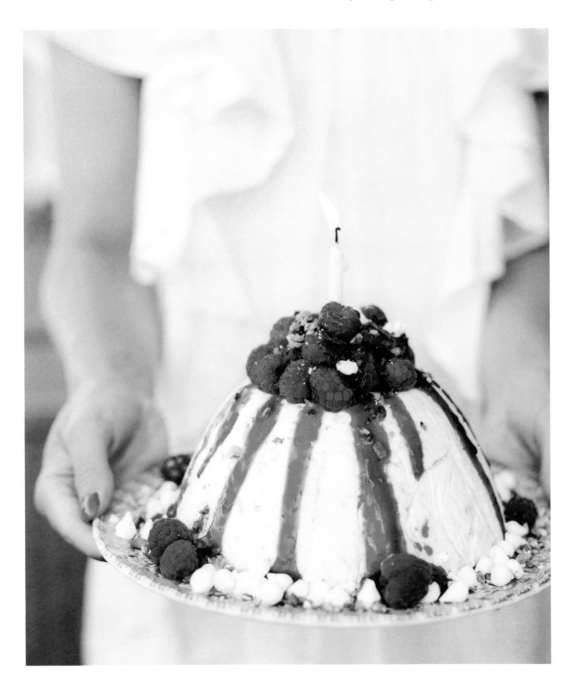

Does shaved chocolate ever *not* look good on cupcakes or a cake?

There are several ways to make chocolate curls, but I like to take shortcuts whenever I can. The "real" way is to temper the chocolate, spread it over a work surface such as a marble platter, wait until it is firm, and then cut the slivers with a knife.

Here's what I do—maybe it is not quite as effective as the method described above, but it is still okay: Place a block of chocolate in a relatively warm place, or heat it for a couple of seconds in the microwave, until it is soft but not melted. Use a cheese plane to cut the chocolate just as you would cheese! This method works best with milk chocolate.

You can also pipe melted chocolate into patterns on a piece of parchment paper using a small round tip (or by clipping a small hole at the end of a pastry bag). Let the chocolate harden, then transfer the shapes onto the cake.

Cocoa Powder and Confectioners' Sugar

You can dust confectioners' sugar or cocoa over a cake by shaking it through a sieve. To use a more professional technique, cut out shapes or make stencils from parchment paper (or use ready-made cake paper), then lay the paper over the cake and use a sieve to dust with the powder.

Coconut Flakes

Pour the amount of coconut flakes you will need into a small plastic bag. Add a touch of pink gel food coloring and a few drops of water (or use liquid red food coloring). Close the bag and massage the contents until the coconut flakes are evenly tinted. Add more coloring if you want a deeper color. Let the coconut dry before using. If you prefer natural food coloring, red beet juice works well too.

Chopped Nuts and Cookie Crumbs

Finely chop different types of nuts or crush cookies and press them onto the sides of a frosted cake for an easy, tasty decoration!

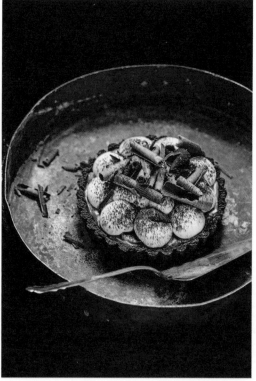

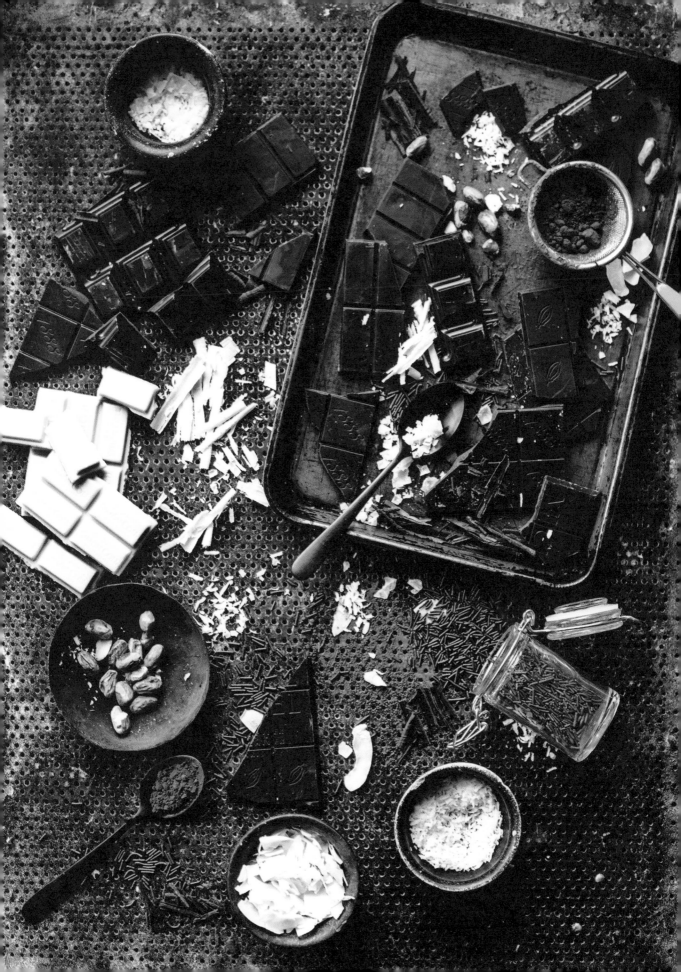

[PIE CRUST]

The best, most fantastic way to make pie is to create fun patterns with the dough. The only limits are your imagination and the amount of dough you have.

Roll out the dough and cut out different shapes with cookie cutters—hearts, circles, leaves, or whatever you like—then arrange the shapes on top of the pie filling. My favorite pattern is the classic basket weave: cut long strips of dough and then layer them in a woven, crisscross pattern. (There are many excellent tutorials online.)

Consider making a braid from three narrow strips of pie dough for encircling the edge of the pie. Make sure the pie dough is at room temperature so it won't tear as you braid it.

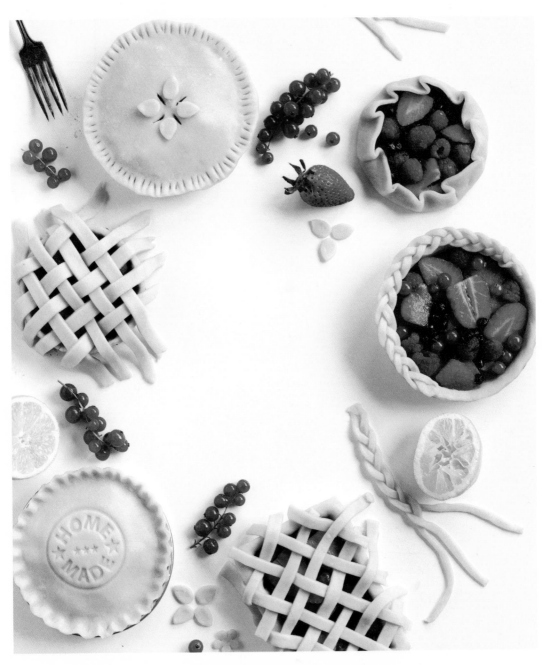

[GLAZES]

Glazes look beautiful and taste delicious on cakes and sugar cookies. They can be in the form of caramel sauce, berry sauce, or chocolate ganache.

To pour a chocolate glaze over the edges of a cold cake, you must work quickly so the chocolate doesn't set too soon. Have an offset spatula on hand to spread the chocolate evenly.

Caramel sauce can be too thick to work with when cold. Carefully warm caramel sauce in the microwave or in a saucepan until it has a loose consistency before pouring it.

Glazes made from confectioners' sugar and water should be used immediately because they solidify quickly.

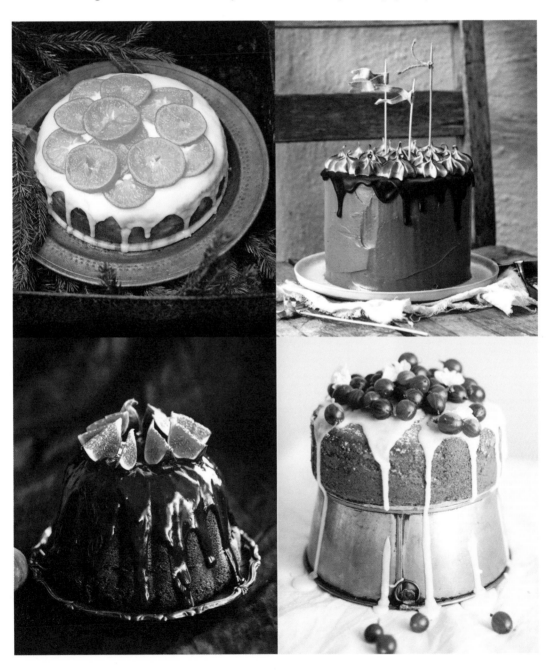

[RESOURCES AND INSPIRATION]

These are some of my favorite resources out of all the fantastic food and baking blogs out there:

www.adventures-in-cooking.com
www.cannellevanille.com
www.cococakeland.com
www.dagmarskitchen.se
www.littleupsidedowncake.com/blog
www.localmilkblog.com
www.mimithorisson.com
www.myblueandwhitekitchen.com
www.nicolefranzen.blogspot.com
www.ourfoodstories.com
www.topwithcinnamon.com

A TASTE OF CHOCOLATE

NO-BAKE CHEESECAKE WITH CHOCOLATE AND RASPBERRIES

An easy-to-make cake with the rich taste of chocolate. The crust is like a giant chocolate chip cookie—could it get any better?

COOKIE CRUST

5¼ tablespoons salted butter

1¾ ounces mixed chocolate, such as dark choco-
late (70% cocoa) and milk chocolate

1 cup all-purpose flour

2 tablespoons cocoa powder

¼ teaspoon salt

¼ teaspoon baking soda

⅔ cup light Muscovado sugar (firmly packed in
the measuring cup)

1 teaspoon vanilla extract, or ¼ teaspoon
vanilla powder

1 egg

CREAM CHEESE FILLING

7 ounces dark chocolate (70% cocoa)

7 ounces milk chocolate

12 ounces cream cheese

¼ cup granulated sugar

2 tablespoons + 2 teaspoons coffee liqueur,
such as Kahlúa, or strong coffee

1¼ cups whipping cream

8 ounces fresh raspberries, for garnish
Confectioners' sugar, for garnish

MAKING THE COOKIE CRUST

1. Preheat the oven to 325°F. Butter a 7-inch springform pan.
2. Melt the butter and let cool. Chop the chocolate.
3. Mix the flour, cocoa, salt, and baking soda in a medium bowl.
4. In a large bowl, beat the melted butter, sugar, and vanilla. Add the egg and beat well. Sift the dry ingredients over the butter mixture and then add the chocolate; beat until the mixture holds together.
5. Press the dough into the bottom of the springform pan and bake for 20 to 23 minutes. Remove from the oven and let cool.

MAKING THE CREAM CHEESE FILLING

1. Chop the dark chocolate and milk chocolate and melt it in the top of a double boiler with simmering water in the bottom pot. Let cool slightly.
2. In a large bowl, beat the cream cheese, sugar, and coffee liqueur until creamy. Fold in the melted chocolate with a spatula and beat until the mixture is smooth.
3. In a separate medium bowl, whip the cream and then fold it into the cream cheese mixture. Beat until all the ingredients are well incorporated.
4. Pour the filling over the cookie crust and smooth out the top with a spoon or offset spatula. Cover the pan with plastic wrap and refrigerate until the filling is firm, 4 to 6 hours (or store in the refrigerator overnight).
5. Remove the cake from the refrigerator and carefully remove the sides of the springform pan. (Holding your hands on the outside of the pan to warm it up a little makes it easier to remove.) Decorate the cake with fresh raspberries and a dusting of confectioners' sugar.

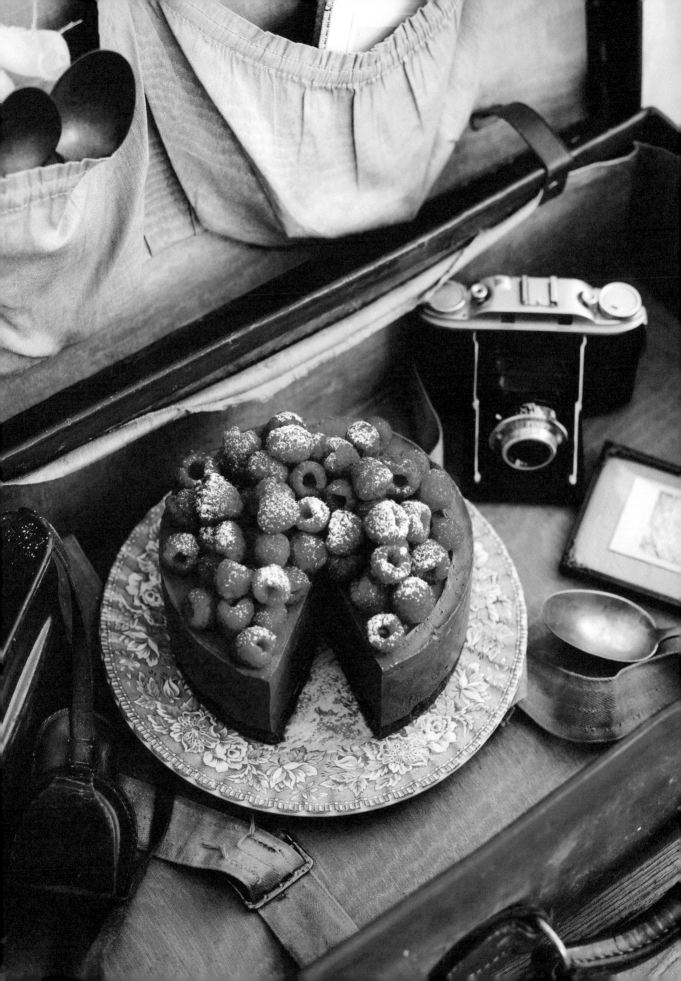

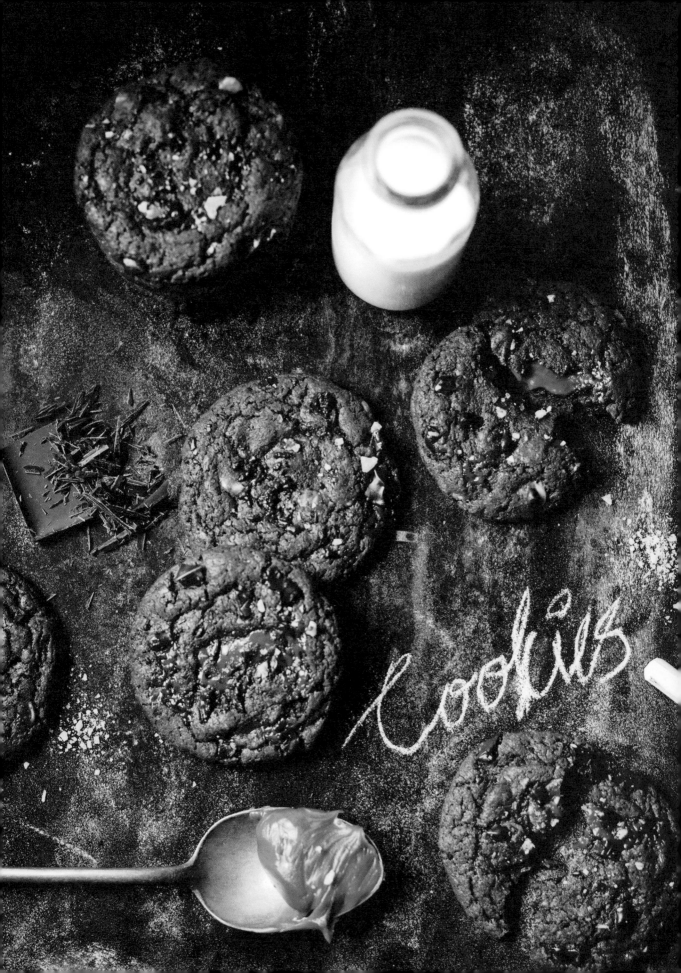

cookies

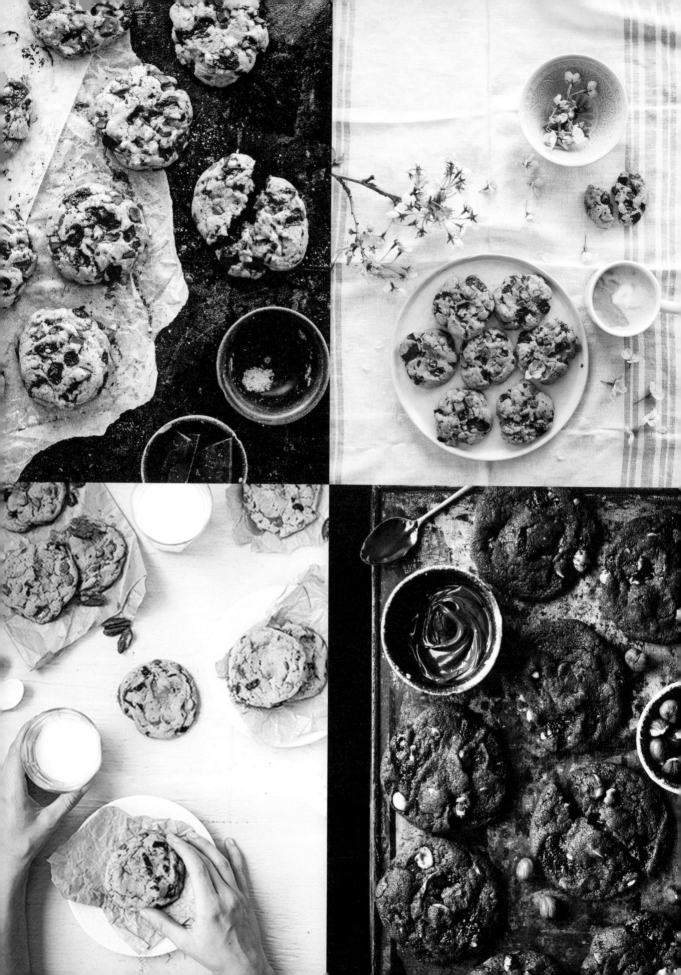

COOKIES

American chocolate chip cookies are undoubtedly the world's best cookies! Try out this baking trick for the best results: don't bake them too long! The cookies should be a little sticky in the center when they have cooled.

APPROXIMATELY 35 COOKIES

MY BEST CHOCOLATE CHIP COOKIES

10 tablespooons unsalted butter

5¼ ounces dark chocolate (70% cocoa)

5¼ ounces milk chocolate

2¼ cups all-purpose flour

¼ teaspoon flaky salt

½ teaspoon baking soda

⅓ cup + 2 tablespoons granulated sugar

¾ cup + 2 tablespoons light Muscovado sugar (firmly packed in the measuring cup)

1 teaspoon vanilla extract, or ¼ teaspoon vanilla powder

1 egg

1 egg yolk

MAKING THE COOKIE DOUGH

1. Melt the butter and let cool. Coarsely chop the dark chocolate and milk chocolate.
2. Mix the flour, salt, and baking soda in a medium bowl.
3. In a large bowl, beat the melted butter, granulated and Muscovado sugars, and vanilla. Add the egg and egg yolk and beat well.
4. Sift the dry ingredients over the batter, add the chocolate, and beat until the dough comes together. Cover the bowl with plastic wrap and refrigerate the dough for at least 2 hours, preferably overnight.

SHAPING AND BAKING THE COOKIES

1. Preheat the oven to 325°F. Line a cookie sheet with parchment paper.
2. Shape the dough into balls, using about 3 tablespoons of dough for each. Place the dough balls on the prepared cookie sheet. These cookies will spread as they bake, so don't place them too close together.
3. Bake the cookies in the center of the oven for 10 to 12 minutes, until just starting to brown.

APPROXIMATELY 14 COOKIES

DULCE DE LECHE COOKIES

COOKIE DOUGH

1 ounce dark chocolate (70% cocoa)

1 ounce white chocolate

¾ cup all-purpose flour

1 teaspoon baking powder

Pinch of salt

3 tablespoons cocoa powder

½ teaspoon ground cinnamon

4 tablespoons salted butter, at room temperature

⅔ cup light Muscovado sugar (firmly packed in the measuring cup)

1 egg

FILLING

⅓ cup *dulce de leche* (see technique on page 39)

Sea salt, for garnish

Making the Cookie Dough

1. Coarsely chop the dark and white chocolate.
2. Mix the flour, baking powder, salt, cocoa, and cinnamon in a medium bowl.
3. In a large bowl, beat the butter and sugar until creamy. Add the egg and continue beating for 1 minute more.
4. Sift the dry ingredients over the batter, add the chocolate, and beat until the dough comes together. Cover the bowl with plastic wrap and refrigerate the dough for 1 hour.

Shaping and Baking the Cookies

1. Preheat the oven to 350°F. Line a cookie sheet with parchment paper.
2. Shape dough into balls, using about 3 tablespoons of dough for each, leaving about one-quarter of the dough for the tops of the cookies. Place the cookies on the prepared cookie sheet. These cookies will spread as they bake, so don't place them too close together.
3. Use your finger to make a small depression in each cookie. Spoon in a little dulce de leche. Flatten a small piece of the remaining dough to cover each cookie.
4. Sprinkle each cookie with a little sea salt and bake the cookies in the center of the oven for 10 to 12 minutes, until just starting to brown.

APPROXIMATELY 25 COOKIES

NUTELLA HAZELNUT COOKIES

COOKIE DOUGH

3½ ounces hazelnuts
3½ ounces dark chocolate (70% cocoa)
1¼ cups all-purpose flour
2 tablespoons cocoa powder
1 teaspoon baking powder
Pinch of salt
7 tablespoons salted butter, at room temperature
¼ cup + 2 tablespoons granulated sugar
⅓ cup light Muscovado sugar (firmly packed in the measuring cup)
⅔ cup hazelnut spread, such as Nutella
1 egg

FILLING

¼ cup + 2 tablespoons hazelnut spread, such as Nutella

Making the Cookie Dough

1. Preheat the oven to 350°F. Line a baking sheet with parchment paper. Spread the hazelnuts out in a single layer on the baking sheet and toast for 10 to 12 minutes, until they are lightly browned and fragrant. Keep an eye on them, because they can burn easily! Remove the pan from the oven (leave the oven on) and take off as much of the skins from the nuts as possible. The easiest way to do this is to dump the nuts onto a clean kitchen towel and rub them against each other with the towel (see page 40).
2. Coarsely chop the skinned hazelnuts. Alternatively, put the hazelnuts in a clean bag and break them into chunks with a mallet. Coarsely chop the chocolate.
3. Mix the flour, cocoa, baking powder, and salt in a medium bowl.
4. In a large bowl, beat the butter and the granulated and Muscovado sugars until creamy. Add the hazelnut spread and egg and beat for 1 minute.
5. Sift the dry ingredients over the batter, add the chopped chocolate and nuts, and beat until the dough comes together. Cover the bowl with plastic wrap and refrigerate for 1 hour.
6. Shape the dough into balls, using about 3 tablespoons of dough for each, leaving one-quarter of the dough for the tops of the cookies. Place the cookies on the prepared cookie sheet. These cookies will spread as they bake, so don't place them too close together.

Filling and Baking the Cookies

1. Fill a pastry bag with the hazelnut spread and cut a small hole at the bottom of the

bag. Use your finger to make a small depression in each cookie. Pipe a little hazelnut spread into each cookie. Flatten some of the remaining dough to create a "lid" to top each cookie. Make sure to pinch the edges of the cookie's top and bottom together so the filling won't leak out.

2. Bake the cookies in the center of the oven for 10 to 11 minutes, until just starting to brown.

APPROXIMATELY 25 COOKIES

CHOCOLATE, PECAN, AND CARAMEL COOKIES

2⅔ ounces pecans

2⅔ ounces milk chocolate

2⅔ ounces dark chocolate (70% cocoa)

14 caramels (about 2⅔ ounces) such as Werther's Original hard candies

2 tablespoons all-purpose flour

½ teaspoon baking soda

¼ teaspoon baking powder

½ teaspoon salt

9 tablespoons salted butter, at room temperature

¼ cup + 2 tablespoons granulated sugar

⅔ cup light Muscovado sugar (firmly packed in the measuring cup)

1 egg

1. Preheat the oven to 350°F. Spread the pecans out in a single layer on a baking sheet and toast for 10 to 12 minutes, until fragrant. Keep an eye on them, because they can burn easily! Leave the oven on.

2. Chop the toasted pecans, the milk chocolate, and dark chocolate. Chop or crush the caramels.

3. Mix the flour, baking soda, baking powder, and salt in a medium bowl.

4. In a large bowl, beat the butter with the granulated and Muscovado sugars until creamy. Add the egg and beat for 1 minute more. Sift the dry ingredients over the batter and then add the chopped chocolate, caramels, and pecans; beat until the dough comes together. Refrigerate the dough for 1 hour before using.

5. Line a cookie sheet with parchment paper. Shape the dough into balls, using 1 tablespoon of dough for each. Place the balls of dough on the prepared cookie sheet. These cookies will spread as they bake, so don't place them too close together.

6. Bake the cookies in the center of the oven for 13 to 15 minutes.

CHOCOLATE CREAM PIE

This is one of my favorite pies! The wonderful chocolate filling goes so well with the fluffy cream and crunchy crust. The filling comes together in about 5 minutes and is silky smooth. The smaller the pie pan, the thicker the chocolate cream layer.

PIE CRUST

5¼ ounces chocolate sandwich cookies, such as Oreos, or Ballerina cookies (available from IKEA or Swedish specialty shops)

2 tablespoons salted butter

CHOCOLATE FILLING

3½ ounces dark chocolate (70% cocoa)

⅓ cup granulated sugar

2 tablespoons cornstarch

Pinch of salt

2 egg yolks

1½ cups milk

1 tablespoon salted butter

1 teaspoon vanilla extract, or ¼ teaspoon vanilla powder

1¼ cups heavy whipping cream

Cocoa powder, for garnish

1¾ ounces milk chocolate slivers, for garnish (see page 88)

MAKING THE PIE CRUST

1. Preheat the oven to 300°F.
2. Crush the cookies (including the filling) into small pieces and then pulse into fine crumbs in a blender or food processor.
3. Melt the butter and pulse to blend with the cookie crumbs. Press the mixture into the bottom and sides of an 8-inch pie pan or tart pan. Bake in the center of the oven for about 10 minutes. Let cool.

MAKING THE CHOCOLATE FILLING

1. Chop the dark chocolate.
2. Whisk together the sugar, cornstarch, and salt in a saucepan.
3. In a medium bowl, beat the egg yolks and milk and then add the egg mixture into the sugar mixture in the saucepan. Warm the mixture over medium heat, whisking continuously until the mixture thickens, 5 to 10 minutes. It should be about the same consistency as a béarnaise sauce. Make sure you keep stirring the whole time, and do not let the mixture come to a boil; otherwise, you may find solid bits of the egg in the mixture.
4. Remove the pan from the heat and add the chopped chocolate, butter, and vanilla; beat until smooth. Let the filling cool to room temperature, 40 to 50 minutes; stir it occasionally while it cools.
5. Pour the cooled filling into the pie crust, cover the pie loosely with plastic wrap, and refrigerate for at least 6 hours (or store it in the refrigerator overnight). I cover the pie with an upside-down baking pan and then put plastic over that: this prevents the plastic wrap from sticking to and ruining the smooth surface of the pie filling.
6. Whip the cream until thick, with soft peaks, and spread it over the chocolate filling immediately before serving. Dust cocoa on top and then sprinkle with chocolate slivers.

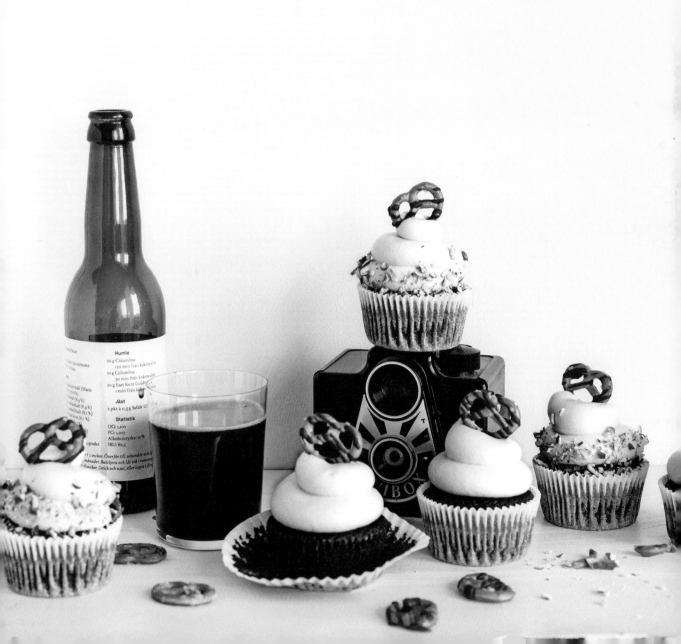

STOUT PRETZEL CUPCAKES

It might seem a little strange to bake sweets with beer, but the rich brew blends well with chocolate for a fantastically moist and tasty result.

CUPCAKES

½ cup stout (dark beer)

7 tablespoons salted butter

⅓ cup cocoa powder

1 egg

⅓ cup sour cream

¾ cup all-purpose flour

¾ cup granulated sugar

¾ teaspoon baking soda

Pinch of salt

CHOCOLATE PRETZELS

1 ounce dark chocolate (70% cocoa)

1 ounce salted pretzels or salted pretzel
 sticks

FROSTING

12 tablespoons salted butter, at room temperature

1¼ cups confectioners' sugar

5¼ ounces cream cheese

1 teaspoon vanilla extract, or ¼ teaspoon
 vanilla powder

MAKING THE CUPCAKES

1. Preheat the oven to 350°F. Line a muffin tin with 12 paper cupcake liners.
2. Pour the stout into a tall glass and let the foam settle. Melt the butter in a saucepan and then whisk in the cocoa and beer. Let the mixture cool.
3. In a small bowl, beat the egg and sour cream together. Add to the butter mixture in the saucepan and stir.
4. Mix the flour, sugar, baking soda, and salt in a medium bowl. Sift the dry ingredients over the butter mixture and stir until smooth.
5. Spoon the batter into the prepared muffin tin—do not fill the cups more than two-thirds full.
6. Bake for 15 to 17 minutes, until a toothpick inserted into the center comes out with moist crumbs. Remove the muffin tin from the oven and let cool on a wire cooling rack.

MAKING THE CHOCOLATE PRETZELS

1. Chop the chocolate and melt in the top of a double boiler with simmering water in the bottom pot.
2. Lay the pretzels out on a piece of parchment paper. Drizzle the melted chocolate over them and let sit until the chocolate is cooled and firm.

MAKING THE FROSTING

Beat the butter in a medium bowl until light and creamy. Add the confectioners' sugar and beat a little more. Add the cream cheese and vanilla. Beat until smooth.

DECORATING THE CUPCAKES

Remove the cooled cupcakes from the muffin tin. Fit a pastry bag with your choice of tip and fill the bag with frosting. Pipe the frosting onto the cupcakes and then decorate them with the chocolate pretzels.

CHEESECAKE BROWNIES
WITH **RASPBERRIES**

These fantastic brownies topped with swirls of cheesecake and dotted with raspberries are a great choice when you have several hungry guests to serve.

BROWNIE BATTER

16 tablespoons (2 sticks) salted butter

4 eggs

1¼ cups granulated sugar

⅔ cup all-purpose flour

¼ teaspoon salt

¾ cup cocoa powder

1 teaspoon vanilla extract, or ¼ teaspoon vanilla powder

CHEESECAKE BATTER

12 ounces cream cheese

¼ cup granulated sugar

1 egg

¼ cup all-purpose flour

4½ ounces fresh or frozen raspberries

MAKING THE BROWNIE BATTER

1. Preheat the oven to 350°F. Butter a 9½ x 13-inch baking pan.
2. Melt the butter.
3. Beat the eggs and sugar in a large bowl until light and fluffy, 4 to 5 minutes. Add the melted butter and beat until smooth.
4. In a medium bowl, mix the flour, salt, cocoa, and vanilla powder, if using. Sift the dry ingredients over the egg mixture and beat only until the batter comes together. Stir in the vanilla extract.
5. Pour the batter into the prepared pan.

MAKING THE CHEESECAKE BATTER

Beat the cream cheese, sugar, egg, and flour in a large bowl until smooth.

ASSEMBLING AND BAKING THE BROWNIES

1. Spoon the cheesecake batter over the brownie batter. Use a utensil to swirl the cheesecake with the brownie batter. Sprinkle the raspberries on top.
2. Bake the brownies for about 45 minutes, until a toothpick inserted into the center comes out with moist crumbs. Remove from the oven and allow to cool completely in the pan before cutting.

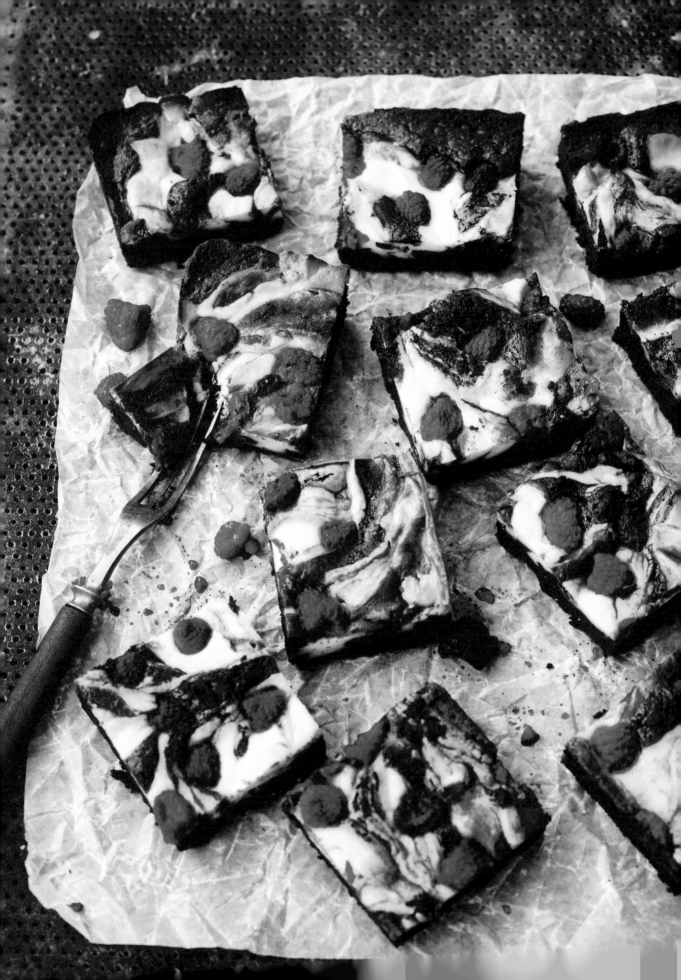

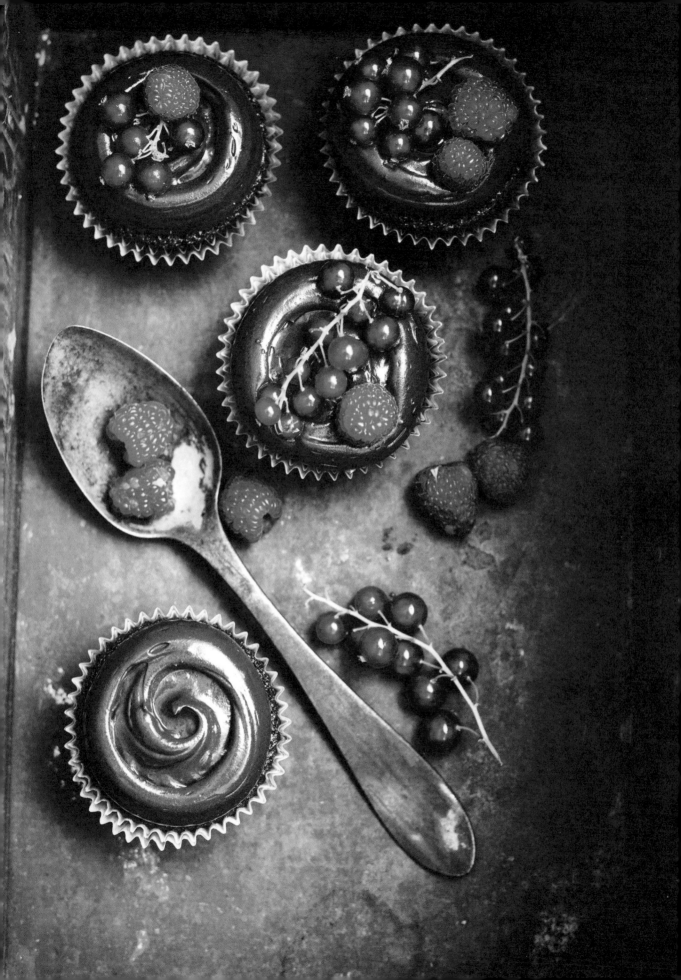

CUPCAKES WITH ESPRESSO FROSTING

A proven recipe that hits it out of the ballpark every time. Espresso frosting is one of my absolute favorites. This recipe makes a lot of frosting, so don't be afraid to pipe it on generously.

CUPCAKES

1¼ cups all-purpose flour

¼ cup + 2 tablespoons cocoa powder

1 teaspoon baking soda

1 teaspoon baking powder

1 cup granulated sugar

5½ tablespoons salted butter

1 egg

1 teaspoon vanilla extract, or ¼ teaspoon vanilla powder

¼ cup + 2 tablespoons boiling water

⅔ cup milk

ESPRESSO AND CHOCOLATE FROSTING

7 ounces dark chocolate (70% cocoa)

21 tablespoons salted butter (2 sticks + 5 tablespoons), at room temperature

1¼ cups confectioners' sugar

⅔ cup cocoa powder

1 teaspoon vanilla extract, or ¼ teaspoon vanilla powder

2 tablespoons espresso or strong coffee

MAKING THE CUPCAKES

1. Preheat the oven to 350°F. Line a muffin tin with 12 paper cupcake liners.
2. Mix the flour, cocoa, baking soda, baking powder, and sugar in a medium bowl.
3. Melt the butter. In a large bowl, beat the egg lightly and then add the melted butter, vanilla, boiling water, and milk and beat. Sift the dry ingredients over the mixture and beat until smooth.
4. Spoon the batter into the prepared muffin tin—do not fill the cups more than two-thirds full.

5. Bake for 17 to 20 minutes, until a toothpick inserted into the center comes out with moist crumbs. Remove the muffin tin from the oven and let cool on a wire cooling rack.

MAKING THE ESPRESSO AND CHOCOLATE FROSTING

1. Chop the chocolate and then melt it in the top of a double boiler with simmering water in the bottom pot. Allow the chocolate to cool slightly.
2. In a large bowl, beat the butter until light and creamy. Add the confectioners' sugar and cocoa and beat until smooth.
3. Pour in the melted chocolate and continue beating until smooth.
4. Add the vanilla and espresso and beat until the frosting is smooth and fluffy.

DECORATING THE CUPCAKES

Remove the cooled cupcakes from the muffin tin. Fit a pastry bag with your choice of tip, fill with frosting, and pipe the frosting onto the cupcakes. Alternatively, use a spoon to spread the frosting onto the cupcakes.

[FLAVOR VARIATION]

MILK CHOCOLATE FROSTING

12 ounces milk chocolate

12 ounces cream cheese, at room temperature

1. Chop the chocolate and then melt it in the top of a double boiler with simmering water in the bottom pot; allow to cool to room temperature.
2. Beat the cream cheese in a large bowl until creamy. Add the chocolate and beat until smooth.

SKILLET-BAKED CHOCOLATE CHIP COOKIES

These large cookies are like gooey, sticky cakes. If you don't have two small cast-iron skillets, you can bake these cookies in a regular baking pan.

2⅔ ounces milk chocolate

2⅔ ounces dark chocolate (70% cocoa)

7 tablespoons salted butter

¼ cup + 2 tablespoons granulated sugar

⅔ cup light Muscovado sugar or dark brown sugar (firmly packed in the measuring cup)

1 egg

1 teaspoon vanilla extract, or ¼ teaspoon vanilla powder

1⅔ cups all-purpose flour

½ teaspoon baking soda

¼ teaspoon salt

1. Preheat the oven to 350°F. Oil two small cast-iron skillets with olive oil or butter.
2. Coarsely chop the milk chocolate and dark chocolate.
3. Melt the butter in a saucepan. Add the granulated and Muscovado sugars and stir well. Take the pan off the heat and let the butter mixture cool slightly. Beat in the egg and vanilla.
4. Mix the flour, baking soda, and salt in a medium bowl. Sift the dry ingredients over the butter mixture and add the chopped chocolate. Beat until combined.
5. Divide the dough between the prepared cast-iron skillets and bake for 17 to 20 minutes, until the cookies are crisp around the edges but still soft in the center. If you bake the dough in one large pan, it may require a longer baking time.

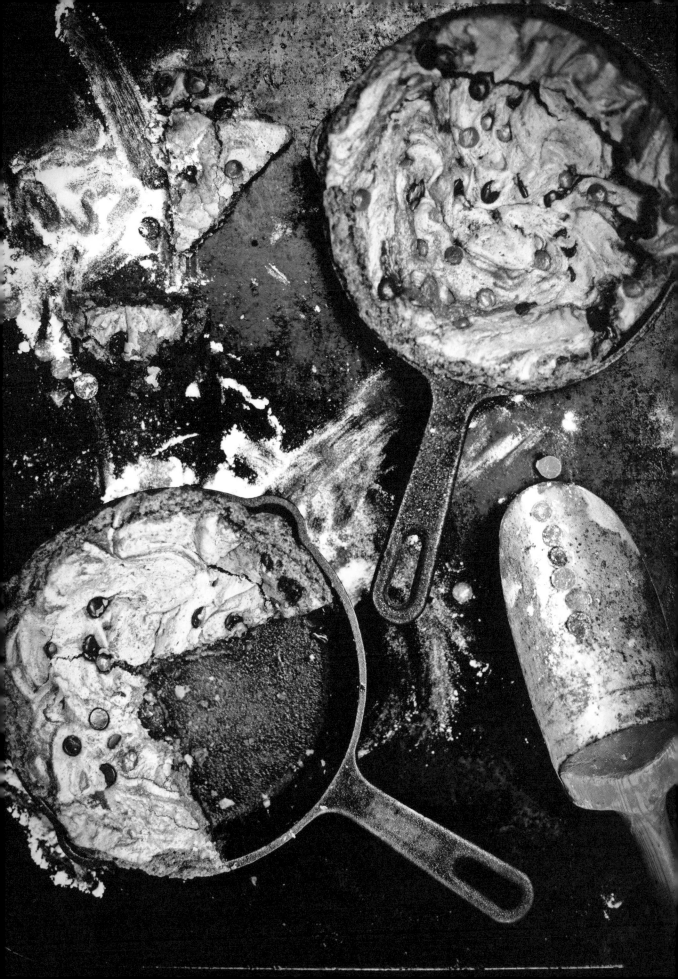

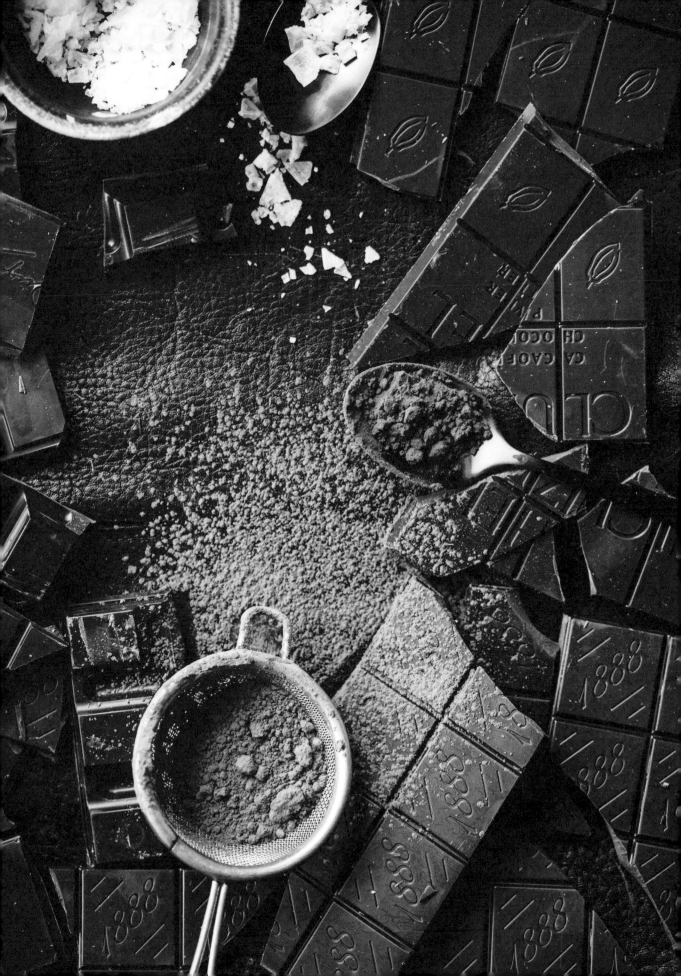

MALTED MILK BROWNIES

Chocolate-filled brownies with a creamy glaze. The malted milk balls and flaky salt on top make these brownies caramel-like.

BROWNIES

2⅔ ounces dark chocolate (70% cocoa)
9 tablespoons salted butter
1 cup all-purpose flour
¼ cup powdered milk
¾ cup granulated sugar
½ cup cocoa powder
¼ teaspoon baking powder
¼ teaspoon salt
3 eggs
1 teaspoon vanilla extract, or ¼ teaspoon vanilla powder

CREAM CHEESE FROSTING

5½ tablespoons salted butter, at room temperature
¼ cup confectioners' sugar
¼ cup cocoa
3 tablespoons powdered milk
½ teaspoon vanilla extract, or ⅛ teaspoon vanilla powder
6 ounces cream cheese

1 ounce malted milk balls
1 ounce dark chocolate (70% cocoa)
Pinch of flaky salt

MAKING THE BROWNIES

1. Preheat the oven to 350°F. Butter a 6 x 9¾-inch ovenproof pan and line it with parchment paper.
2. Coarsely chop the chocolate.
3. Melt the butter.
4. Mix the flour, powdered milk, sugar, cocoa, baking powder, and salt in a medium bowl.
5. In a large bowl, beat the eggs and vanilla. Sift the dry ingredients over the egg mixture, add the melted butter, and beat until smooth.
 Note: The batter may seem rather thick, but that is how it should be!
6. Add the chopped chocolate and beat until incorporated.
7. Pour the batter into the prepared pan and bake for 20 to 25 minutes, until a toothpick inserted into the center comes out with moist crumbs. Let cool completely in the pan.

MAKING THE CREAM CHEESE FROSTING

In a large bowl, beat the butter until creamy. Add the confectioners' sugar, cocoa, and powdered milk and beat. Add the vanilla and cream cheese and beat until the frosting is smooth.

ASSEMBLING THE BROWNIES

Remove the cooled brownies with the parchment from the pan and spread the frosting over them before cutting. Chop the malted milk balls and shave or chop the chocolate (see page 88) and sprinkle over the brownies. Finish with a little flaky salt.

SEA SALT CHOCOLATE MACARONS

When preparing macarons, it is very important that all the measurements be exact. You should weigh most of the ingredients. Take a look at pages 41–42 for a few more tips and tricks for making these luxurious French cookies.

MACARONS
3.9 ounces egg whites (from about 3 extra-large eggs)
3½ ounces almond flour
6½ ounces confectioners' sugar
½ ounce cocoa powder
¼ cup granulated sugar
1 teaspoon flaky salt

CHOCOLATE FILLING
3½ ounces dark chocolate (70% cocoa)
¼ cup + 2 tablespoons whipping cream
1 tablespoon salted butter

Making the Macarons

Day 1:

Measure the egg whites into a large bowl. Cover the bowl with plastic wrap and leave at room temperature overnight.

Day 2:

1. Pulse the almond flour, confectioners' sugar, and cocoa in a food processor until well combined.
2. Beat the egg whites until foamy. Add the granulated sugar, 1 tablespoon at a time, as you beat the whites. Continue beating until it forms a firm meringue.
3. Sift the dry ingredients over the meringue and fold in with a spatula. The meringue should be neither too loose nor too firm. If you want to be certain that the meringue is the right consistency, spoon out a little onto some parchment paper. The meringue should spread out and acquire a smooth surface after a while. If the test piece remains a bit conical in shape, beat the meringue a little more.
4. Line 2 cookie sheets with parchment paper. Fit a pastry bag with a round tip and fill the bag with meringue. Pipe out small pools of meringue onto the paper. Leave to harden for about 20 minutes. Sprinkle a bit of flaky salt on each cookie. Leave the cookies for about 40 minutes, until they've developed a "skin" on the top. Carefully test with a finger; if they are sticky at this point, leave to rest longer, up to 1½ hours.
5. Preheat the oven to 300°F. Bake one cookie sheet of macarons at a time, each for 11 to 13 minutes, until the cookies lift easily from the sheet. Remove from the oven and let cool on the pans. Carefully lift the cooled cookies from the parchment paper.

Making the Chocolate Filling

1. Finely chop the chocolate and pour into a medium heatproof bowl.
2. Heat the cream and butter in a saucepan and remove from the heat just before the mixture comes to a boil. Pour the cream mixture over the chocolate and let stand for a few seconds. Stir the chocolate until it has melted completely and the cream is shiny. Let the filling cool until it begins to thicken and has a spreadable consistency. To speed up the cooling, refrigerate the filling, checking on it every 5 minutes so it doesn't get too hard.
3. Spread or pipe the chocolate filling over the bottoms of half of the cookies and top with the remaining cookies. Store the macarons in an airtight container in the refrigerator. They taste best refrigerated for 1 to 2 days.

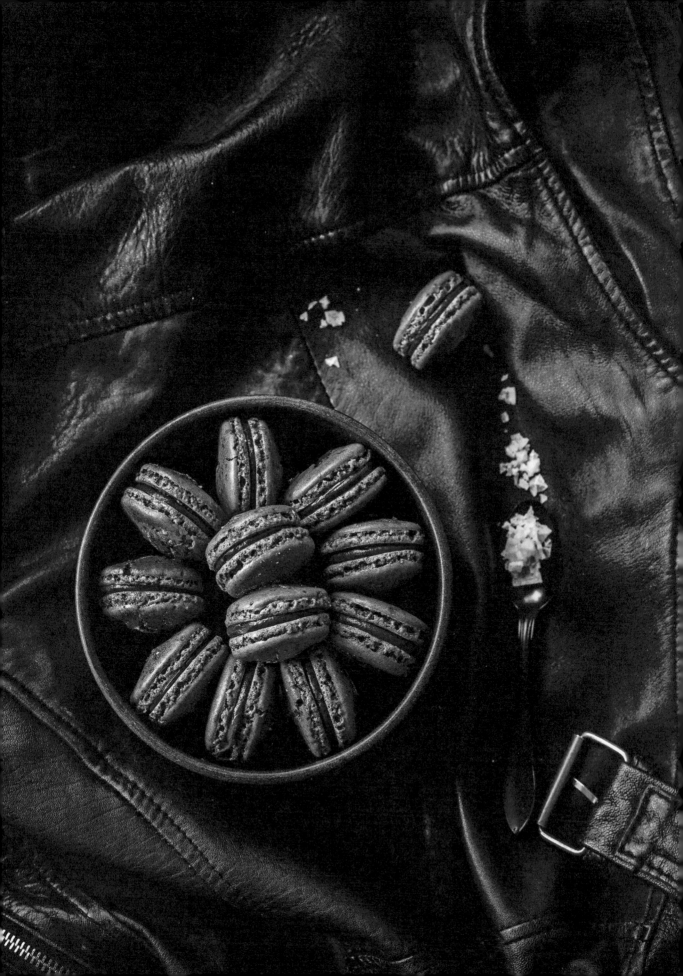

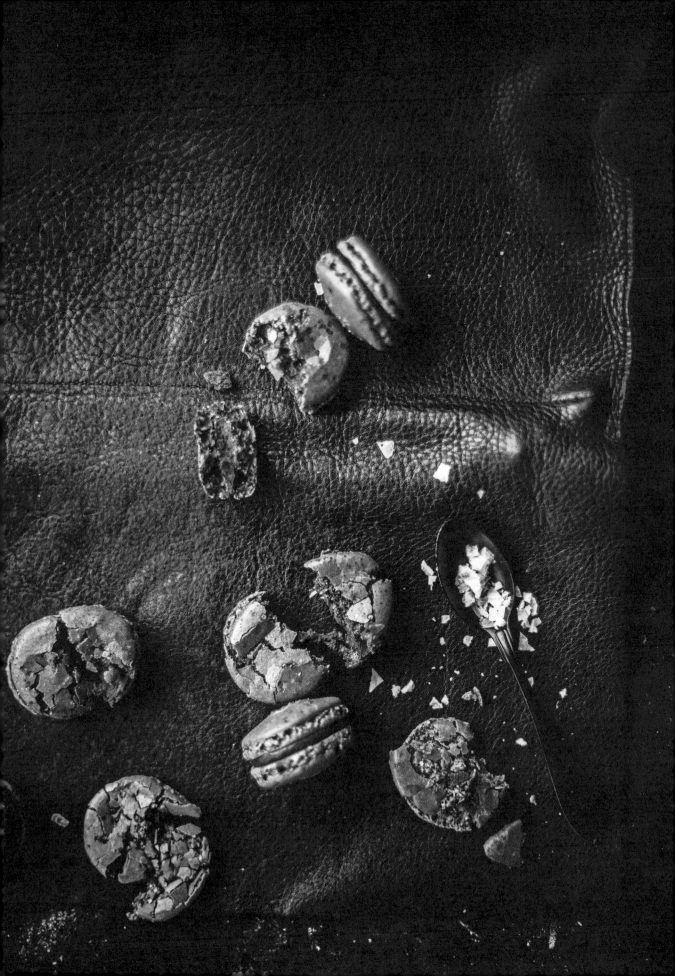

CHOCOLATE CAKE WITH WITH MERINGUE BRÛLÉE

Chocolate lovers will fall for this chocolate cake to beat all chocolate cakes.

CAKE LAYERS

5½ tablespoons salted butter
1½ cups granulated sugar
1¼ cups all-purpose flour
⅔ cup cocoa powder
1 teaspoon baking powder
1 teaspoon baking soda
½ teaspoon salt
2 eggs
¾ cup milk
¾ cup boiling water

MILK CHOCOLATE FROSTING

7 ounces milk chocolate
21 tablespoons (2 sticks + 5 tablespoons)
 salted butter, at room temperature
3 tablespoons espresso or strong coffee
⅔ cup confectioners' sugar
Pinch of salt
1 teaspoon vanilla extract, or ¼ teaspoon
 vanilla powder

CHOCOLATE GLAZE

2⅔ ounces dark chocolate (70% cocoa)
2¼ tablespoons salted butter

MERINGUE FROSTING

2 egg whites
¼ cup + 2 tablespoons light Muscovado sugar
 (firmly packed in the measuring cup)

MAKING THE CAKE LAYERS

1. Preheat the oven to 350°F. Butter and flour two 6-inch cake pans.
2. Melt the butter and let it cool slightly.
3. Mix the sugar, flour, cocoa, baking powder, baking soda, and salt in a large bowl. Add the cooled butter, the eggs, and milk and beat until smooth. Add the boiling water and beat until smooth.
4. Divide the batter evenly between the prepared pans. Bake in the center of the oven for 35 to 40 minutes, until a toothpick inserted into the center comes out with moist crumbs. Let cool in the pans for a few minutes, then turn out onto a wire cooling rack to cool completely.

MAKING THE MILK CHOCOLATE FROSTING

1. Chop the milk chocolate and melt it in the top of a double boiler with simmering water in the bottom pot. Let cool slightly.
2. Beat the butter in a medium bowl until light and creamy. Add the espresso, confectioners' sugar, salt, and vanilla and beat until smooth and creamy. Add the melted chocolate and beat a little more.

ASSEMBLING THE CAKE

Cut the cooled cake layers in half horizontally so you have four thin layers. Place one layer on a plate. Cover the layer with frosting and add another layer. Continue stacking and frosting until the last layer has been added, then cover the entire cake with frosting (see page 82). Refrigerate the cake while you make the chocolate glaze.

MAKING THE CHOCOLATE GLAZE

1. Chop the chocolate and melt it with the butter in a saucepan over low heat. Let cool to room temperature.

2. Take the cake out of the refrigerator and pour the chocolate glaze over it. Quickly spread the glaze with an offset spatula or a spoon so that it runs down the sides. Refrigerate the cake again.

MAKING THE MERINGUE FROSTING

1. Pour boiling water into a saucepan or the bottom of a double boiler and simmer over low heat. Put the egg whites and Muscovado sugar into a heatproof bowl or saucepan and place over a the simmering water in the bottom pan. Using a hand whisk, beat the mixture until it reaches 150°F, or until all the sugar crystals have dissolved.

2. Pour the mixture into a large bowl and beat with an electric mixer until the meringue is light and fluffy. Continue beating until the mixture cools, about 10 minutes.

3. Fit a pastry bag with a round tip and fill the bag with meringue frosting. Remove the cake from the refrigerator and pipe rosettes on top of the cake. Brown the meringue rosettes with a kitchen blowtorch (optional).

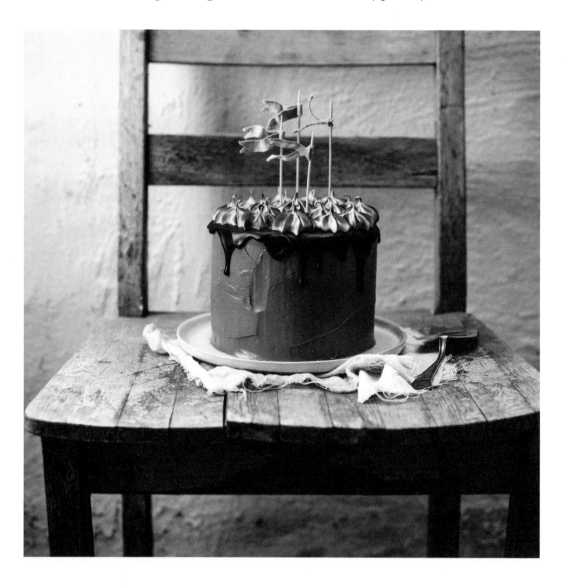

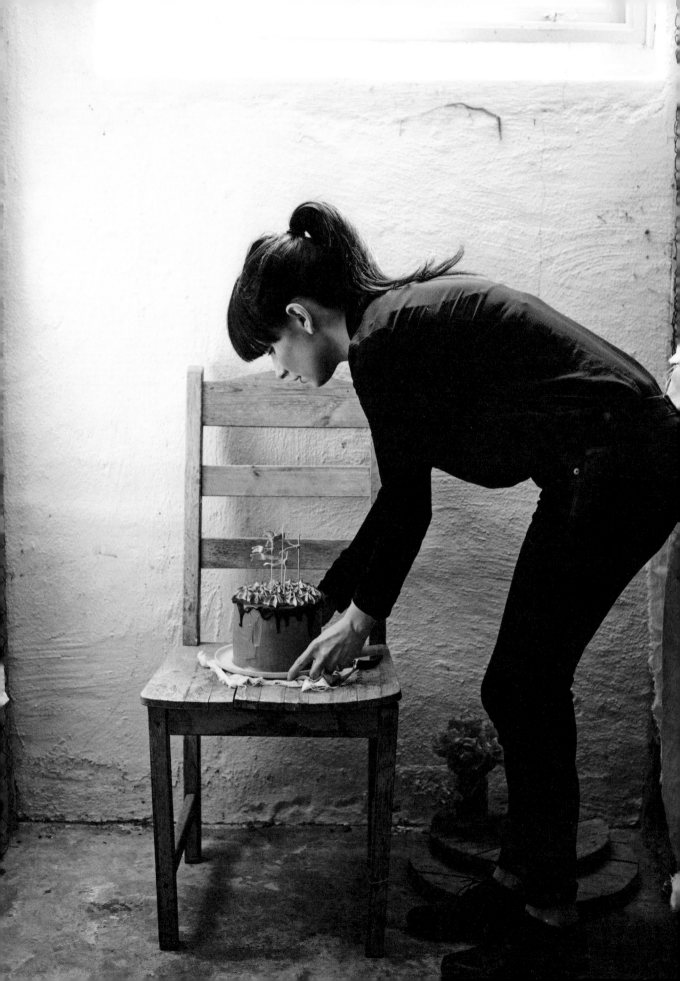

[STYLING AND PHOTOGRAPHY]

[STYLING]

Through styling, you can tell a story, highlight special qualities of the baked goods, or demonstrate a process. I take photos that entice others to bake. These photos might be for a magazine, to be shared online, or in this case, for a book, so it is also important that I capture specific moments in the baking process that can be difficult to explain in words only.

I try not to think too much about rules about what is "pretty" and what isn't, but go completely on my instincts about what works well together. The following are just tips—try to find your own look when you style your baking, whether you're arranging your sweet treats for photographing or for company.

MY STYLING PROCESS

Every food stylist and food photographer works in a different way with their pictures. Here is what I do:

I almost always begin by baking. While the sweets are cooling, I look through my props, my backgrounds, fabrics, china, silverware, and so on . . . and try to paint a picture in my head of how the scene will look. Some people like to sketch out their ideas on paper.

I wash the dishes, clean the work surfaces, and pull out and dust off everything that I need. I have a table near my living room window that is always ready to be used for photos. The light is lovely there, and if it is too strong on some days, I can just diffuse it with a thin curtain.

When everything is prepared, I set up the sweets and the props as I've imagined them. Sometimes it works well right off and sometimes it doesn't.

I take a few pictures and look at them closely on the computer screen. If the arrangement feels right, I will take more pictures of the baking from several angles so I will have many images to choose from. If the styling doesn't feel right, I will move things around or remove some items. If it *still* doesn't feel right, sometimes the only way is to start again from scratch and completely rethink the photograph.

This method may not work with all types of sweet treats. Ice cream melts quickly, so you have to be prepared before you start taking photos. For ice cream, I begin with the styling that I imagined and then set up a dummy, for example, an egg in the ice cream cone. That way, I can test the photo and make sure everything looks right before staging the real object of the photos.

PROPS AND BACKGROUNDS

Simplest rule to follow: Choose props you love! I like old things that have a patina just because that suits my style and my photos. About nine out of ten items in my prop cupboard came from secondhand stores or antique shops.

Find a set of china that you like. It doesn't need to be more than a couple of plates or bowls.

When staging a photo, choose china and other items that complement the food in some way. If you are using a busy background, such as a fabric printed with small flowers, try a single-color platter rather than one with a pattern. But these choices depend entirely on the situation. Sometimes, "more is more" is preferable to minimalism.

Sometimes the most unexpected objects can become the best part of a picture: a chair or an old suitcase, for example, or a worn piece of fabric. Even old doors, windows, and old apple crates can be perfect props!

The easiest method is to photograph against an existing background, such as white wallpaper. However, it is surprisingly easy to make your own backgrounds. Buy some cheap boards or a large piece of plywood at a hardware store. Test out various paint colors from a hobby shop or hardware store,

and stain the wood. Besides a paintbrush, use various kinds of tools to create texture, such as sandpaper or a roller or sponge. The advantage of using plywood is that you can paint two different backgrounds, one on each side.

I also use gift wrap, wallpaper, silk, and many kinds of fabric as backgrounds. Seek out the types of fabric you like. I prefer using linen, primarily in neutral colors, and I trim the edges and wash it for a pretty texture. Sometimes I dye white linen fabric with coffee or the cooking liquid from boiled beets. Patterned fabric is beautiful, but it can be a challenge because it can easily draw the focus away from the main motif.

Movement in Photos

By "movement," I mean that something is happening while the photo is being taken. Have a friend help, or set up your camera on a tripod. Use the self-timer to take a photo while, for example, you pour caramel sauce on a cake, sift confectioners' sugar over berries, or chop chocolate for garnishing.

Even little things such as some scattered crumbs or randomly arranged linen napkins give a feeling of movement and the impression of something happening in the photo.

Making Do with Imperfections

I want my styling to look "real." If a few berries fall down from a cake when I am slicing it, I leave them be and take the photo, rather than straightening everything and cleaning up.

Once, when I was taking pictures of a pavlova, the entire background fell on top of the cake and completely smashed it. Instead of giving up and walking out, I took a photo of the mayhem, which I posted on my blog along with the funny story.

I prefer a bit of natural messiness (or, maybe I should say, organized chaos) in my photos. I think that looks more authentic, as when we are really baking.

It's a good idea to style with things that belong in the picture. For example, you can sprinkle some raspberries around a cake if it is a raspberry cake, or place a bowl of frosting next to your cupcakes. And why not sprinkle some chopped chocolate on the table when displaying a chocolate cake?

[DO-IT-YOURSELF: PENNANTS]

A line of pennants across a cake is an easy and pretty way to decorate, and they are really quick to make.

You can make pennants with skewers, pretty ribbon, paper, or washi tape. You can find ribbons with thin wire inside that hold any shape and need no gluing. Check for inspiring materials at craft shops and fabric stores, which usually have an excellent selection of ribbons.

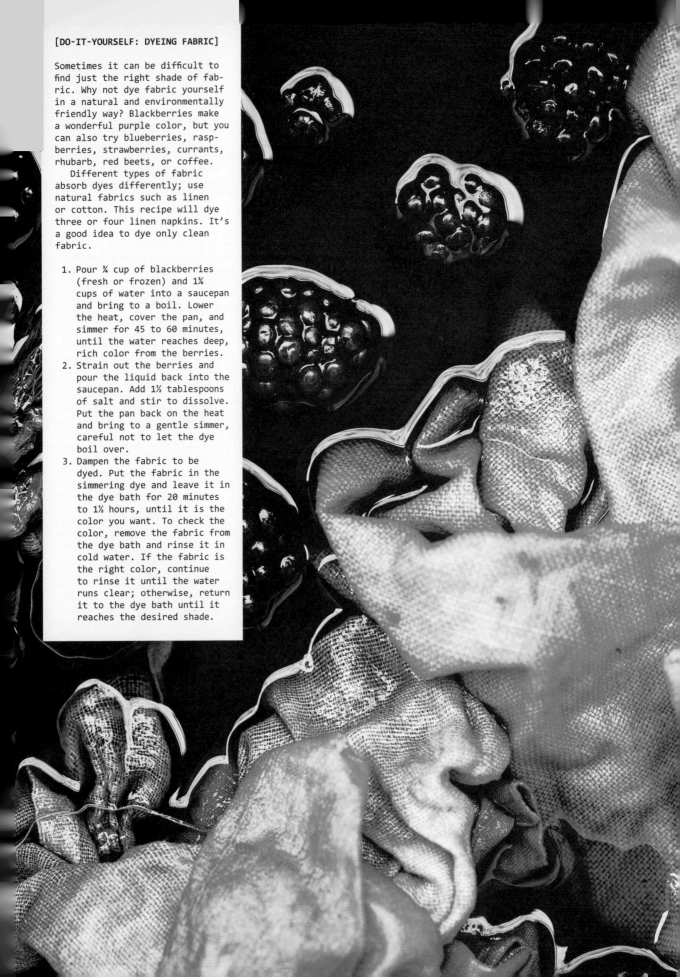

[DO-IT-YOURSELF: DYEING FABRIC]

Sometimes it can be difficult to find just the right shade of fabric. Why not dye fabric yourself in a natural and environmentally friendly way? Blackberries make a wonderful purple color, but you can also try blueberries, raspberries, strawberries, currants, rhubarb, red beets, or coffee.

Different types of fabric absorb dyes differently; use natural fabrics such as linen or cotton. This recipe will dye three or four linen napkins. It's a good idea to dye only clean fabric.

1. Pour ¾ cup of blackberries (fresh or frozen) and 1¾ cups of water into a saucepan and bring to a boil. Lower the heat, cover the pan, and simmer for 45 to 60 minutes, until the water reaches deep, rich color from the berries.
2. Strain out the berries and pour the liquid back into the saucepan. Add 1½ tablespoons of salt and stir to dissolve. Put the pan back on the heat and bring to a gentle simmer, careful not to let the dye boil over.
3. Dampen the fabric to be dyed. Put the fabric in the simmering dye and leave it in the dye bath for 20 minutes to 1½ hours, until it is the color you want. To check the color, remove the fabric from the dye bath and rinse it in cold water. If the fabric is the right color, continue to rinse it until the water runs clear; otherwise, return it to the dye bath until it reaches the desired shade.

[COMPOSITION]

 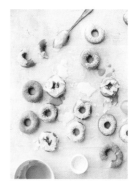

Comparing these two photos, it is obvious how the choice of background affects the mood of the picture. The pink background gives the picture a soft, summery feeling, while the wood background creates a harder, more autumnal mood. The hands (they are my hands, so the photos were taken with a self-timer from a camera on a tripod) are included to give the photos a feeling of movement. The two glasses indicate that the person depicted has company.

The photo at left was taken with a sheer curtain in front of the window (which was off to the left) and using a reflector board in the form of Styrofoam (off to the right) to lighten the shadows, thus creating a "soft" light.

The picture to the left feels more structured and arranged, while the one to the right is more natural and perhaps a more accurate take on glazing doughnuts. Whichever one you prefer is a matter of taste!

I think the first photo is quite lovely, but I get an almost wintry feeling from it. To ease that, I added some pink glaze to the scene and rearranged everything for more relaxed messiness.

 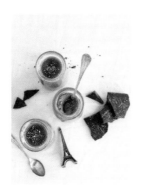

The dark photo was taken with side lighting and a narrower light source: I lowered the Venetian blinds in my living room.

The lighter photo was taken in exactly the same place and even with the same side lighting. I changed the background to white fabric, opened all the blinds, and changed the camera angle.

I personally prefer the dark photo because I find it more interesting. It has more depth, and I like the angle that better shows the shape of the little jars.

I often style with everyday household items, but I like to add a few quirky objects in my photos, such as toy cars, souvenirs, Polaroid prints, and old cameras. For this picture of Butterscotch Pots de Crème (page 139), I selected a little Eiffel Tower for a play on the French name.

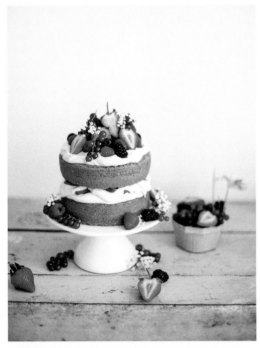

Initial test photo. It looks good, but I decided I wanted a bit more color and movement.

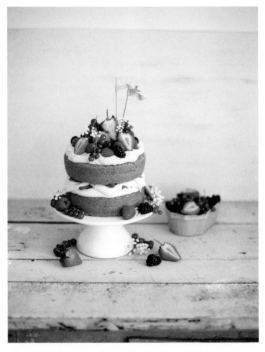

I've added pennants and tried a different background, but that didn't work at all.

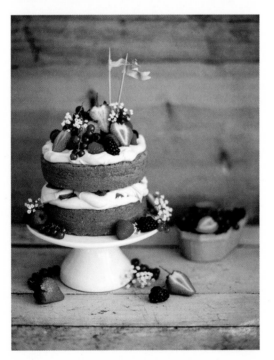

I tried a wood backdrop, but now the cake seems to melt into the background.

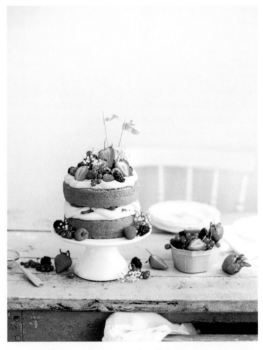

Now I think it looks good, with the chair and a couple of small plates in the background. I also like seeing more of the table.

[TAKING THE PHOTOGRAPH]

What really makes a photograph "good"? With practice—and passion and desire—you can improve your skills at both styling and photography. This also means practicing looking at photos. The best way to do that is to take a lot of photos.

It is a good idea to have basic knowledge about how your camera works. You do not need to have the most expensive or the latest model. These days you can take fantastic photos with just your smartphone. A more advanced camera gives you the advantage of being able to control the results better. It is easier to control where the focus lands, what the depth of field will be, and how light or dark it will be. Begin by reading the manual, and learn how to take photos manually by adjusting the ISO, shutter speed, f-stops (aperture size), and so on. Automatic settings do not always give the results you want.

Too many rather than too few pictures is better, preferably with different shutter speeds and f-stops as well as from different angles. Sometimes only a small adjustment is needed to get the perfect picture.

My Camera Equipment

I use a Canon EOS 5D Mark II (camera) for most of my photographs. It is almost always fitted with a Canon 50 mm f/1.4 lens that I've had for a few years and which I love. It is a medium-quality lens that I highly recommend.

It is a given that you'll need a memory card for your digital camera. Buy two or three cards so that you'll have them with you when you are out shooting and can't immediately transfer the photos to a computer.

It's nice to have a self-timer for when you might want to take a self-portrait. It can also be necessary for photographing a moment in the baking process (such as pouring caramel sauce over a cake).

A tripod is very helpful for avoiding blurry pictures when photographing in low light. During the fall and winter months here in Sweden, a tripod is pretty much a necessity for me. As a rule of thumb, I never take a handheld photo with a shutter speed longer than $1/125$ second, because the photo would be blurred even if I made sure to hold the camera steady.

Of course, all of this depends on what type of camera and lens you are using. It is so annoying when you open a day's worth of photos on the computer and they are all out of focus. A good tripod shouldn't cost more than thirty dollars or so.

I use an external hard drive to ensure that I have backups of all my photos. This is insurance in case everything goes wrong and my photos disappear. Photos are invaluable, and a unique shot cannot be re-created.

There are all kinds of filters that can be placed on a lens. I normally use UV filters, primarily to protect the lens. Cheap insurance!

Shutter Speed

Shutter speed determines how long the shutter remains open and therefore how long the light falls on the sensors in the camera. The longer the time, the lighter the picture.

F-Stops and Depth of Field

Even the f-stops can affect how much light is captured in the picture. F-stops can be described as the options for how open the lens is, known as its aperture. By adjusting the size of the aperture, you can also adjust how much light reaches the sensors.

The lower the stop number (for example, f/1.4 or f/5.6), usually listed after the focal length in the name of the lens, the larger the aperture and, generally, the more light sensitive the lens is. The stops also affect the depth of field in the picture, in other words, how much will be in focus in the photo. If, for example, you set the aperture at 1.4 (which

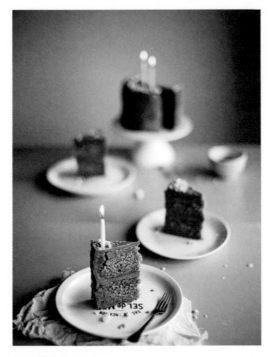

Stop f/1.4.

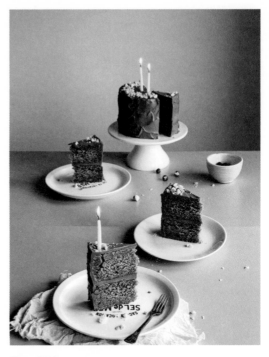

Stop f/11.

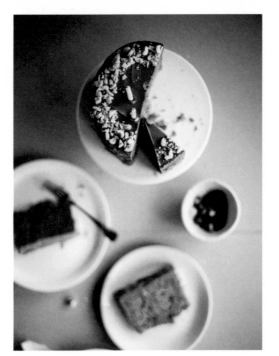

Stop f/1.4.

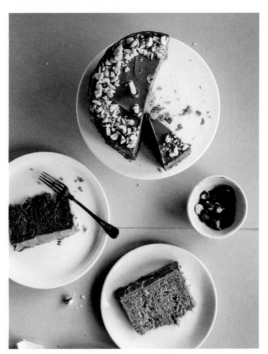

Stop f/11.

means that you need a lens that can open up to f/1.4), only whatever is at exactly the same distance as the object you are aiming at will be in focus. This is called a "short depth of field."

A short depth of field can be very effective if you want to focus on a particular detail in a picture. When, for example, I want to photograph from the side and have a busy background, I shoot with a short depth of field to obscure the busyness and focus only on the detail.

If you set the aperture at f/22, you will have a long depth of field. To take photos with a long depth of field, you'll need a longer shutter speed than when you shoot with a short depth of field in the same light conditions. A long depth of field is appropriate when you want to clearly show several items in a picture.

WHITE BALANCE

Have you sometimes taken photos inside your house at night and noticed how much yellow light is in the pictures? It is the "white balance" that determines that.

Most of the time, I take photos with the white balance on automatic because the camera adjusts it correctly, but sometimes you will have to make the adjustments yourself. The best method is to take the photos in the RAW file format so the white balance can be easily adjusted afterward in Photoshop, for example. One less detail to think about when shooting!

ISO

ISO is a way to measure light sensitivity on film. Even though we don't use film for digital photography, we still use ISO ratings.

Photograph with as low an ISO value as possible (100 is recommended). Sometimes you might need a higher ISO value, such as when it is dark and you don't have a tripod. The lower the ISO number, the less "noise" in the picture.

FLASH

As a rule, never use the automatic flash on your camera. The light will be flat and the food will look unappetizing. For that reason, I recommend that you always take pictures in daylight if possible.

CLOSE-UPS

Close-ups are appropriate sometimes, but not always. Keep in mind that you need to see what the picture represents and that the food should look appetizing.

For close-ups and many other situations, I use a Canon 100 mm f/2.8 lens, which produces fantastically sharp pictures.

ANALOG VERSUS DIGITAL

When I started in photography, I still used film (analog), but now that seems like a lost art. Although I really like analog photography, today the best choice is clearly to use a digital camera.

[LIGHT SETTINGS]

Working with natural light, as I do, means that not only do you have to learn how to feel and see the light, but you also have to learn how to control the light you are working with. It is obviously best to work during the hours when the light is at its peak, but if you don't have that option, you can simplify matters by learning a few tricks.

LIGHT

There are quite a number of factors to consider when setting the light for a picture: weather, direction of the sun, time of day, season, and so on.

Sometimes when I am photographing and the diffuse light is absolutely perfect, the sun suddenly comes out. Those are the few times when I might curse the fine weather!

I think it is best to take photos in daylight filtered through a window. Choose a room or a window where you think the light is good and take your photos there. If you have a north-facing window, congratulations! That means that part of the room has indirect natural light and you have the best setup for taking pictures.

Unfortunately, I do not have a north-facing window, so I usually take photos in my living room, which has a large window facing west. It is wonderful to take photos there in the fall and winter, but on a beautiful summer day with bright sunshine, I have to stop the photo session at about 2:30 P.M. On summer evenings, I use an east-facing window for taking pictures.

WHERE IS THE LIGHT COMING FROM?

Another aspect to experiment with is deciding from which direction the light should come. Light shining directly on the item to be photographed can look flat, but it can be advantageous in some situations. Light from the sides adds more depth to a photo, while backlighting can be quite interesting sometimes. Most often, I use side lighting.

Try to avoid taking photos with bright sunlight shining directly on the object. Usually bright light is harsh and creates sharp contrasts. In general, you should not take photos when the sun is shining directly into a room. Hanging a sheer white curtain or a length of fabric over the window softens harsh light considerably.

SHADOWS

When photographing with backlighting, you might need some light shadows supplied by a reflector board, or just use a large piece of white fabric, Styrofoam, or foam board.

OUTDOOR PHOTOGRAPHY

Photographing outdoors allows for even and effective light. Try taking photos in the shade, however, because direct sun creates harsh contrasts, just as it does indoors. When I want to do outdoor photos quickly and easily, I simply work on my balcony, which has a nice concrete floor.

DARK OR LIGHT PICTURES

"Dark" and "light" do not refer only to how the picture is exposed but to how everything looks in the photo, from the background and props to the mood conveyed. When I am taking dark photos, I usually underexpose (according to the camera's light measurements), and when I want light pictures, I generally overexpose a little. You have to experiment with your own camera.

When I am taking dark photos, I want the object in focus to be relatively light and clearly visible even when the overall picture is dark. My living room has two small and one large window, side by side. When I am taking dark photos, I lower the blinds in the large window and one of the small windows so the only source of light is the second small window. This allows me to concentrate the light that I think works best for dark pictures. This method needs a longer shutter speed and, therefore, a tripod.

Various baked goods require various photo angles. It is a good idea to photograph cakes from the side to emphasize their height, decorations, and overall presence.

Freshly baked cookies on a platter are lovely when photographed from directly above. If you want to photograph cookies from the side, try piling several next to a glass of milk.

Train your eye: experiment by taking photos of your baking from every imaginable angle and see which you like best.

To emphasize the pretty piping on these cupcakes, I photographed them from above.

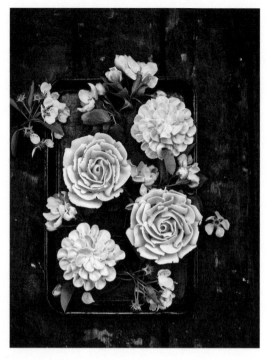

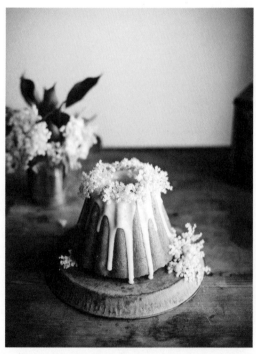

I decided to photograph this cake from the side at a rather high angle. I wanted to show how the glaze was running down the side and also focus on the flowers and the hole at the top of the sugar cake.

To emphasize the height of the cake and the caramel sauce running down it, I decided to take this photo from the side.

[PHOTO EDITING]

To me, photo editing is almost always necessary. I edit my pictures after shooting, even if just to tweak simple things, such as adjusting the white balance, exposure, contrast, and color depth.

I work with Photoshop because it is the program I learned first. There are other good programs, such as Lightroom. If you photograph in the RAW format, the digital photos will have a lot more information than JPEG files, and so they can be adjusted more extensively later on, if the picture is under- or overexposed, for example. If you aren't familiar with RAW, the photos may at first seem a little flat and uninteresting, but that is why editing is necessary.

This picture was taken in my living room on a sunny spring day. The sun began shining in the room, and so the photo has a yellow tone even though the white balance was on automatic.

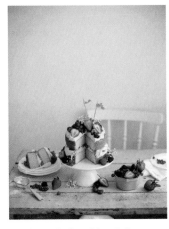

I adjusted the white balance. In order to eliminate the yellow in the picture, blue was needed for balance.

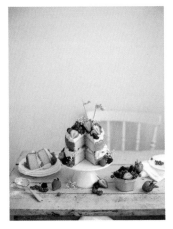

The previous photo was a little dark and so I lightened it a bit.

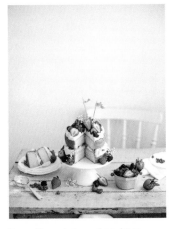

Here the picture has been lightened even more and I added extra contrast and color depth to bring out more color from the berries. Nailed it!

[RESOURCES]

BAKING PANS AND OTHER EQUIPMENT
www.bagarenochkocken.se
www.kakburken.se
www.kalasform.se
www.klaraform.se
www.lyckasmedmat.se
www.nordicware.com
www.tartdecor.se
www.williams-sonoma.com
www.wilton.com

VINTAGE PROPS

www.ebay.com
Ebay is one of the best places to find vintage props and beautiful old objects.

You can find everything there, from old platters to silverware to fabric, and everything is more or less fantastic.

You can often find objects at a very good price, whether a set price or at auction.

Don't forget that both postage and customs will be added to anything you order from overseas, which could make the purchase rather expensive. Most sellers recommend that you contact them before you make a bid so they can calculate the postage costs.

Tips for search words: old baking pan, vintage cake pan, vintage baking sheet, vintage pie pan

www.etsy.com
Etsy works about the same way as ebay, but the sellers usually list set prices for their offerings. Items on Etsy might be a little more picked over, but you can find most things there. Just as for buying on ebay, contact the seller concerning postage before you place an order.

Tips for search words: the same as for ebay

NUTS AND CARAMEL

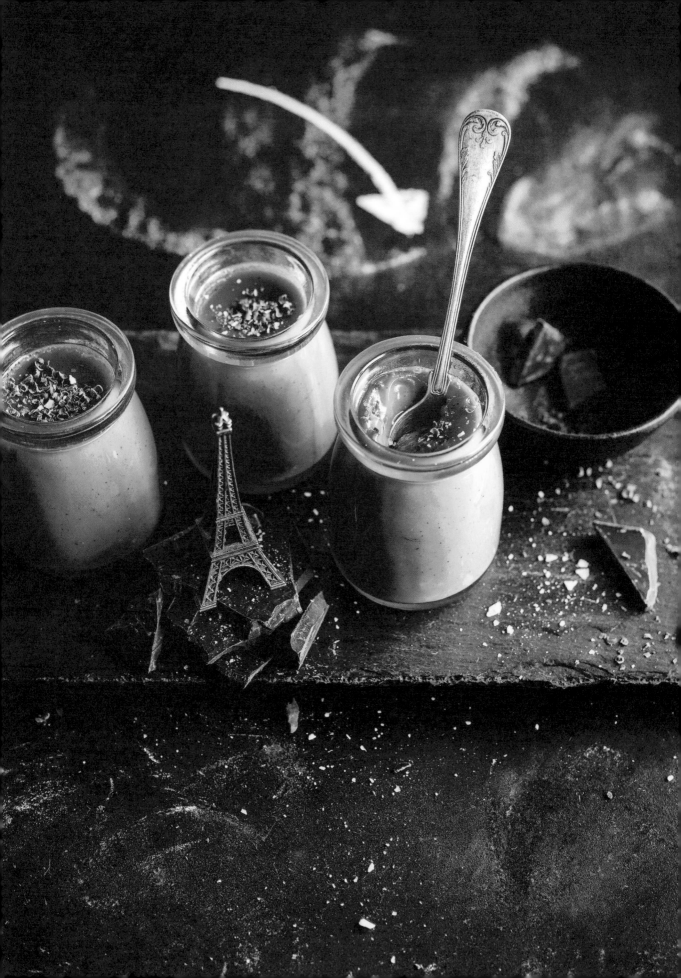

BUTTERSCOTCH POTS DE CRÈME

These pretty little cream puddings loaded with the flavor of caramelized sugar are perfect for serving many guests at a buffet.

3 cups whipping cream

1 vanilla bean

Pinch of salt

8 egg yolks

¾ cup light Muscovado sugar (firmly packed in the measuring cup)

4 tablespoons salted butter

1 tablespoon whisky (optional)

2 tablespoons grated dark chocolate, for garnish (70% cocoa)

1. Preheat the oven to 300°F.
2. Pour 2¼ cups of the cream into a saucepan. Slice the vanilla bean lengthwise and add it to the saucepan. Add the salt. Carefully warm the mixture over low heat until hot, 5 to 8 minutes. Do not allow it to boil.
3. Lightly beat the egg yolks in a medium bowl and set aside.
4. Put the Muscovado sugar and butter into a deep, heavy-bottomed saucepan and heat until the sugar begins to melt, then stir until all the sugar has melted and the mixture is smooth. At the moment when the mixture begins to bubble up (make sure the sugar doesn't burn), slowly add the cream mixture. Be careful—the mixture can boil furiously and spill over! Stir until the caramel is smooth and remove from the heat.
5. Drizzle some of the caramel in a thin stream over the egg yolks and whisk it in. Pour the egg mixture back into the saucepan with the rest of the caramel. Add the whisky, if you like, and then press the caramel through a sieve into a bowl.
6. Bring a kettle of water to a boil.
7. Arrange 8 to 10 serving-size jars (⅓ cup each) in a large baking pan. Divide the caramel among the jars. Pull the oven rack partway out and put the pan with the filled jars on it, then pour boiling water in the large pan. The water should cover the jars halfway up the sides. Cover the entire large pan with aluminum foil.
8. Bake for 45 to 50 minutes, until the pudding is firm and no longer wobbly in the center. Carefully lift each jar out of the hot water and place on a wire rack to cool. Store in the refrigerator until cold.
9. Fifteen minutes before you are ready to serve the pots de crème, take them out of the refrigerator. Sprinkle the dark chocolate over each pudding. In a medium bowl, lightly whip the remaining ¾ cup cream and serve with the pots de crème, on top or on the side.

CARAMEL MACADAMIA TART

Nuts and caramel are ever the best of friends. Sweet meets salt in this substantial tart that offers a little something extra for every dessert lover.

PIE CRUST

1¼ cups all-purpose flour

⅓ cup cocoa powder

¼ teaspoon salt

12 tablespoons salted butter, at room temperature

⅔ cup confectioners' sugar

2 egg yolks

CARAMEL CREAM

3 ounces dry-roasted and salted macadamia nuts

¼ cup + 2 tablespoons whipping cream

1 teaspoon vanilla extract, or ¼ teaspoon vanilla powder

1¼ cups granulated sugar

7 tablespoons unsalted butter

¼ teaspoon salt

CHOCOLATE GANACHE

3½ ounces dark chocolate (70% cocoa)

¼ cup whipping cream

CARAMELIZED NUTS

2 tablespoons dry-roasted and salted macadamia nuts

¼ cup + 2 tablespoons granulated sugar

1 teaspoon flaky salt

MAKING THE PIE CRUST

1. Preheat the oven to 350°F. Butter a 9-inch tart pan.
2. Mix the flour, cocoa, and salt in a medium bowl.
3. In a large bowl, beat the butter and sugar until light and creamy. Add the egg yolks and beat a little more. Sift the dry ingredients over the butter mixture and stir until evenly incorporated.
4. Press the dough into the bottom and sides of the prepared tart pan. Prick the bottom with a fork. Place the pan in the freezer for 10 minutes and then bake for 20 minutes. Let cool.

MAKING THE CARAMEL CREAM

1. Chop the macadamia nuts.
2. Pour the cream and vanilla into a saucepan and carefully warm over low heat until hot. Do not let the mixture boil. Cover with a lid and set aside.
3. Pour the sugar into a separate saucepan and warm over medium heat until the sugar begins to melt around the edges. Carefully stir until the sugar is golden brown and completely melted. The sugar should heat to about 350°F on a kitchen thermometer.
4. Add the butter and stir until the butter melts. Slowly add the cream mixture, stirring constantly. Be careful—the mixture can begin to boil furiously and spill over! Keep stirring until the mixture is smooth. Add the salt and the chopped macadamia nuts. Pour the caramel cream into the baked pie crust and let cool at room temperature for 1 to 2 hours, until the caramel cream is somewhat firm.

MAKING THE CHOCOLATE GANACHE

1. Finely chop the chocolate and put it in a small heatproof bowl.
2. Heat the cream in a saucepan, but do not let it boil. Pour the cream over the choc-

olate and let it sit for about 30 seconds. Stir until the chocolate has melted and is a shiny cream.

3. Let the mixture cool to room temperature, then pour it over the cooled caramel layer. Leave at room temperature to firm up, 30 to 60 minutes.

Making the Caramelized Nuts

1. Line a baking sheet with parchment paper. Chop the macadamia nuts.

2. Pour the sugar into a saucepan and warm over medium heat until the sugar begins to melt around the edges. Carefully stir the hot sugar until it has completely melted and is golden brown. Add the chopped macadamia nuts and quickly pour the mixture onto the parchment paper in as thin a layer as possible. Let cool completely.

3. Chop the caramelized nuts into small pieces and sprinkle over the tart. Finish by sprinkling the tart with flaky salt.

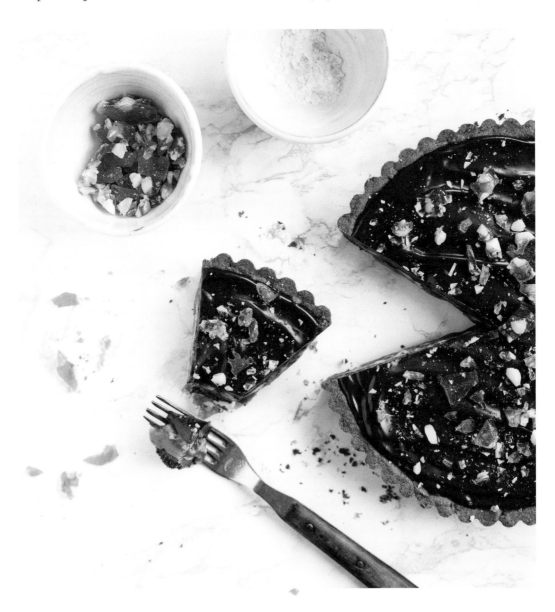

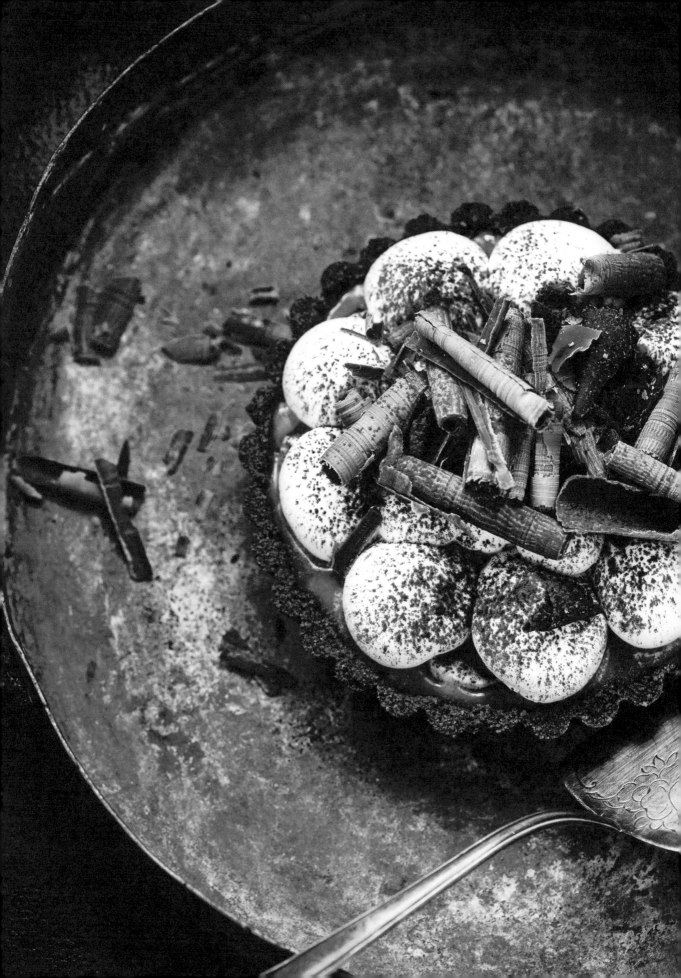

BANOFFEE PIE
(BANANA AND CARAMEL CREAM PIE)

This banana caramel dream originated in Great Britain in the 1970s. Make two small pies, as in the recipe, or one big pie.

CARAMEL CREAM

½ cup whipping cream

1 teaspoon vanilla extract, or ¼ teaspoon vanilla powder

¼ cup granulated sugar

5½ tablespoons cold salted butter, diced

1 teaspoon flaky salt

PIE CRUST

5½ tablespoons salted butter

5¼ ounces graham crackers or digestive biscuits

2 tablespoons cocoa powder

2–3 bananas

¼ cup + 2 tablespoons whipping cream

Cocoa powder, for garnish

1¼ ounces shaved milk chocolate, for garnish (see page 88)

MAKING THE CARAMEL CREAM

1. Warm the cream and vanilla in a saucepan over low heat, until hot. Do not let the mixture boil. Cover with a lid and set aside.
2. Put the sugar in another saucepan and warm over medium heat until it begins to melt around the edges. Carefully stir the hot sugar until golden brown and completely melted. The sugar should heat to about 350°F on a kitchen thermometer.
3. Add the butter and stir until it has melted. Slowly add the warm cream, stirring continuously. Be careful—the mixture can boil furiously and spill over! Add the salt and stir until the mixture is smooth. Pour into a clean jar and let the caramel cream cool at room temperature.

MAKING THE PIE CRUST

1. Melt the butter.
2. Pulse the graham crackers into fine crumbs in a food processor. Add the cocoa and the melted butter and pulse to combine.
3. Press the dough into the bottom and sides of two 5½-inch tart pans with removable bottoms. Refrigerate for 30 to 60 minutes.

ASSEMBLING THE PIE

1. Take the pie crust out of the refrigerator and pour the caramel cream evenly between the two pie shells. Refrigerate for 20 to 30 minutes, until the caramel cream has set.
2. Slice the bananas and divide the slices in a single layer evenly between the pies. Whip the cream in a medium bowl. Fit a pastry bag with a round tip and pipe the whipped cream on top of the pies. Sift cocoa over the pies and then decorate with the shaved chocolate.

PULL-APART CINNAMON BREAD
WITH BROWN BUTTER FILLING

This bread is a close, delicious cousin to swirly cinnamon buns. The recipe calls for the same basic dough as for Monkey Bread (page 146), so enjoy experimenting with variations on a theme. If you don't have fresh yeast, you can use 1 tablespoon dry yeast whisked with ¼ cup lukewarm water and add 3 tablespoons flour to the dough to offset the extra liquid.

DOUGH

2 tablespoons fresh yeast

1 cup milk

1 teaspoon ground cardamom seeds

¼ cup granulated sugar

5½ tablespoons salted butter, at room temperature

½ teaspoon salt

3 cups all-purpose flour

BROWN BUTTER FILLING

7 tablespoons unsalted butter

¼ cup + 2 tablespoons granulated sugar

1 tablespoon ground cinnamon

MAKING THE DOUGH

1. Crumble the yeast into a large bowl.
2. Heat the milk and cardamom in a saucepan over low heat until lukewarm. Pour a little of the warm spiced milk over the yeast and whisk until the yeast dissolves. Add the rest of the spiced milk to the bowl.
3. Add the sugar and butter and beat until fully incorporated. Add the salt and flour a little at a time and turn out onto a floured work surface. Knead until the dough is smooth, 5 to 10 minutes.
4. Return the dough to the bowl and cover with plastic wrap. Let rise in a warm place for about 1 hour.

MAKING THE BROWN BUTTER FILLING

1. Melt the butter in a saucepan over medium heat. Simmer, stirring occasionally, until the butter is golden brown and smells nutty. Turn off the heat and let the butter cool until firm. The butter should begin to firm up but still be somewhat soft. If you want to speed up the cooling, pour the butter into a bowl and refrigerate.
2. In a medium bowl, beat the cooled butter with the sugar and cinnamon until creamy.

ASSEMBLING AND BAKING THE BREAD

1. Generously butter the inside of a long bread pan.
2. When the dough has risen, turn it out onto a lightly floured work surface. Roll the dough out to a rectangle, approximately 18 x 12 inches, making the edges as straight as possible.
3. Spread the filling over the dough in an even layer.
4. Cut the dough into 6 strips (about 3 x 12 inches each). Stack the strips and cut into six 2 x 3-inch rectangles. You should have 6 small piles with 6 rectangles in each. Stand the piles on their sides in the pan, so that the piles join into one long, sideways stack. Separate the layers a little

with your fingers. Cover the pan with a clean kitchen towel and let the bread rise for 45 minutes.

5. Preheat the oven to 350°F. Bake the bread in the lower part of the oven for 35 to 40 minutes, until it has a nice brown color. Check on it after 15 minutes to make sure the bread is not turning dark already. If it is, cover the loaf with parchment paper or aluminum foil.

6. Remove the bread from the oven and let cool completely in the pan. Serve by pulling apart the bread.

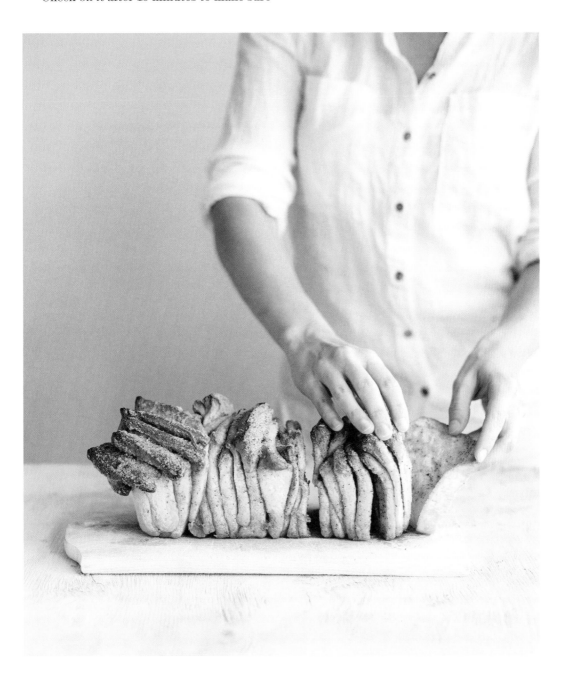

MONKEY BREAD

Also called bubble bread or cinnamon cluster, monkey bread is a great American treat that we love here in Sweden too. You can tear off as many bites as you want to eat. If you don't have fresh yeast, you can use 1 tablespoon dry yeast whisked with ¼ cup lukewarm water and add 3 tablespoons flour to the dough to offset the extra liquid.

DOUGH

2 tablespoons fresh yeast

1 cup milk

1 teaspoon ground cardamom seeds

¼ cup granulated sugar

5½ tablespoons salted butter, at room temperature

½ teaspoon salt

3 cups all-purpose flour

FILLING

12 tablespoons salted butter (you might need less)

¾ cup light Muscovado sugar (firmly packed in the measuring cup)

1 tablespoon ground cinnamon

MAKING THE DOUGH

1. Crumble the yeast into a large bowl.
2. Heat the milk and cardamom in a saucepan over low heat until lukewarm. Pour a little of the warm spiced milk over the yeast and whisk until the yeast dissolves. Add the rest of the spiced milk to the bowl.
3. Add the sugar and butter and beat until fully incorporated. Add the salt and then the flour a little at a time and turn out onto a floured work surface. Knead until the dough is smooth, 5 to 10 minutes.

4. Return the dough to the bowl and cover with plastic wrap. Let rise in a warm place for about 1 hour.

MAKING THE FILLING

1. Melt the butter and let it cool slightly.
2. Mix the sugar and cinnamon together in a small bowl.

ASSEMBLING AND BAKING THE BREAD

1. Butter a large Bundt pan. Roll out the dough to a rectangle approximately 16 x 20 inches. Cut the dough into small squares, approximately 1½ x 2 inches (a pizza cutter works well for this). You should have about 70 to 90 squares, but the exact number isn't important.
2. Roll each square into a ball, dip it in the melted butter, and then roll it in the cinnamon-sugar mixture. One at a time, place the balls side by side in the prepared pan; complete each layer before beginning the next layer.
3. Cover the pan with plastic wrap and let the dough rise for 1 to 1½ hours.
4. Preheat the oven to 350°F and bake the bread for 30 to 35 minutes, until browned.

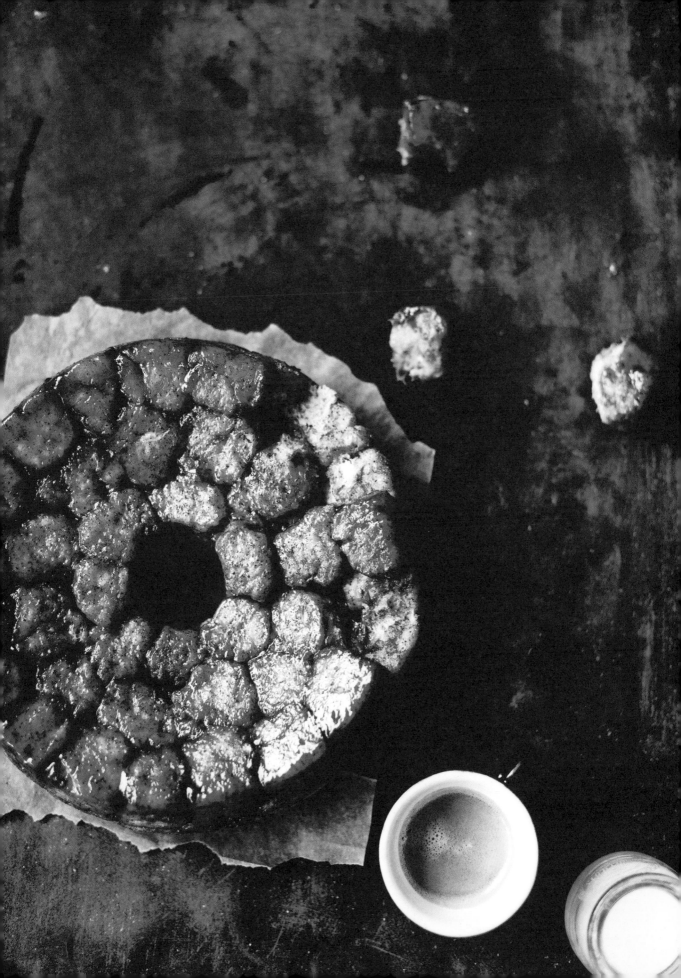

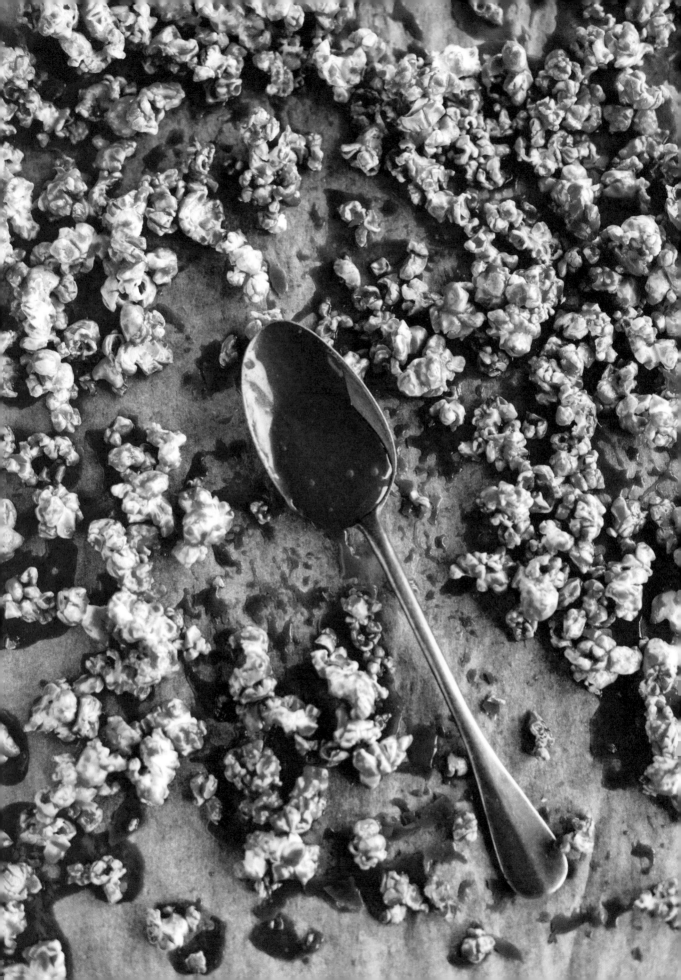

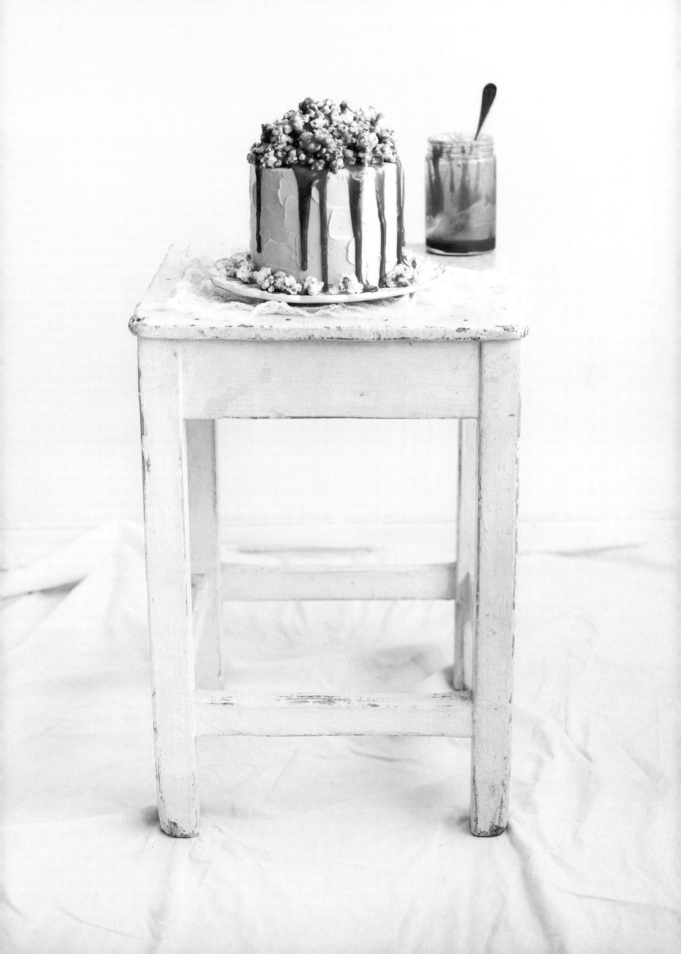

CHOCOLATE CAKE TOPPED
WITH **CARAMEL POPCORN**

Crunchy caramel popcorn is one of my favorite snacks, preferably combined with chocolate. Your only challenge will be not to eat all the popcorn before you garnish the cake.

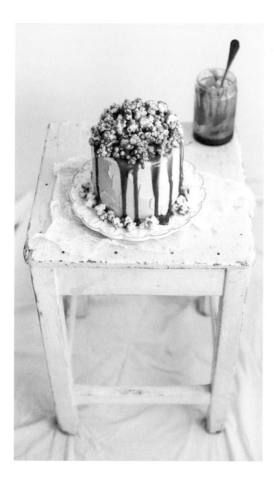

CAKE LAYERS

5½ tablespoons salted butter
2 cups all-purpose flour
⅔ cup cocoa powder
1½ teaspoons baking powder
1½ teaspoons baking soda
1⅔ cups granulated sugar
Pinch of salt
2 eggs
¾ cup + 1 tablespoon milk
⅔ cup strong hot coffee or boiling water

CARAMEL CREAM

⅔ cup whipping cream
1 cup granulated sugar
7 tablespoons cold unsalted butter, diced
½ teaspoon flaky salt

CARAMEL SWISS MERINGUE BUTTERCREAM

4 egg whites
¾ cup granulated sugar
18 tablespoons (2 sticks + 2 tablespoons)
 salted butter, at room temperature
¼ cup + 2 tablespoons Caramel Cream (see above)

CRISPY CARAMEL POPCORN

6 to 7 cups popped popcorn
¼ cup + 2 tablespoons Caramel Cream (see above)

MAKING THE CAKE LAYERS

1. Preheat the oven to 350°F. Butter and flour two 8-inch cake pans. (Use two 6-inch cake pans for a sky-high variation.)
2. Melt the butter and let it cool slightly.
3. Sift the flour, cocoa, baking powder, baking soda, sugar, and salt into a large bowl. Add the eggs, milk, coffee, and melted and cooled butter and beat until the batter is smooth, about 2 minutes.
4. Divide the batter evenly between the prepared pans. Bake in the lower part of the oven for 40 to 45 minutes, until a toothpick inserted into the center comes out with moist crumbs. Let the layers cool in the pans for a while and then turn out onto wire cooling racks to cool completely.

MAKING THE CARAMEL CREAM

1. Carefully warm the cream in a saucepan over low heat. Do not boil. Cover with a lid and set aside.
2. Heat the sugar in a separate saucepan over medium heat until the sugar begins to melt around the edges. Stir until the sugar is golden brown and completely melted, taking care that it does not boil over. The sugar should heat to about 350°F on a kitchen thermometer.
3. Add the butter and turn the heat to low. Be careful: it may sputter and bubble. Stir the mixture until the butter melts. Slowly add the warm cream, a little at time, and stir until the mixture is completely smooth. Stir in the salt.
4. Pour the hot caramel cream into a clean jar and let cool at room temperature while you prepare the frosting.

MAKING THE CARAMEL MERINGUE FROSTING

1. Pour boiling water into a saucepan or the bottom of a double boiler and simmer over low heat. Put the egg whites and sugar into a heatproof bowl or saucepan and place over the simmering water in the bottom pan. Using a hand whisk, beat the mixture until it reaches 150°F, or until all the sugar crystals have dissolved. Pour the mixture into a large bowl and beat with an electric mixer until it develops into a white and fluffy meringue. Continue beating until the meringue is cool, about 10 minutes total.
2. Add the butter a little at a time, beating after each addition. When all the butter has been incorporated, beat for another 3 to 5 minutes, until the frosting coheres. Add $\frac{1}{4}$ cup plus 2 tablespoons of the cooled caramel cream and beat until the frosting is smooth and even.

MAKING THE CRISPY CARAMEL POPCORN

1. Preheat the oven to 300°F. Line a baking sheet with parchment paper.
2. In a large bowl, stir together the popcorn and $\frac{1}{4}$ cup plus 2 tablespoons of the cooled caramel cream until the popcorn is coated. Spread the coated popcorn out on the prepared baking sheet. Bake the popcorn in the center of the oven, stirring occasionally, for about 15 minutes, until crispy. Remove the pan from the oven and let cool.

ASSEMBLING THE CAKE

1. Slice each cake layer in half horizontally so you have four thin layers.
2. Place one of the cake layers on a cake plate. Spread an even layer of caramel meringue frosting over the layer. Stack and cover the next two layers the same way.
3. Place the last layer on top with the cut side down. Spread a thin layer of frosting over the entire cake. Refrigerate the cake for about 20 minutes, until the outer layer of the frosting has firmed up slightly.
4. Spread another layer of frosting over the entire cake and smooth it all around.
5. Pile the popcorn on top of the cake and pour the remaining caramel cream over it. If the caramel cream has cooled too much to pour, warm it a bit first.

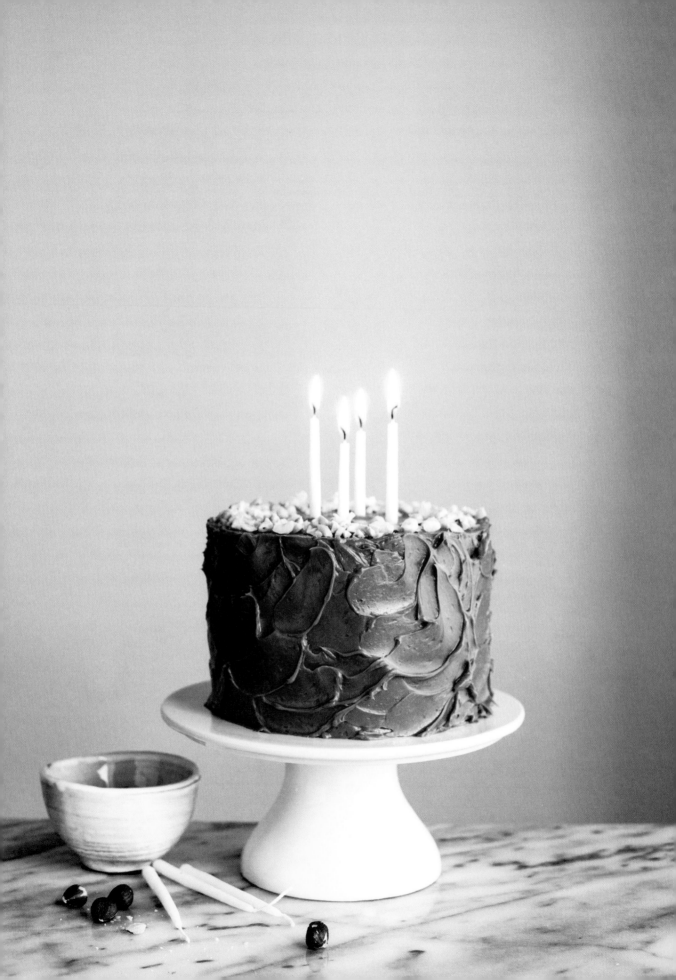

HAZELNUT CAKE
WITH ESPRESSO AND NUTELLA

A sky-high cake of toasted hazelnuts paired with buttercream and espresso. You can make your own hazelnut flour by toasting, skinning, and grinding the hazelnuts, if you'd like.

CAKE LAYERS

2¼ cups store-bought hazelnut flour or toasted, finely ground hazelnuts

1 cup all-purpose flour

1 tablespoon + 1½ teaspoons baking powder

Pinch of salt

9 tablespoons salted butter, at room temperature

¾ cup granulated sugar

3 eggs

½ cup espresso or strong coffee

½ cup milk

2 tablespoons hazelnut liqueur, such as Frangelico (optional)

FROSTING

14 tablespoons salted butter, at room temperature

¼ cup + 2 tablespoons Nutella

¼ cup + 2 tablespoons confectioners' sugar

2 tablespoons espresso or strong coffee

1¾ ounces whole hazelnuts, toasted and peeled (page 40), for garnish

MAKING THE CAKE LAYERS

1. Preheat the oven to 350°F. Butter and flour two 6-inch cake pans.
2. Mix the hazelnut flour, all-purpose flour, baking powder, and salt in a medium bowl.
3. In a large bowl, beat the butter and sugar until light and creamy. Add the eggs, one at a time, beating thoroughly after each addition.
4. In a spouted bowl, whisk together the espresso, milk, and hazelnut liqueur.
5. Alternate adding some of the dry ingredients and some of the espresso mixture to the egg mixture, beating after each addition, until all ingredients have been incorporated. Beat the batter until smooth.
6. Divide the batter evenly between the two cake pans. Bake in the lower part of the oven for 35 to 40 minutes, until a toothpick inserted into the center comes out with moist crumbs. Let the layers cool in the pans for a while and then turn out onto wire cooling racks to cool completely.

MAKING THE FROSTING

In a large bowl, beat the butter, Nutella, confectioners' sugar, and espresso until shiny and creamy.

ASSEMBLING THE CAKE

1. Place one of the cake layers on a cake plate. Cover with one-third of the frosting and add the other cake layer. Spread or pipe the rest of the frosting on top of the cake, or spread a thin layer over the entire cake.
2. Chop the hazelnuts and sprinkle over the top of the cake.

NUTS AND CARAMEL

153

PEANUT BUTTER CUPCAKES

Peanut butter and chocolate are a classic, wonderfully tasty combination. You can decorate these cupcakes with chopped peanut butter cups or milk chocolate for extra indulgence.

CUPCAKES

1¼ cups all-purpose flour

¼ cup + 2 tablespoons cocoa powder

1 teaspoon baking soda

1 teaspoon baking powder

1 cup granulated sugar

5½ tablespoons salted butter

1 egg

1 teaspoon vanilla extract, or ¼ teaspoon vanilla powder

¼ cup + 2 tablespoons boiling water

⅔ cup milk

PEANUT BUTTER FROSTING

14 tablespoons salted butter, at room temperature

1¼ cups confectioners' sugar

1¼ cups peanut butter

7 ounces cream cheese, at room temperature

6 large peanut butter cups, or about 1¼ ounces milk chocolate, for garnish

MAKING THE CUPCAKES

1. Preheat the oven to 350°F. Line a muffin tin with 12 paper cupcake liners.
2. Mix the flour, cocoa, baking soda, baking powder, and sugar in a medium bowl. Melt the butter.
3. In a large bowl, lightly beat the egg and then beat in the melted butter, vanilla, boiling water, and milk. Sift the dry ingredients over the milk mixture and beat until the batter is smooth.
4. Spoon the batter into the prepared muffin tin, but do not fill the cups more than two-thirds full.
5. Bake for 17 to 20 minutes, until a toothpick inserted into the center comes out with moist crumbs. Remove the muffin tins from oven and let cool on a wire cooling rack.

MAKING THE PEANUT BUTTER FROSTING

In a large bowl, beat the butter until light and creamy. Add the confectioners' sugar and beat a little more. Add the peanut butter and cream cheese and beat until smooth.

DECORATING THE CUPCAKES

Remove the cooled cupcakes from the muffin tin. Fit a pastry bag with your choice of tip and fill with the frosting. Pipe the frosting onto the cupcakes. Sprinkle with chopped peanut butter cups.

PEANUT BUTTER CHEESECAKE

Creamy cheesecake with peanut butter is not your everyday cheesecake! The cheesecake filling is covered with a creamy layer of milk chocolate cream.

PIE CRUST

5¼ ounces chocolate sandwich cookies

3¼ ounces roasted and salted peanuts

2 tablespoons salted butter

CHEESECAKE FILLING

24 ounces cream cheese, at room temperature

1 cup peanut butter

⅔ cup light Muscovado sugar (firmly packed in the measuring cup)

⅔ cup granulated sugar

1 teaspoon vanilla extract, or ¼ teaspoon vanilla powder

3 eggs

¾ cup whipping cream

CHOCOLATE CREAM

5¼ ounces milk chocolate (50% cocoa)

⅔ cup whipping cream

¼ cup peanut butter

2 tablespoons salted butter

¼ cup + 2 tablespoons sour cream, at room temperature

1 ounce roasted and salted peanuts, for garnish

6 large peanut butter cups, or approximately 1¼ ounces milk chocolate, for garnish

MAKING THE PIE CRUST

1. Preheat the oven to 350°F. Line the bottom of a 9½-inch pie pan or springform pan, 2 inches deep, with parchment paper.
2. Pulse the cookies and peanuts in a food processor until they form fine crumbs.
3. Melt the butter and pour it over the crumbs. Pulse briefly to combine. Press the mixture onto the bottom of the pan and a little up the sides.
4. Bake for 10 minutes. Remove from the oven and let cool.

MAKING THE CHEESECAKE FILLING

1. Lower the oven heat to 300°F.
2. In a large bowl, beat the cream cheese and peanut butter until creamy. Add the Muscovado sugar, granulated sugar, and vanilla and beat a little more. Add the eggs one at a time, beating thoroughly after each addition. Stir in the cream.
3. Pour the batter into the prebaked pie shell and bake in the lower part of the oven for 55 to 70 minutes, until the edges of the filling are set but the center is still wobbly. Turn off the oven and set the oven door ajar. Let the cheesecake cool in the oven for 20 minutes or so.
4. Remove the cheesecake from the oven. Let it cool to room temperature and then refrigerate for at least 4 hours.

MAKING THE CHOCOLATE CREAM

1. Once the cheesecake is completely chilled, finely chop the chocolate and pour into a heatproof bowl.
2. Heat the cream, peanut butter, and butter in a saucepan over medium to medium-high heat until the mixture begins to bubble, stirring occasionally. Pour the hot cream mixture over the chocolate and let sit for 30 seconds. Stir until smooth.
3. Let the mixture cool slightly, then stir in the sour cream. Let cool at room temperature until the chocolate cream is spreadable.

FINISHING THE CHEESECAKE

Spread the chocolate cream on the cheesecake. Chop the peanuts and peanut butter cups and sprinkle on top of the cake. Serve immediately or refrigerate again after putting on the topping.

CHOCOLATE PAVLOVA WITH MALTED MILK BALLS, TOFFEE CRUNCH, AND PECANS

This fantastic pavlova delivers every time. I go totally weak when faced with the combination of meringue, chocolate, and cream. Nothing beats it.

CHOCOLATE MERINGUE LAYERS

1¾ ounces dark chocolate (70% cocoa)

6 egg whites

1¼ cups granulated sugar

3 tablespoons cocoa

1 tablespoon cornstarch

1 teaspoon white vinegar

MASCARPONE FILLING

8 ounces mascarpone

2–3 tablespoons granulated sugar

2¼ cups whipping cream

2 tablespoons espresso or strong coffee

COFFEE-CHOCOLATE SAUCE

⅓ cup granulated sugar

¼ cup + 2 tablespoons espresso or strong coffee

3 tablespoons cocoa

1¾ ounces chopped malted milk balls

1¾ ounces chopped crunchy chocolate-toffee candy bar

1¾ ounces toasted, chopped pecans

MAKING THE CHOCOLATE MERINGUE LAYERS

1. Preheat the oven to 350°F. Cut a piece of parchment paper the size of your baking sheet. Draw two circles, 6 inches in diameter, as far apart as possible without coming too close to the edge. Turn the paper upside down and lay it on the baking sheet.
2. Chop the chocolate and melt in the top of a double boiler with simmering water in the bottom pot. Let cool slightly.
3. In a large bowl, whip the egg whites to a soft foam. Add the sugar a little at a time and continue beating until the meringue is firm. You should be able to tip the bowl without the meringue's sliding out.
4. Sift the cocoa and cornstarch over the meringue. Add the vinegar and beat until smooth. Fold in the melted chocolate with a few strokes.
5. Spoon the meringue onto the two circles on the parchment, dividing it evenly between them. Keep in mind that the meringue will spread out as it bakes. Put the baking sheet into the oven and reduce the heat to 255°F. Bake the meringue layers for $1\frac{1}{4}$ to $1\frac{3}{4}$ hours, until they are hard and crispy around the edges but still sticky in the center. Turn off the oven and set the door ajar. Leave the meringue in the oven to cool completely.

MAKING THE MASCARPONE FILLING

In a large bowl, whip the mascarpone with the sugar until creamy. Pour in the whipping cream and beat. When adding the cream the mixture can liquefy, but continue beating until it thickens. Add the espresso and beat briefly to incorporate.

MAKING THE COFFEE-CHOCOLATE SAUCE

Whisk together the sugar, espresso, and cocoa in a saucepan over high heat. Bring to a boil, then lower the heat and simmer for 3 to 5 minutes, until the sauce has thickened slightly. Remove from the heat and let cool.

ASSEMBLING THE PAVLOVA

1. Carefully place one meringue layer on a cake plate and spread half of the mascarpone filling over it. Sprinkle with half of the chopped malted milk balls, toffee bar, and pecans.
2. Add the other meringue layer and spread the rest of the mascarpone filling over it. Decorate with the remaining chopped malted milk balls, toffee bar, and pecans. Drizzle the coffee-chocolate sauce over the the top. Refrigerate the pavlova for several hours before serving. It is best eaten the same day.

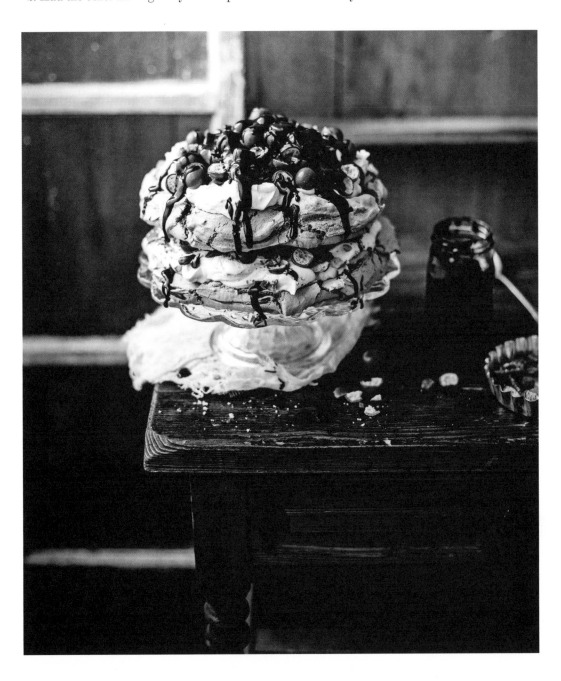

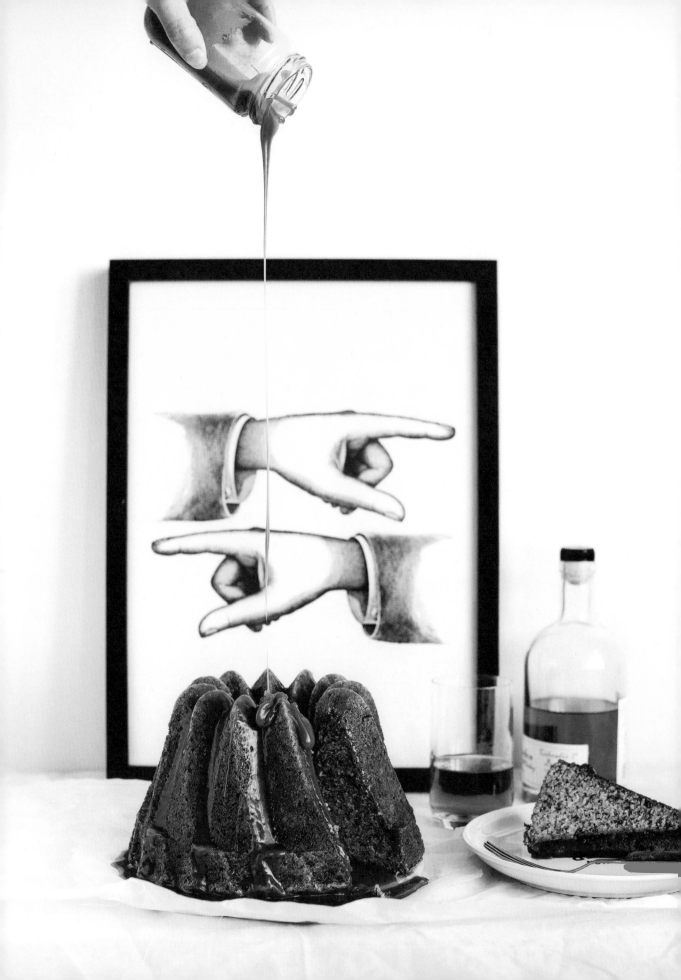

BANANA CAKE
WITH WARM BOURBON SAUCE

This fantastically tasty and moist cake with warm bourbon sauce is made better only by a scoop of vanilla ice cream. It's the perfect way to use up those overripe bananas that no one wants to eat. Cover the cake with plastic wrap and leave overnight before pouring the sauce over it so the flavors have time to develop.

BANANA CAKE

3 cups all-purpose flour

2 teaspoons baking soda

½ teaspoon salt

16 tablespoons (2 sticks) salted butter, at room temperature

2 cups granulated sugar

2 eggs

1 cup sour cream

4 very ripe bananas (21–23 ounces)

BOURBON SAUCE

⅔ cup light Muscovado sugar (firmly packed in the measuring cup)

4 tablespoons salted butter

¼ cup + 2 tablespoons whipping cream

½ teaspoon salt

1 tablespoon bourbon

MAKING THE BANANA CAKE

1. Preheat the oven to 350°F. Butter and flour a large Bundt cake pan that holds about 2½ quarts.

2. Mix the flour, baking soda, and salt in a medium bowl.

3. In a large bowl, beat the butter and sugar together until light and creamy, about 5 minutes. Add the eggs one at a time, beating thoroughly after each addition.

4. Sift the dry ingredients over the butter mixture and add the sour cream. Mash the bananas and add them. Stir until the batter is smooth and holds its shape. Pour the batter into the prepared pan.

5. Use a spoon to level the top of the batter, and tap the bottom of the pan against the tabletop to eliminate any air bubbles. Bake in the lower part of the oven for 65 to 70 minutes, until a toothpick inserted into the center comes out with moist crumbs.

Note: Check on the cake after about 20 minutes to make sure it isn't becoming dark. If it is, cover the cake with aluminum foil.

Let the cake cool slightly in the pan, then turn out onto a wire cooling rack to cool completely. Wrap the cooled cake in plastic wrap and leave out overnight to develop the flavors.

MAKING THE BOURBON SAUCE

1. Heat the sugar and butter in a saucepan over medium-high to high heat, stirring occasionally, until everything has melted.

2. Add the cream and bring the mixture to a boil. Lower the heat and simmer for 2 minutes. Remove from the heat and stir in the salt and bourbon.

3. Drizzle some of the sauce over the cake and serve the rest on the side while still hot. This cake is especially good served with vanilla ice cream.

NUTS AND CARAMEL

161

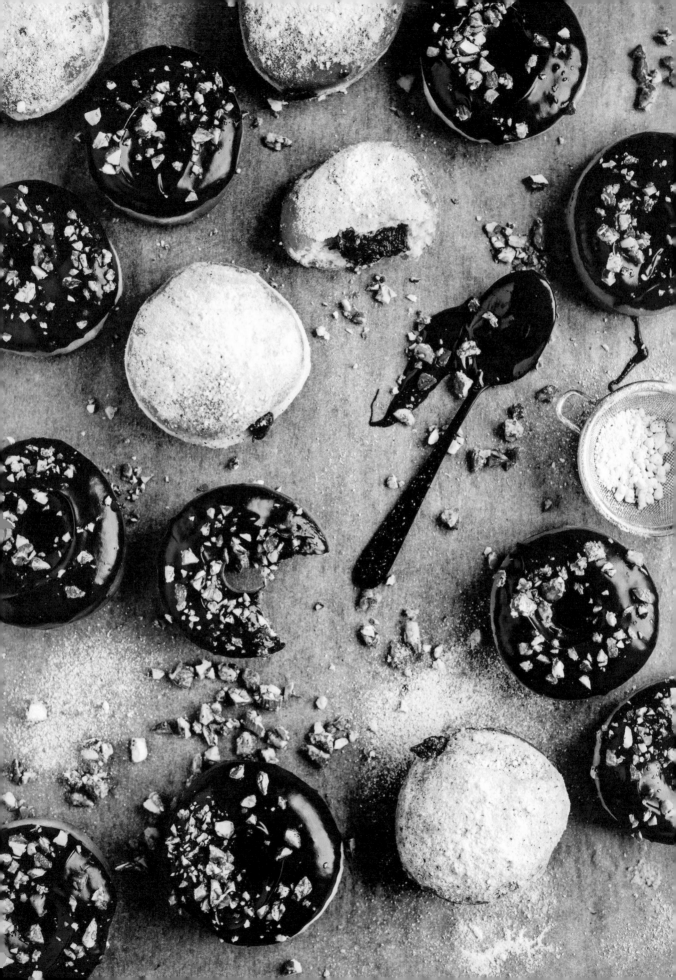

DOUGHNUTS TOPPED WITH CRUNCHY ALMONDS

Topped with chocolate glaze and crunchy almonds, these have the perfect sweet-salty pairing. The doughnuts should be eaten fresh, so invite all your friends and family over when you plan to make them.

DOUGHNUTS

¼ cup warm water (104°F–113°F)

1½ teaspoons active dry yeast

⅔ cup whole milk

2 egg yolks, at room temperature

3 tablespoons salted butter, at room temperature

2 tablespoons granulated sugar

¾ teaspoon salt

About 2¼ cups all-purpose flour

2¼ cups vegetable oil for frying (canola, sunflower, or peanut oil; see page 32)

ALMOND TOPPING

1 egg white

1 teaspoon water

Pinch of salt

5¼ ounces sweet almonds

2 tablespoons granulated sugar

¼ teaspoon ground cinnamon

½ teaspoon salt

CHOCOLATE GLAZE

2⅔ ounces milk chocolate

2⅔ dark chocolate (70% cocoa)

4 tablespoons unsalted butter

MAKING THE DOUGHNUTS

1. Whisk the warm water and dry yeast in a large bowl. Let stand for 5 minutes.
2. Heat the milk in a saucepan over low heat until lukewarm. Stir the yeast and water mixture and then add the warm milk, egg yolks, butter, and sugar. Stir until the butter has melted and all the ingredients are incorporated, about 30 seconds.
3. Add the salt and flour, incorporating with your hands or using the dough hook of a mixer. Turn the dough out onto a floured work surface and knead until supple. Oil a bowl. Place the dough in the bowl and cover with a clean kitchen towel. Let rise until doubled in size, 1 to 1½ hours.
4. Turn the dough out onto a floured work surface and roll out until ⅜ to ⅝ inch thick. Using a doughnut cutter or round glass, 2½ to 2¾ inches in diameter, cut out as many circles as possible. Using a smaller cutter, ¾ to 1 inch in diameter, cut out the center of each circle of dough (I use a piping tip). Gather up the doughnut holes and dough scraps into a ball, roll it out again, and cut out more doughnuts the same way.
5. Line a baking sheet with parchment paper and place the doughnuts on it. Cover with a clean kitchen towel and let the doughnuts rise until doubled in size, 45 to 60 minutes.

MAKING THE ALMOND TOPPING

1. Preheat the oven to 300°F. Line a baking sheet with parchment paper.
2. Whisk the egg white, water, and salt in a small bowl. Chop the almonds and put them into a large bowl. Add the egg white mixture and stir until the almonds are completely covered. Add the sugar,

163

cinnamon, and salt and stir to thoroughly coat.

3. Spread out the almond mixture on the prepared baking sheet. Bake the almonds for 23 to 25 minutes, until they are golden brown.

FRYING THE DOUGHNUTS

1. Pour the oil into a small heavy-bottomed saucepan or Dutch oven and heat to 355°F.
2. Lower 1 or 2 doughnuts into the hot oil with a slotted spoon and fry until golden, about 1 minute on each side. Handle the doughnuts carefully so you don't press out the air bubbles that formed during rising.
3. Lift the fried doughnuts out of the oil with a slotted spoon and drain on paper towels or a wire cooling rack. Continue frying until all the doughnuts have been cooked.

MAKING THE CHOCOLATE GLAZE

1. Chop the milk chocolate and dark chocolate and put them into a saucepan. Add the butter and warm over low heat, stirring continuously, until the chocolate and butter have melted. Pour into a deep bowl.
2. Dip one side of each doughnut into the chocolate glaze and then sprinkle with the almond topping.

These are best when served immediately, or at least the same day.

DOUGHNUTS WITH CREAMY NUTELLA FILLING

These rich doughnuts have a creamy cheesecake-like Nutella filling, quite a surprise treat when you bite into them.

DOUGHNUTS

¼ cup warm water (104°F–113°F)

1½ teaspoons active dry yeast

⅔ cup milk

2 egg yolks, at room temperature

3 tablespoons salted butter, at room temperature

2 tablespoons granulated sugar

¼ teaspoon salt

About 2¼ cups all-purpose flour

2¼ cups vegetable oil for frying (canola, sunflower, or peanut oil; see page 32)

NUTELLA FILLING

7 ounces cream cheese

¼ cup Nutella

CRUNCHY TOPPING

3 graham crackers or digestive biscuits

1 cup confectioners' sugar

1 teaspoon ground cinnamon

Pinch of salt

MAKING THE DOUGHNUTS

1. Whisk the warm water and dry yeast in a large bowl. Let stand for 5 minutes.
2. Heat the milk in a saucepan over low heat until lukewarm. Stir the yeast and water mixture and then add the warm milk, egg yolks, butter, and sugar. Stir until the butter has melted and all the ingredients are incorporated.
3. Add the salt and flour to the bowl, incorporating with your hands or using the dough hook of a mixer. Turn the dough out onto a floured work surface and knead until the dough is supple. Oil a bowl. Place the dough in the bowl and cover with a clean kitchen towel. Let rise until doubled in size, 1 to 1½ hours.
4. Turn the dough out onto a floured work surface and roll out until ⅜ to ⅝ inch thick. Using a doughnut cutter or round glass, 2½ to 2¾ inches in diameter, cut out as many circles as possible. Gather together any dough scraps into a ball, roll it out again, and cut out more doughnuts in the same way.
5. Line a baking sheet with parchment paper and place the doughnuts on it. Cover with a clean kitchen towel and let the doughnuts rise until doubled in size, 45 to 60 minutes.

MAKING THE NUTELLA FILLING

1. Beat the cream cheese and Nutella in a medium bowl.
2. Fit a pastry bag with a small tip (a star or round tip is fine; the exact type doesn't matter, but the tip should be no larger than ¼ inch in diameter). Fill the bag with the Nutella filling, place the bag in a bowl, and refrigerate while you make the topping and fry the doughnuts.

MAKING THE CRUNCHY TOPPING

Crush the graham crackers with a mortar and pestle or pulse them in a food processor and then transfer to a small bowl. Add the confectioners' sugar, cinnamon, and salt and stir well; set aside.

Frying the Doughnuts

1. Pour the oil into a small heavy-bottomed saucepan and heat to 355°F.
2. Lower 1 or 2 doughnuts into the hot oil with a slotted spoon and fry until golden, about 1 minute on each side. Handle the doughnuts carefully so you don't press out the air bubbles that formed during rising.
3. Lift the fried doughnuts out of the oil with a slotted spoon and drain on paper towels or a wire cooling rack. Continue frying until all the doughnuts have been cooked.
4. Dip each doughnut in the crunchy topping. Press the tip of the pastry bag into the side of the doughnut and fill with Nutella filling; enough of the tip should be inserted that the filling doesn't come out the sides. Dust with more confectioners' sugar if desired.

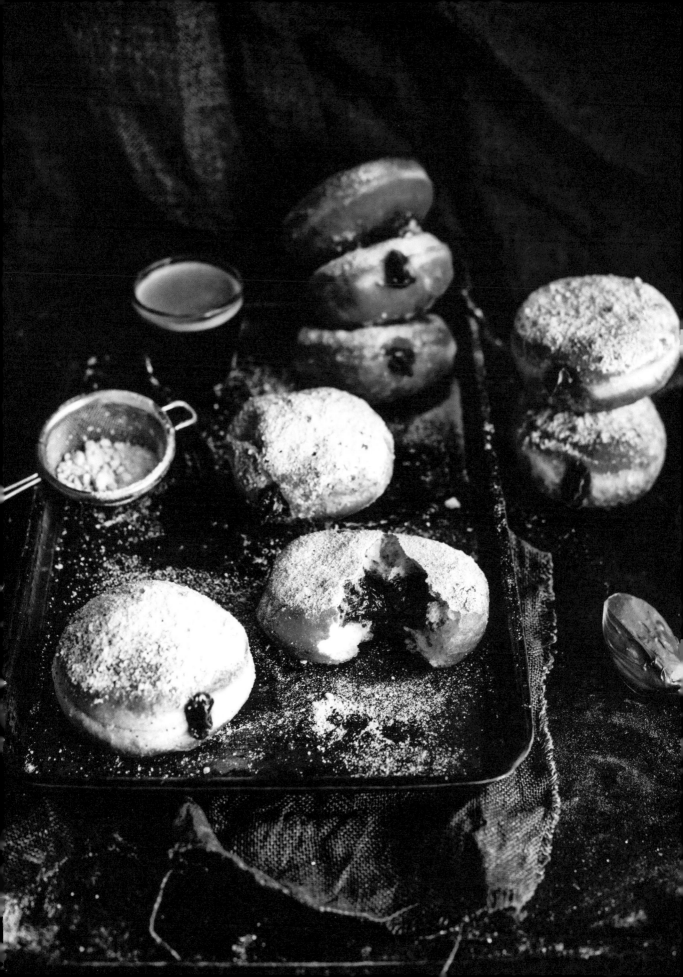

RECITE INDEX

ACKNOWLEDGMENTS

Thank you to . . .

Christian, for tasting cake after cake, batter after batter. You are my rock!

My wonderful family, for always being there with support and help.

My wonderful friends.

Emma, because you are so positive when I say something won't work and because you always help.

Peter and Gunilla, for allowing me to photograph in your lovely house. Thank you also for so kindly letting me borrow whatever I needed.

All the great people at Bonnier Fakta, and an especially big thanks to my fantastic editor, Eva, who never for a second hesitated to put on an apron and test my recipes.

Katy Kimbell, for the awesome styling. You are the best!

Atmosphere Antiques, for lending me such pretty things.

All the wonderful blog readers who follow me year after year and always sustain me with their great commentary!

ABOUT THE AUTHOR

In just a few years Linda Lomelino has become a world star on social media with her blog, *Call Me Cupcake*, and under her Instagram profile, "@linda_lomelino." Her unique photos have propelled her to the level of most "liked" food photographers on social media.

My Sweet Kitchen is her third book, following the well-received *Lomelino's Cakes* (2014) and *Lomelino's Ice Cream* (2015).

Roost Books
An imprint of Shambhala Publications, Inc.
4720 Walnut Street
Boulder, Colorado 80301
roostbooks.com

Original text and photos © 2014 by Linda Lomelino
English translation © 2016 Shambhala Publications, Inc.
Photography by Linda Lomelino
Design by Katy Kimbell
First published by Bonnier Fakta, Stockholm, Sweden
Published in the English language by arrangement with Bonnier Rights, Stockholm, Sweden
English translation: Carol Huebscher Rhoades

9 8 7 6 5 4 3 2 1

First U.S. Edition
Printed in China

⊗This edition is printed on acid-free paper that meets the
American National Standards Institute Z39.48 Standard.
♻Shambhala Publications makes every effort to print on recycled paper.
For more information please visit www.shambhala.com.

Distributed in the United States by Penguin Random House LLC and in Canada by Random House of Canada Ltd

LIBRARY OF CONGRESS CATALOGING-IN-PUBLICATION DATA
Names: Lomelino, Linda, author, photographer.
Title: My sweet kitchen: recipes for stylish cakes, pies, cookies, donuts, cupcakes, and more—plus tutorials
for distinctive decoration, styling, and photography / Linda Lomelino.
Other titles: Sweet food & photography
Description: Boulder: Roost Books, [2017] | Revised edition of work originally published in Sweden under the title:
Sweet food & photography.
[Stockholm]: Bonnier Fakta, 2014. | Includes index.
Identifiers: LCCN 2015021292 | ISBN 9781611803068 (hardcover: alk. paper)
Subjects: LCSH: Baking. | Desserts. | LCGFT: Cookbooks.
Classification: LCC TX763 .L67 2017 | DDC 641.81/5—dc23 LC record available at https://lccn.loc.gov/2015021292

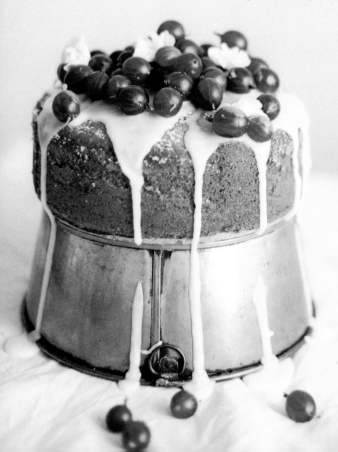

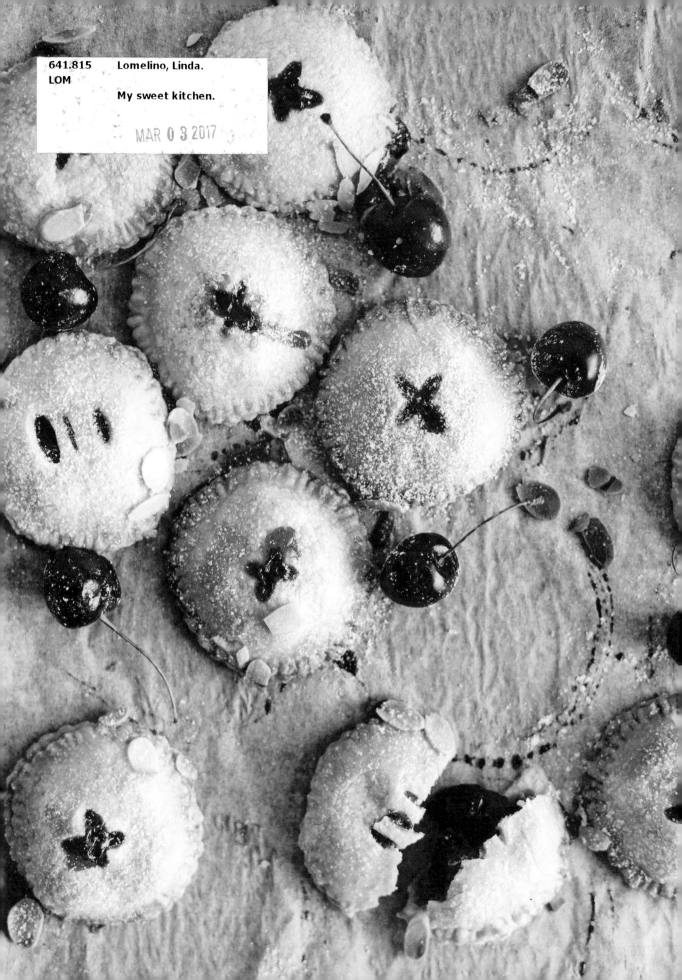